The Avant-Garde
in the history of painting

Germain Bazin

Conservateur en chef au Musée du Louvre

Translated from the French
by Simon Watson Taylor

With 265 illustrations, 52 in colour

Thames and Hudson · London

The Avant-Garde
in the history of painting

Contents

Introduction

In French military terminology, the term 'avant-garde' designates an advance detachment whose task it is to prepare the way for the main fighting force, which retains the decisive role. Applied strictly to other fields of human activity, this expression should, therefore, designate precursors rather than creators, all those who are ahead of their time and who, having glimpsed some new form prematurely, leave others to exploit it when the time is ripe. So, in painting, Savoldo and Pordenone foreshadow Caravaggio, Herrera the Elder prefaces Goya, Hercules Seghers and Elsheimer anticipate Rembrandt's visionary style.

Our own epoch has given a different sense to the expression 'avant-garde', at least in the field of art, attributing to this position decisive powers of invention capable of replacing established forms with fresh ones, the anticipatory character of which is due less to their inherent qualities of innovation than to their determination to break with the society from within which they are formulated. The retrospective application of this revolutionary notion of the nature of innovation to particular painters in previous eras runs the risk of distorting the meaning of the expression completely, especially now that we are saddled with the romantic concept of the *peintre maudit*, the artist damned by fate, the value of whose creative work tends to be assessed in terms of the ostracism it engenders. Such an attitude has exalted Caravaggio, with his reputation as a stormy petrel, over Rubens who lived like a prince; it has become fashionable to ignore the fact that, far from being a social outcast, the painter of *The Calling of St Matthew* astonished his contemporaries with the revelation of his genius and immediately inspired a school of followers. It is not possible to understand the art of other times on the basis of a determination to visualize the artist as a man at odds with society. It should be realized that, on the contrary, the civilizations which preceded the modern world granted the artist the greatest possible freedom in the invention of the forms best suited to serve their ideals. Although the medieval Church inspired programmes, it refrained from coercing the image-makers. Becoming belatedly apprehensive about the spirit of the Reformation, the Church occasionally took it upon itself to be stern, but even then avoided unnecessary harshness: the Inquisition did not oblige Veronese to destroy the *Feast in the house of Levi*, merely to modify certain aspects. Similarly, those parishes or confraternities which were so horrified by Caravaggio's plebeian naturalism that they turned down certain works they had commissioned simply allowed him to keep them, and did not take offence even when some picture they had rejected, such as the *Death of the Virgin*, later became the occasion of a personal triumph for the artist.

During the Renaissance period, the artist, even when working for the Church, enjoyed considerable creative freedom. It was common knowledge at the time that Fra Filippo Lippi had bestowed upon the Madonna the features of his mistress, a nun whom he had seduced in her convent. Fouquet endowed the Virgin of his *Madonna and Child* with the face of King Charles VII's mistress. Grünewald found a patron and a monastery to harbour his terrible visions. The artist was sometimes considered to be above the law; a pope pardoned Benvenuto Cellini for a murder, while Caravaggio, who had also killed a man, had already been pardoned by Paul V when, as a fugitive, he died of fever on the barren coast of Porto Ercole.

From the time of the Renaissance onwards, the artist was particularly highly regarded for his inventive qualities. The literate princes of the sixteenth, seventeenth and eighteenth centuries were constantly on the alert for novelties and competed vigorously for their creators. Many bold ventures were due as much to the environment as to the artist. We marvel today at the inventive genius of Arcimboldi, preceding surrealism as it does by several centuries; yet in the atmosphere of a Milan steeped in academicism he made little impression as an artist, and it needed the mannerist court of Prague to reveal him to himself.

The quarrel between those with an aversion to novelty and those addicted to it is a contemporary phenomenon. Certain present-day art critics and biographers who prefer their artists to be cripples, drunkards, social outcasts, suicides, anarchists, swashbucklers or scoundrels might be well advised

to consider the great innovators of the past as other than asocial beings; they would then have to admit that Goya, revered today as the quintessential rebel, was a man astute enough to scheme for his own ends with the various regimes which were squabbling over Spain, and to survive with equal resilience in the camp of 'collaboration' and that of 'resistance'.

This is not to imply that today's fundamental discord between artist and society never existed previously. Precedents are to be found in seventeenth-century Holland, where the greatest painters, Frans Hals, Ruisdael, Rembrandt and Vermeer, all had to resign themselves sooner or later to breaking with their social environment and retreating into the solitude of genius, with all the consequences that such a break implied. The condition of pariah imposed upon the 'avant-garde' artist appears, in fact, to be a specific aspect of the kind of bourgeois civilization which seems to need to compensate for the boldness of its measures in the field of action by an aesthetic and ethical conservatism designed to provide the feeling of stability necessary to its activity.

In aristocratic civilizations, on the contrary, the artist is a magician; a society eager for displays of sophisticated wit expects from him a constant and inventive flow of unexpected diversions. Without fearing the disapproval of his court, Philip IV not only recognized Velázquez's genius but indulged him in his ambition to become a grandee, treating the painter as his friend and confidant. Velázquez was the first artist to be liberated from the tyranny of commissioned work; the rank of nobility the king bestowed upon him prevented him from ever again involving his art in commercial transactions. The paintings of Velázquez's Seville period would seem to rule out the possibility that he would have developed exactly as he did without the protection of Philip IV. There were other painters at the court of Madrid, and ones with a greater aptitude for flattery, but it was the quality of genius that the king discerned in Velázquez, and that alone, that attracted him.

It must be admitted that the Bourbons showed less respect for the independence of genius than the Hapsburgs – Charles V, Philip II and Philip IV. When Louis XIII of France tore Poussin away from Rome, it was to serve his own glory rather than that of the unfortunate artist, who found himself so overwhelmed with work that he made his escape as quickly as was decently possible. Louis XIV, the inspired despot who bent all the arts of his time to his will, went even further. During the eighteenth century, the French court favoured academicism, and the original artistic invention that went on was conducted quite outside its sphere; meanwhile in Spain the coming to power of the Bourbons brought in its train an academic despotism that was completely to undermine indigenous art.

In this book I have set out to identify as the members of the 'avant-garde' of painting all those who were pioneers, all those who have enabled it to proceed from conquest to conquest, until its reversion, in our own time, to nothingness. These pioneers may equally well be those who were in advance of their time, or on the contrary those who revealed their time to itself; in any case, no surprise should be felt at the inclusion among 'avant-garde' painters of artists such as Raphael or Correggio who launched veritable revolutions in art. One might even go so far as to say that these are both *peintres maudits*, at least posthumously! 'If he were to return today,' said Picasso speaking of Raphael, 'with exactly the same canvases, nobody would buy a single one from him. Nobody would even look at them.'

On the other hand, those artists will be excluded – without reference to the author's own preferences – whose genius fulfilled itself harmoniously within the pattern set by the achievements of their predecessors: such artists as Titian, Poussin, Gauguin, for example. This does not involve a rejection of classicism as an innovating position, since Raphael and Giotto are ranked among the great 'inventors'. Any reproaches relative to the long-lasting academicism that classicism engendered should be addressed to the succeeding generations rather than to classicism itself. It has been my aim here to consider Raphael from the viewpoint of a man of 1511 privileged to contemplate the brand-new frescoes of the Stanza della Segnatura in the Vatican, and not in the spirit of a modern exasperated by four centuries of Raphaelism.

This fresh perception of the things of the past demands a tremendous effort of will to free oneself from the whole accumulation of ideas deposited by 'tradition'. But what would become of tradition if it could not count on the revolutionaries to defend it against the traditionalists? It is the revolutionaries' perennial youthful rebellion against the past which eventually ensures the continuation of a *living* tradition, and tradition, having the continuity of human civilization in its care, is indebted to them for preserving its vitality.

As perspective recedes, the sharp detail of the original blurs and fades, to merge into the general line of evolution. Tradition and evolution are interdependent; anything that passes from hand to hand is bound to lose some substance through

constant usage, and this gradual erosion needs to be compensated for by a constant deposit of new sediment. Life itself offers us the prime example of this process: its continued existence depends entirely on its being transmitted from one individual to another, and yet since the world began no individual has ever reproduced the exact characteristics of his immediate predecessor.

Even if not necessarily in conflict with the social environment, artistic creation remains very much a battle. Both bourgeois civilization and the marxism it has spawned as a reaction against it have demeaned the conflict to one between man and man, whereas its real site is deep within the soul, a conflict between man and himself, between man and God. The Greeks expressed this spiritual laceration in the myth of Prometheus. Creation involves violence, but it is essentially a violence to oneself. The artist's destiny is to assume the burden of human contradictions so as to elucidate or resolve them. The nineteenth century made the artist a scapegoat, a role which he is well qualified to play. But from time immemorial, and even in the present age, he has also been honoured as an inspired being, able by means of the visible to deliver to humanity some tidings of the invisible.

CWKPATHC

1 *Socrates*. Painting found in a house at Ephesus in 1963. 1st century B.C.

1 The lost heritage

Plato, whose thought, as developed by neoplatonism, was to leave so profound a mark upon the Renaissance, professed complete contempt for art. He believed that the transition from essence to appearance always involved a fall from grace; the artist, instead of emulating the philosopher by climbing back up the slope which leads down from the One to the Infinite, allows himself to slide down it to the very bottom. The painters who were Plato's contemporaries, in the full throes of discovering nature, inevitably appeared to him to be corrupters. Even Zeuxis, who had needed five models, all young women chosen from among the greatest beauties of Corinth, in order to portray Helen's loveliness, found no favour in his eyes; Zeuxis could never attain more than a composite beauty, for absolute beauty is that which assumes no corporeal appearance and which is the sole destiny of the dialectic of love.

Plato finally admitted art into his ideal society, on the grounds that it might to some extent help the gross-minded to restore in themselves those impulses which had become distorted by the flux of events; but he remained hostile to the idea of judging a work of art by subjective criteria (that is to say, by the pleasure it afforded) and dedicated the artist to 'imitation'. However, this assigned role was by no means intended to induce the artist to reproduce appearances in process of growth; it constituted, rather, a form of approach to the reality which is essence, to be achieved by respecting just proportions, such as those defined during the previous century by Polycletus in his *Canon*. In this way, art was to be fixed permanently in an academic mould, and Plato offered the artists of his time the example of Egyptian hieratic art, which had not evolved for thousands of years.

But the philosopher's admonitions were in vain. The artists of the fourth century preferred to follow the precepts of Gorgias, who advocated the practice of illusionism. Furthermore, they were influenced by the doctrines of Aristotle, for whom art should be lively and play a healthy role in society through the process of *catharsis*, the purgation of the passions; in complete opposition to Plato, then, Aristotle favoured those two sources of creation, boldness and

innovation, which typify the 'avant-garde'. So the two conflicting principles which were to nourish the whole evolution of European painting had already been laid down in the fourth century BC, the great century of Greek painting.

It is not difficult to understand why painting, in view of the determination with which it strove for likeness at that time, should have seemed to Plato to be the most dangerous of the arts. The man of genius who had forced destiny during the previous century was Polygnotus of Thasos. The paintings he had executed with Micon in Athens and those he had made alone for the *leskhe* (meeting-place) of the Cnidians in Delphi represented a *Battle between the Greeks and the Amazons*, the *Capture of Troy*, and the *Battle of Marathon*. There is no more splendid subject than a battle – Paolo Uccello was to make full use of its resources in a later epoch – for the painter seeking to capture expression, action and position in space, and this is precisely what Polygnotus had succeeded in portraying in his work, thus liberating his art from the constraints of the surface: he had transformed an art of drawing into one of painting. And yet, as a true classicist, this contemporary of Phidias upheld that truth which was subject to the rules of measurement and beauty. The theatre was at the height of its glory then, and the requirements of stage design spurred artists on to increasingly audacious feats of *trompe-l'œil* and artifice. The first stage-setting, according to Vitruvius Pollio, 'was created in Athens in the time of Aeschylus by Agatharchos; he wrote a treatise on this art, followed by Democritus and Anaxagoras who dealt with the same subject'. These recipes were perfected at the end of the fifth century by Apollodorus the skiagrapher (skiagraphy is the art of depicting shadows), who succeeded in conjuring from plane surfaces the illusion of the exterior world, with its relief and colouring. This constituted the avant-garde of painting of that time, and was already the target of criticism from the traditionalist supporters of Polygnotus's classicism. Zeuxis and Parrhasius went even further in the same direction. Pliny recounts that a bunch of grapes depicted by Zeuxis in a stage-setting was so lifelike that birds used to swoop down and peck at them; and

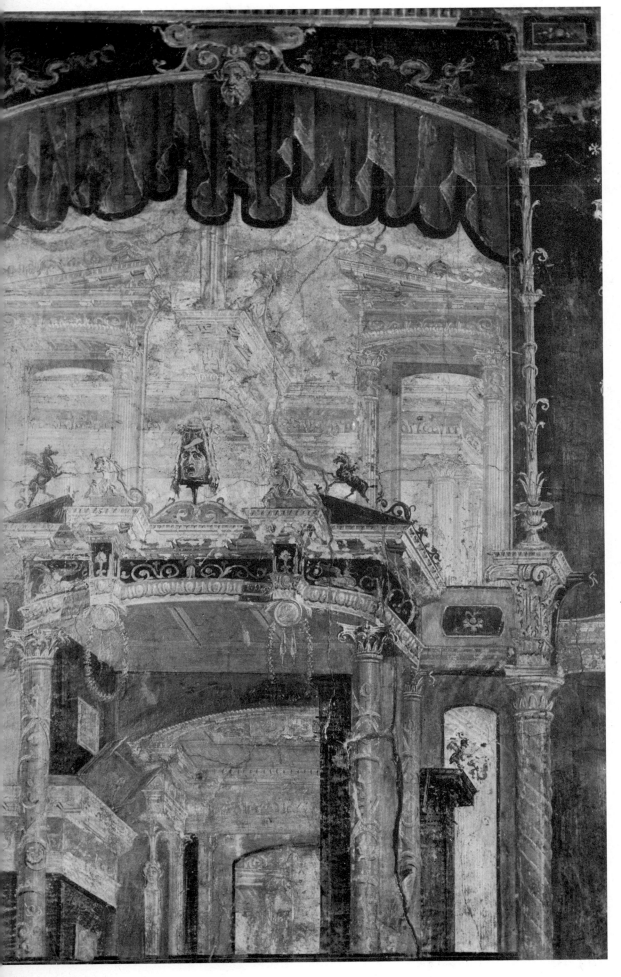

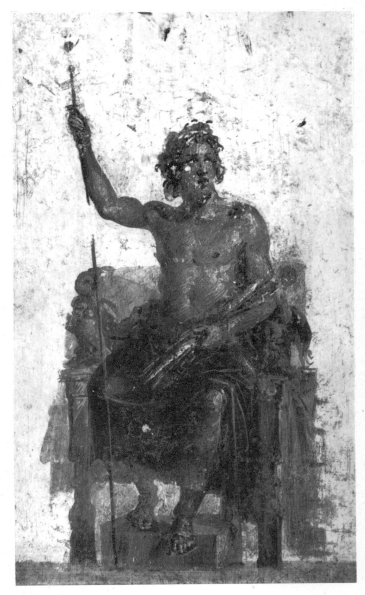

◀ 2 Decoration from a house at Herculaneum. Naples, Museo Nazionale.

3 *Zeus*. Painting in the House of the Vettii at Pompeii, probably derived from a work by Apelles.

While certain paintings at Herculaneum and Pompeii are evocative of Greek classicism, others are more concerned with the illusionistic impression sought by artists such as Zeuxis and Parrhasios.

Parrhasius once painted a draped curtain with such cunning that a fellow artist, seeing it for the first time, tried to draw it aside, thinking that it was real and concealed the picture. These exemplary anecdotes, which were doubtless invented by sophists, allow us to guess at the nature of the aesthetic conflicts involved. According to Pliny, Zeuxis remarked that if the child he had painted beside the grapes had been equally lifelike the birds would never have dared peck at them; but to the

general astonishment, the artist destroyed the fruit, retaining only the child because he considered it more 'perfect'. From this period onwards, schools and sects proliferated. While Parrhasius aimed to express life through eloquence of contour, Zeuxis perfected relief by the use of light and shadow, and so invention continued its gradual progress. Shading added its effect to virile bodies that had become more muscular, and later appeared on the smooth surface of female nudes. Then 'points of light' began to make breastplates sparkle, as in works by Titian and Rubens. The foreshortening that enhanced the relief became bolder, and Apelles went so far as to make the hand of his Alexander jut out from the image, an audacity that was not to be repeated in the West until the seventeenth century. In Apelles's time, painting began to emerge from the wall surface, becoming a mobile object, hanging against a living-room wall or resting on a moulding. Everything became a suitable theme for painting: historical subjects, portraits, landscapes and still-lifes. This last genre grew particularly popular, and towards the end of the fourth century or the beginning of the third Piraikos made a speciality of it, painting barbers' and cobblers' signs. He also

5 Detail of wall-painting from the House of the Cryptoporticus at Pompeii.

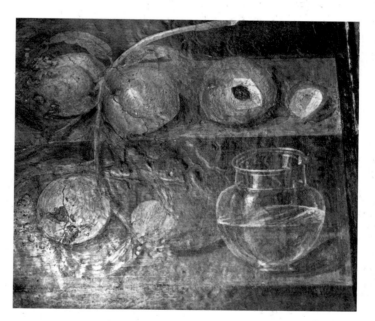

6 *Peaches, nuts and glass*. Detail of a wall-painting from Herculaneum. Naples, Museo Nazionale.

Many Romano-Campanian paintings were inspired by the *xenion*, a type of domestic still-life invented by the Greeks of the Hellenistic period; some of these paintings show how such easel pictures, with their protective shutters, were arranged in the room.

4 Detail of a *lekythos* from Eretria. Third quarter of 5th century BC. Athens, National Museum.
Unlike those vases whose red and black figures represent a decorative conception, the funerary *lekythoi* carry painted designs which give some idea of the expressive graphic skill of the great Greek masters.

depicted various foodstuffs, doubtless in the form of small pictures protected by shutters, like those to be seen represented in *trompe-l'œil* in the first-century mural designs at Pompeii and Rome. The mosaicist Sosos of Pergamum (third or second century BC) had the strange idea of representing the floor of a dining-room before it had been swept clean of the scraps from the meal; the ancients designated this particular type of painting *rhyparographia*, that is to say 'garbage painting', a word-play on *rhopographia*

which meant 'painting of minute objects' and was in its turn opposed to *megalographia*, the word for mural painting. The imitation of everyday objects had a great success until the end of the ancient world. The Romans bought the Greek originals for high prices, had copies painted on their walls, or reproduced the motifs on their tessellated floors. These genre pictures were the forerunners of the Spanish *bodegones*. Others among these small pictures of still-lifes were called *xenia* (or presents) and perpetuated the old tradition of making gifts of fruit, game, glassware or silverware to one's hosts (*pl. 6*).

It is useless to attempt, as some have done, to pierce the mystery of these vanished works by examining the paintings on vases. One could as well try to visualize Raphael by studying the pottery of Urbino. In addition, the birth of classical painting coincided with the decadence of vase decoration, which had, in any case, adhered strictly to the silhouette form; the single exception is the Attic funerary *lekythoi* of the fifth and fourth centuries (*pl. 4*), oil-jars with a white ground, whose decorative technique is closer to that of painting. As for the following century, the vases of Centuripae (Sicily) and the Lipari Islands permit us to appreciate their fresh colours and blended contours in the context of Hellenistic painting. It was at this moment in time that the philosopher Philostratus wrote: 'Everything possesses its own colour, clothes, weapons, houses and living-rooms, woods, mountains, springs and the *air which envelops all things*.' Might not this remark, inspired no doubt by the paintings of his contemporaries, apply equally well to impressionist pictures? But the paintings which have survived are either partly effaced or of coarse quality and yield us little useful information. The third-century tomb at Kazanlik in Bulgaria, on the very frontier between the Greek and barbarian worlds, presents a painted scene that is doubtless somewhat archaistic: the quadriga (*pl. 7*) shows the artist's happy attempt to suggest the horses' impatience by distributing their contrasting postures across the surface with considerable animation; however, a certain 'barbarism' shows itself in the weakness of the drawing, something in which the Greeks were always unsurpassed.

It will prove more useful to examine the abundant, if belated, evidence provided by the Roman paintings rediscovered in Pompeii, Herculaneum, Stabiae and Rome. It is true that these paintings have been called into question, as much by their supporters as by their opponents, and Italian criticism is at present divided by a controversy on the subject of their real merit. The critic Carlo Ragghianti (*Pittori di Pompeii*, Milan 1963) defends the originality of these paintings in relation to Hellenic art, whereas the archaeologists consider them to be the provincial result of an academic or unrefined imitation of the masterpieces of Hellenic painting. Ranuccio Bianchi-Bandinelli, in articles published in 1940 and 1941 (collected in *Storicità dell'arte classica*, Florence 1950), has supported this latter thesis: using precise examples, taken mostly from the celebrated Villa of the Mysteries, he has no difficulty in showing that the Campanian painters produced flagrant imitations containing blunders typical of unintelligent copyists. Taking an opposite point of view, Ragghianti has been the first to approach these paintings as works of art executed by individuals, whether copyists or not; by distinguishing 'mannerisms', that is to say elements of individual style in these works, he has been able to arrange them in an order of ascription to particular 'masters', rather than limiting them to the anonymous classification of styles in use before him. No agreement can ever be possible, probably, between the archaeological criticism of Bianchi-Bandinelli and the formal criticism of Ragghianti, since they derive from basically incompatible principles. The archaeologists base their judgments on the criterion of the absolute perfection attained by Greek classicism, a criterion that Bernard Berenson defended throughout his life, adding to it its prolongation in Italian classicism. The more modernist criticism of Ragghianti proceeds from the principles of Alois Riegl, according to which every artistic gesture is significant and expresses a formal will that may well find itself never more apparent than in imitation. Ragghianti puts forward as one example of originality within the context of imitation Arnolfo di Cambio copying the early Christian sarcophagi. As for the question of 'clumsiness', in the light of the re-evaluation of primitive civilizations which followed upon Riegl's initiative, this has ceased to represent a negative value. By virtue of these more or less conscious principles, the 'provincialism' of Roman art has been restored to honour during the last decades, so there seems no reason why similar esteem should not be extended to the particular provincial form constituted by Campanian painting.

In default of the irretrievable beauty of Greek painting, Roman Campania has at least preserved for us its genres and subjects. The platonic theory of the transmission of classic form allows us to perceive in various mythological scenes a reflection of the masterpieces of the great fifth- and fourth-century masters, although it is not possible for us to trace these interpretations back to a specific master — interpretations which are freer than the copies of

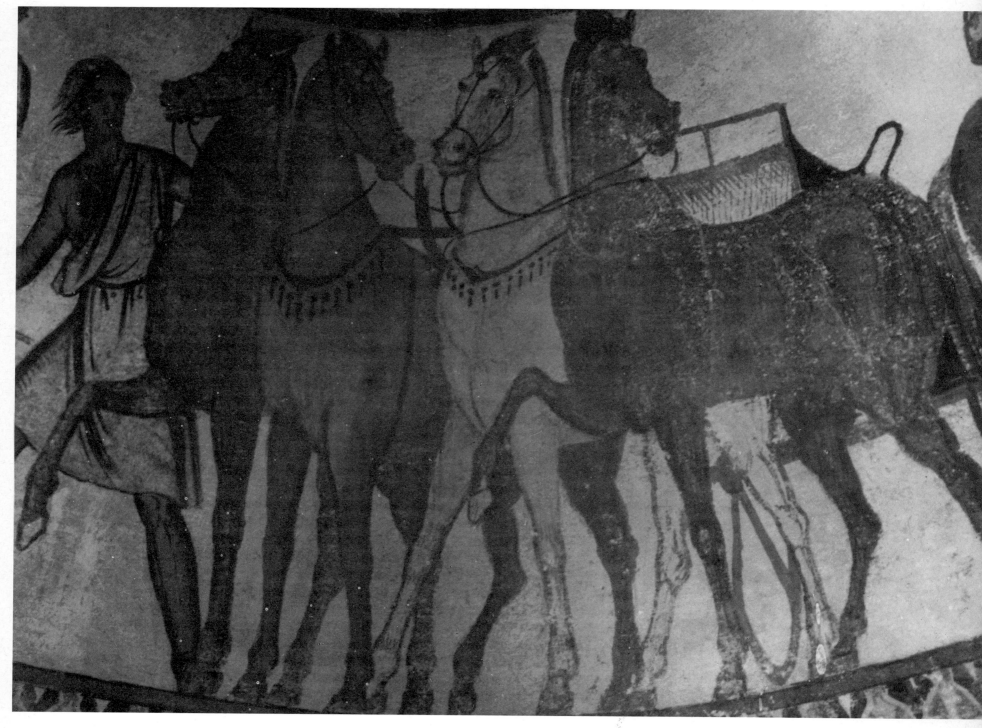

statuary made during the same epoch. Most of these scenes possess a classical grandeur, and it is a mosaic which probably expresses best the extraordinary boldness of painting during the Hellenistic period: the *Battle of Issus* (*pl. 9*) is certainly a copy of a celebrated work executed for one of Alexander's successors by some court painter (Philoxenes of Eretria, Helenus of Alexandria, Protogenes, Aetion?). Despite the loss of refinement resulting from the translation into mosaic, we can appreciate the play of hues, lights, reflections and cast shadows, the forcefulness of the expressions, the dynamism of the action and, most of all, the art of suggesting

depth. The form of the horse in the foreground, viewed from the rump, is entirely gathered back on itself; not until Rubens will an equally bold use of foreshortening be found.

The three towns buried by Vesuvius display a comprehensive panorama of antique painting, and include all the varieties of landscape which the West was later to reinvent. Here is the classical landscape, serving as framework for an epic action, reminiscent of Poussin or Claude (the Odyssey landscapes in the Vatican's Museo Profano); here is the 'sacred landscape' of Hellenistic derivation, depicting animals and temples dispersed in nature in a dream-

7 *Quadriga*. Detail of a wall-painting from a tomb at Kazanlik, Bulgaria. 3rd century BC.

Contemporary with the great masterpieces of Greek painting, these magnificent horses reflect, with an admixture of provincial crudity, the intense realism of the great masters of the classical period.

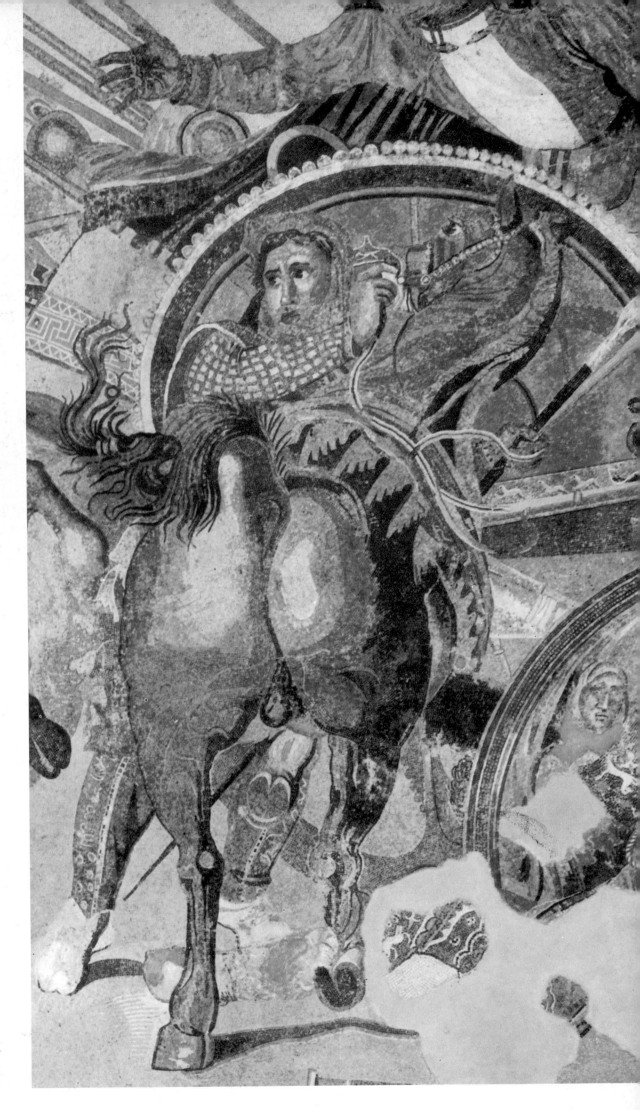

8 *Achilles and Briseis*. Detail of a painting from the House of
the Tragic Poet at Pompeii. Naples, Museo Nazionale.

9 *The Battle of Issus*. Detail of a mosaic from the House of
the Faun at Pompeii. Naples, Museo Nazionale.

In certain works at Pompeii and Herculaneum the
expressive liveliness, powerful foreshortening and intensity of
movement evoke the dynamism of seventeenth-century
baroque art.

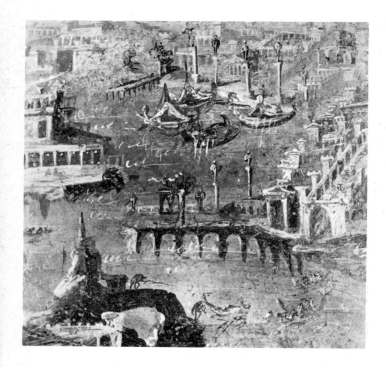

like atmosphere, whose poetic inspiration evokes eighteenth-century idyllic landscapes; the exotic landscape, introducing African animals, is of Alexandrian origin; and here, too, are seascapes, port scenes (*pl. 10*) and townscapes. The wall-paintings of the Villa of Livia at Primaporta (Rome, Museo delle Terme), and certain murals recently excavated at Pompeii, have revealed to the astonished excavators that the 'verdure' genre of painting of our Middle Ages was already practised by the ancients. This whole broad vista of the spectacle offered by nature lacked one single feature: it was left to the painters of Western art to invent the portrait-landscape *reproducing* a motif or limited aspect of nature, for the ancients conceived landscapes only as composed wholes.

Although historical painting was held in highest esteem, the Romans of Campania took special delight in genre scenes, and it is thanks to such paintings that we are fully acquainted with the details of their family and social existence, through scenes of home life, the street, the tavern and even the public brothel. Picaresque story-pictures are sometimes painted in a satirical spirit akin to that of Jacques Callot. The *xenia* inform us what food they ate and the kind of tableware they used. We know their predilection for animals, as well as for birds, flowers, butterflies and especially for the joyous forms of naked children, those *amorini* who perform every possible human task while at play. And all the stages of development of the art of skiagraphy have been revealed to us by the houses of Pompeii.

The Italians inherited from the Romans this

10 *View of a port.* Detail of a wall-painting from a house at Stabiae. Naples, Museo Nazionale.

11 Detail of a landscape. Naples, Museo Nazionale. The landscape is one of the great inventions of Greek painting, and Pompeii and Herculaneum have preserved for us several examples, although these were never realistic views painted from nature.

12 Detail of a decoration in the House of the Masks, discovered in 1961 on the Palatine at Rome. A marvellously preserved example of those imaginary architectures, condemned by Vitruvius for their audacity, which were doubtless intended to suggest theatre scenes.

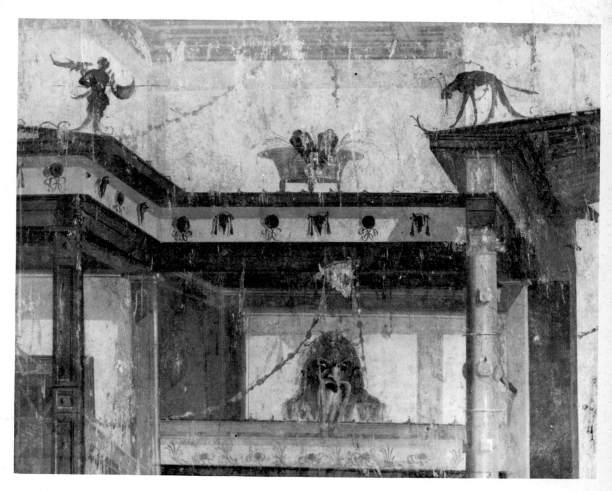

preference for domestic privacy in which it is the walls of the rooms which open on to dream-forests and fantastic architectures. There is no general agreement on the question of whether the Romans practised the art of *perspectiva artificialis* with a single vanishing-point. Judging by the Pompeiian mural decorations of the 'Second Style', it may be considered that they came very near to this through the convergence of lines upon a vanishing axis, but with several directions of lighting, as for example in a wall painting from a villa at Boscoreale (Naples). The paintings of the Third and, more especially, the Fourth Style, incorporating several vanishing points and exuberant pictorial detail, bear witness to the fact that towards the close of the Hellenistic world scenography was as rich in resources as it ever was in the baroque opera of the seventeenth and eighteenth centuries. This wall painting from Herculaneum (*pl. 2*), with its marvellously realistic curtain that makes one think of the celebrated curtain painted by Parrhasios, surely evokes also the most poetic fantasies created by Giuseppe Galli Bibiena in his eighteenth-century stage designs. It is clear, then, that in spatial invention the ancients anticipated the great baroque artists of the West, at least in terms of mural painting, although they appear to have remained ignorant of an allied art, that of ceiling painting.

We are immensely the gainers from the natural disaster which struck down the unfortunate inhabitants of Pompeii, Herculaneum and Stabiae in AD 79, and preserved for posterity, under the ashes, this astonishing treasury of antique painting. In surveying these ruins, we are able to study all the stages of antique treatment of artistic themes, from the classical style, respectful of form, to the freest possible execution, involving dabs of light and shadow, evocative of Magnasco or of Goya in the period of his deafness. This latter manner (*pl. 13*) has erroneously been termed 'impressionist'; the ancients named this cursive style *compendiaria* (abbreviated). The term 'impressionist' should be limited to work executed in pure colour, which the ancients also practised, but apparently towards the end of their artistic evolution, at the moment when painting was about to yield its supremacy to mosaic. In the first Christian mosaics, dating from the fourth and fifth centuries, in Santa Maria Maggiore at Rome, and in Hagios Giorgios and the Acheropita at Salonika, the whole effect is obtained by colour alone, an intense colour which was to lose its richness, if not its brilliance, in Byzantine art. In these mosaics, drawing and shading are entirely absent, while an absolute clarity makes the light vibrate, breaking it up into its chromatic variations. No doubt the technique of mosaic lent itself particularly to this 'divisionism'. At Hagios Giorgios, Salonika, the way in which the gradations of volume are achieved solely by variations of colour evokes Cézanne, while at Santa Maria Maggiore one thinks rather of Renoir, the Renoir of Cagnes, conjuring infinite shades of tone from his palette.

From Polygnotus to the Master of Salonika, in ten centuries, antique painting travelled along the same path that in Western art was later to lead from Giotto to impressionism. In less than two centuries, all this was to be swept away by barbarian invasions and the spiritual revolution of Christianity. The break was a brutal one, and only one art, that of the portrait, experienced all the intermediary stages involved in the transition from the real to the unreal. It is perhaps in this domain that the Romans, with their predilection for naturalism and individualism, demonstrated the greatest inventiveness. The truthful meaning of the human effigy had been vitiated by the idealized beauty or gesture imposed upon it by the Greeks. A man shown in terms of unadulterated physical truth, such as the famous baker of Pompeii, is a purely Roman work, and no comparable verism in portrait painting is to be found until the advent of Jan van Eyck. The woman accompanying the baker is depicted in a more conventional manner, as is the case throughout history with female effigies, although the Romans occasionally probed deeper than the gallantry demanded by custom; a bust from Pompeii, in the Museo Nazionale in Naples, portrays the archetypal Mediterranean matron such as may still be seen any day on the screen in Italian popular films.

The art of the portrait, realized in encaustic on panel, flourished in Lower Egypt from the first to the fourth centuries AD. These effigies, representing figures still in the bloom of youth, were hung in the atrium of the family's house, and on the death of their model they were wrapped in the mummy's bandages. A marvellous field for the study of races at the end of the ancient world is provided by this gallery portraying all the ethnic groups which intermingled in Egypt: Greeks, Jews, Syrians, Persians, Negroids, Indians, Copts and Romans. The change which overtook humanity during the closing years of the ancient world can nowhere be more effectively studied than in the Middle East, the scene of a decisive encounter with the tormenting problems of spiritual life. The earliest of these portraits look out at this world, while those from the latest period look out at the world beyond: the gaze of these enormously enlarged ocular globes begins to waver, grows anxious, then becomes fixed

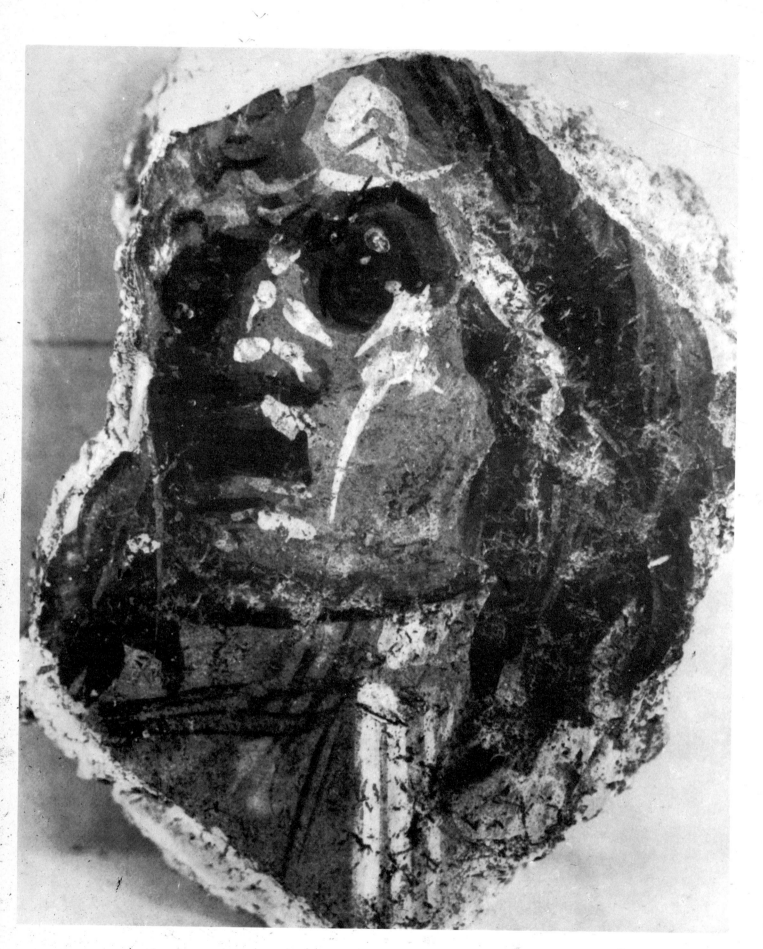

13 *Head of a woman*. Wall painting
discovered at Stabiae.

The free use by Romano-Campanian
painters of an abbreviated treatment
called *compendiaria* is sometimes
prophetically evocative of Goya's
expressive vigour.

in contemplation of the invisible (*pl. 14*). After these ecstatic glances had been extinguished in Faiyum, the Coptic monks, before being overwhelmed by the tide of Islam, continued to reproduce them clumsily in the new Christian imagery, the popular reflection of the great Byzantine art. But by one of the most extraordinary paradoxes of history, antique painting was continued beyond its time by other monks, those of the monastery of St Catherine at Sinai. Preserved by the desert from the theological controversies of the sixth century and the iconoclastic quarrels of the eighth, spared by the Arabs themselves from any encroachment, these monks pursued until the seventh century the living art of antique painting, and this in the form of icons at a moment when, for theological reasons, these images were eliminating all intimate relationship with the world of appearances, retaining only the minimum of visible support necessary for the manifestation of the idea. Looking at this sixth-century face (*pl. 15*), with its heavy sensual eyes and rosy complexion, who would guess, if it were not for the Syrian *maphorion* (a head-dress worn by priests and women), that it belonged to a representation of the Virgin Mary painted at the very moment when, in Byzantine art, she was becoming pure Idea in the solemn guise of the *theotokos* (Mother of God) or the compassionate one of the *hodegitria* (divine guide)? It is strange to think that it took the 1956 Suez campaign to reveal to the world this treasure-trove of icons, preserved inviolate in Sinai and glimpsed hitherto only by a few scholars.

The West was never able to inherit the riches of antique painting. The original examples vanished with the civilization which had given birth to them, and the tradition was broken by Christianity. Being a means of exploration of the real, such painting remained unadaptable to the new Christian civilization which guided the image in the direction of an entirely different vocation that was both spiritualistic and unrealistic. This process culminated in the virtual disappearance of the art of painting, and the arts of coloration were given expression during the Middle Ages through other mediums: mosaic, stained glass, miniature, enamel. The awakening of Western art was accomplished through sculpture. The relatively uninventive style of the Romanesque fresco, and of Italian painting before 1250, bears witness to the backwardness of strictly pictorial form in comparison to the world of sculpture which, from the Master of the Miègeville Tympanum in the church of Saint-Sernin at Toulouse to Nicola Pisano, constitutes the true artistic avant-garde between 1100 and 1250.

Painting, properly so called, was, however, preserved in Byzantium in the form of icons, although these have vanished almost as completely as have the paintings of the ancient world. The sad smile on the face of the twelfth-century *Our Lady of Vladimir* (*pl. 16*), a surviving witness of an engulfed world, testifies that a flicker of life was at that moment animating Byzantine art. The frescoes of Serbia, those of Mileševa (*c.* 1235) and especially those of Sopoćani (*c.* 1260), as well as certain icons of the same school, show the development of a tendency resulting from the deep urge towards classicism which Byzantine civilization had been experiencing since the ninth century, and which constituted an important factor in the gradual relaxation of hieratic convention, the consequent increased suppleness of style, and the appearance of an impulse towards nature. This impulse found outlets in the schools deriving from Byzantium, the Greek school (the fourteenth-century wall paintings at Mistra), the Serbian and the Russian schools.

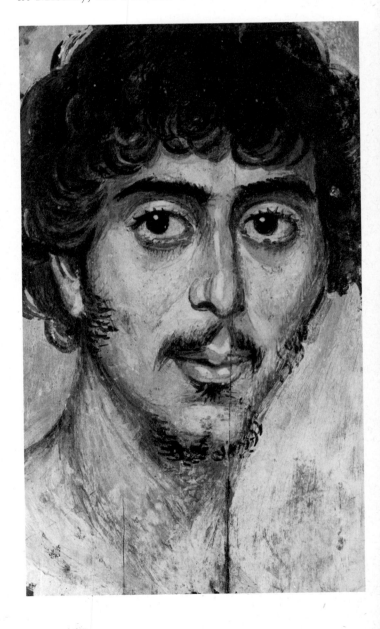

14 *Portrait of a man*. 2nd century A.D. Graeco-Egyptian. Berlin-Dahlem, Staatliche Museen.

The psychological portrait, succeeding the idealized portrait of the Greeks and the realistic portrait of the Romans, expressed the spiritual anguish prevalent during the closing phases of the ancient world.

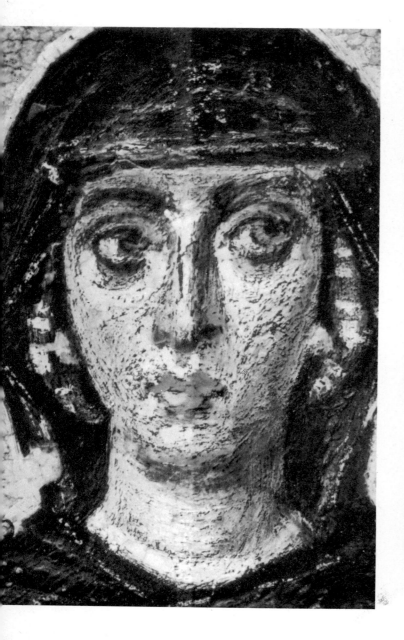

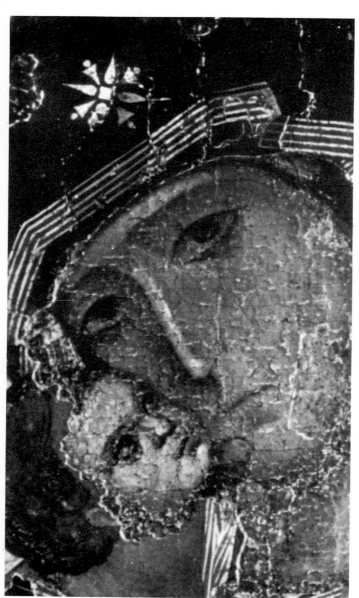

15 Detail of *Madonna and Child*. 6th century A.D. Icon from the monastery of St Catherine at Sinai

The sensual expression and crimson lips of the Madonna of Sinai allow an element of antique humanism to show through the Eastern hieratic convention which was to triumph in Byzantine art.

16 *Our Lady of Vladimir*. 12th century A.D. Moscow, Tretyakov Museum.

After several centuries of theological art, a thrill of life suddenly permeated the icons of Byzantium once more, during the eleventh and twelfth centuries. This awakening of human feeling, when it occurred in the West a little later, was more profound.

The surprising points of similarity between the paintings of Mistra and those of Tuscany have led to some theorizing about the latter's influence, but these affinities prove rather that Byzantine art was in the process of rejoining the West in the course of its own evolution. The same applies to Russia. At the beginning of the fifteenth century, at the opposite pole of the Christian world, the Moscow-centred art of the icon shared with the fourteenth-century school of Siena a traditionalist attitude which, eschewing all drastic innovation, moved forward through a constant refinement of fundamental plastic and spiritual concepts; these concepts were themselves derived from the sum of Byzantine artistic production over the centuries, which still retained alive, buried deep within it, some of the ferment deposited there by antiquity. Despite everything, life insinuated itself into this formalism, as it did at Siena, so transforming this supremely anti-humanist attitude. Andrei Rublev's Christ, for example, is already on a par with the Christs of the Quattrocento; the graceful linear style of this artist evokes Duccio and his theological spirituality, and, to a lesser degree, that of Fra Angelico. Rublev, like Duccio – although in the latter's case the Gothic impulse helped stimulate his development – shows how the art of painting tended to free itself from Byzantine constraints, but without any deliberate attempt to break away.

Thus Byzantium achieved its own self-renewal within the context of a harmonious evolution. But this evolution had already been overtaken, a century previously, by the revolution accomplished in Tuscany by Giotto, who had established the new foundations of the art of painting. Byzantium's renovation no longer represented anything but the ultimate refinement of a decadent and doomed civilization.

17 Giotto (*c.* 1266–1337). Detail of
St Francis giving his cloak to a poor man.
Assisi, Upper Basilica.

2 The initiator

Certain historians, still respecting Vasari's predilections, see Cimabue as the pioneer of modern Italian art. But Cimabue should, on the contrary, be given his rightful position as the last great exponent of the Byzantine aesthetic which prospered in Tuscany throughout the first half of the thirteenth century in two forms: popular and expressive in the emotional works of the Pisa and Lucca schools, more preoccupied with abstract form in the works of the Florentine school. Cimabue's style has affinities with that of the contemporaneous frescoes at Sopoćani in Serbia, though it is even more formal and less sensitive. The tenth-century mosaics of the narthex of Hagia Sophia show that, by way of Venice, no doubt, the great Cenno di Peppe drew the inspiration for his monumental art from the very source of official tradition, solidly entrenched on the banks of the Bosphorus and carefully preserved from any foreign contact. The ossified modelling, the partitioning which transforms the figures into a game of patience, the rejection of true space, the deliberate aim to transmute every element of reality into an abstract pattern and thus to elevate every singular form to the dignity of a concept, all these, together with the virtuosity with which linear arabesque is handled, are expressed in identical fashion at Hagia Sophia, at Sopoćani and in Cimabue's Madonnas.

The strength of Byzantine tradition in thirteenth-century Italy explains why the renovation of plastic values in the West reached this country almost a whole century later than the rest of Europe. It might have been thought that the example of French Gothic art, then at the peak of its achievement, would have helped to loosen these bonds, but such was not the case. The art of Nicola Pisano derived from a separate, native tradition, and it is significant that from its very beginnings Italian art, in the person of this great sculptor, turned towards antiquity for its models. A slightly older contemporary of Giotto, Pietro Cavallini, followed the same path. Inspired by the atmosphere of the eternal city, he liberated himself from Byzantinism, not through the observation of nature but by plunging back in time to ancient Rome. He was the first to exhume this formalistic Roman-style grandeur

which was destined in its turn to become a tradition, and very often a restrictive one, until the nineteenth century.

Cimabue marks the end, not the beginning, of an era. The true pioneer of Western painting, the pillar on which the whole edifice rests, is Giotto. Whether purposely (Masaccio, Raphael) or unconsciously (Caravaggio, David), painters throughout the succeeding centuries were to return to the principles that he originally posed. Giotto's contemporaries, Boccaccio, Petrarch, Dante, were keenly aware of this creative force among them, and extolled him as the founder of Western figurative painting. Protected by popes, summoned to practise his art in Assisi, Rome, Naples, Padua, Rimini, he became the first painter to rise above the status of artisan and to be elevated to the same heroic dignity of genius that the humanists had hitherto reserved for poets.

Although only part of Giotto's prolific output has survived, it is still sufficiently extensive to allow us to reconstruct the artist's career in its entirety. The three cycles which serve to define him constitute a powerful unity and present almost perfect examples of the three phases of a master's evolution. The series of frescoes he devoted to the Legend of St Francis, at Assisi (*pls 17–18*), show us the artist at grips with a new subject, in full flow of creativity, inventing attitudes, gestures, expressions and compositions, impulsively and sometimes awkwardly, and tackling the problem of spatial values well before the masters of the Quattrocento, that is to say from the very beginning of modern painting. The frescoes in the Scrovegni Chapel (*pls 20–1, 23–5, 28–9*) in the Arena at Padua (1304–6) represent the flowering of genius in full maturity, with realism perfectly balancing formal grandeur in an intensity of dramatic action that has never been surpassed. The Peruzzi and Bardi Chapels of Santa Croce in Florence, which he decorated some time after 1317, demonstrate a certain formalism, and show the artist ageing serenely and more preoccupied with composition than with expression. In truth, if the Assisi link were to be suppressed, as recent English and American criticism has sought to do, in order to reassign the merit for having founded Italian

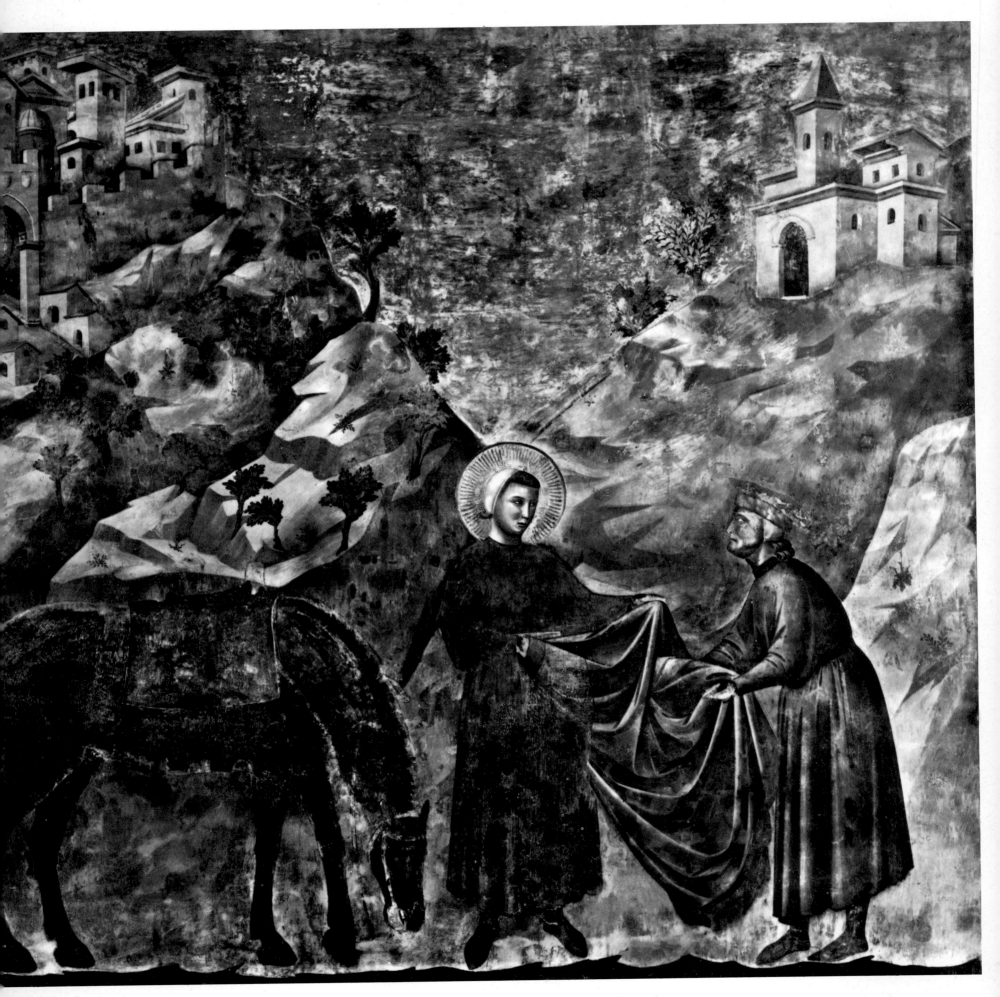

painting to a hypothetical 'Master of the Life of St Francis', Giotto's marvellous and majestic career would be shorn of its essential continuity. More than that: the stylistic evolution of the Italian school during this critical era would become entirely confused if any weight were given to the idea that the Paduan frescoes might have been painted before those of the Assisi cycle, which would then be relegated to the work of an imitator. Italian criticism, with its added advantage of innate percipience, seems to me to be better inspired in respecting a tradition which is, in any case, buttressed by very strong arguments.

At Assisi, Giotto became the creator of a new style of images that actualized religious art by situating it in an historical and heroic perspective and by inserting its representations into an inhabited space. Although the artist's encounter with the newly established legend of St Francis may have been providential in suggesting to him a hitherto unexplored theme, Giotto had no time for the Franciscan myth. His *St Francis receiving the stigmata at Assisi*, a calm and powerful hero with a robust and well-nourished body, is in a world apart from the emaciated ascetic of Monte La Verna, his body mortified, his soul engulfed in divine hypostasis, as he was depicted so often by the neo-Byzantines of the Dugento and the Sienese of the Trecento.

After the death of St Francis, his followers were split by a dispute between the 'spiritual' faction, which advocated the retention in its full purity of the spirit of poverty with all that that entailed, and the 'conventual' faction, which argued that the missionary future of the Order and the Church demanded stable foundations and, consequently, the possession of property. Supported by the popes, the triumphant conventuals celebrated their victory by the construction of a magnificent basilica and a great monastery. Working for them as he did, Giotto inevitably shared their viewpoint, but in any case his own temperament alienated him from mysticism and led him to conceive of the human body as a force which he sometimes endowed with an almost athletic intensity. In the twenty-eight frescoes of the Lower Basilica of Assisi, Giotto breaks with the Franciscan mystical tradition to present us with the emotionally charged panorama of a hero at grips with the world, imposing his will upon the forces of nature, bringing to the papacy the bulwark of a new order.

At Padua, in the frescoes of the life of Christ in the Arena Chapel, pathos is raised to the level of the essential drama, the struggle between Good and Evil, and is resolved by the triumph of the supreme hero, Christ. Giotto brings religious art down from the ideal regions to which Byzantium had elevated it, and fits it into the dimensions of the human drama. I once wrote that in this respect Giotto paved the way for the Renaissance superman, capable of fulfilling his destiny without the aid of divine grace; but this rash statement would better have been applied to his heir, Masaccio. Giotto, on the contrary, *realizes* Christianity; he realizes it in its essential truth, that of being the religion of the Man-God. Certainly his Christ is a man, but one who assumes the totality of humanness with a perfection that could derive only from the Man-God. From this perfection flows beauty. Whether God or man, the human figure ceases to be the more or less grimacing ghost that had filled the mosaics with an air of gloom, and rediscovers the harmonious proportions once given him by the Greeks. Giotto straightened the Byzantines' aquiline noses and restored the Greek profile to honour: the old Simeon of the *Presentation at the Temple* (*pl. 21*), renouncing his status as prophet, assumes the beauty of the divine Plato.

All the personages who, in the Arena Chapel, Padua, participate in the sacred drama around Christ, share in this superior humanity. Of all the themes dear to Christian artists, that of the Annunciation is certainly the favourite, for it shows a human being confronting destiny. The Virgin in Simone Martini's *Annunciation*, a frail being shrinking back in sudden terror at the apparition of the celestial messenger, is the very image of human weakness, while Fra Angelico's Virgin (*pl. 62*), a humble, gentle dove, bends her head in submission to the divine will: they both belong to the order of grace, the grace from which humanity has fallen. But Giotto's Virgin in the Arena Chapel (*pl. 20*), her head held high, her sturdy body set solidly upon the ground, is ready to come to grips with the supernatural; she draws the strength to accomplish her destiny from her Adamic nature, as the only child of man preserved by divine decree from human sin. The forces of Evil can gain no foothold upon this immovable rock, for the Mother of God is also the mother of mankind and the protectress of all sinners who seek refuge under her ample cloak.

After Giotto, one must await the Spanish sculptors of the seventeenth century to find once more such lofty Christological images, or figures of Virgins so profoundly imbued with a sense of their mission to bring to the mystery of the Incarnation all the latent power of an unblemished human being. However, in expressing the drama of the Redemption in all its impassioned and living reality, Giotto inevitably opens the way to everything human, the worst as well as the best: in embodying

18 Giotto. *St Francis giving his cloak to a poor man.* Assisi, Upper Basilica.

Giotto brought about a veritable reincarnation of painting, transposing the story into an inhabited space and creating expressive values which recall the greatness of Greek tragic poetry.

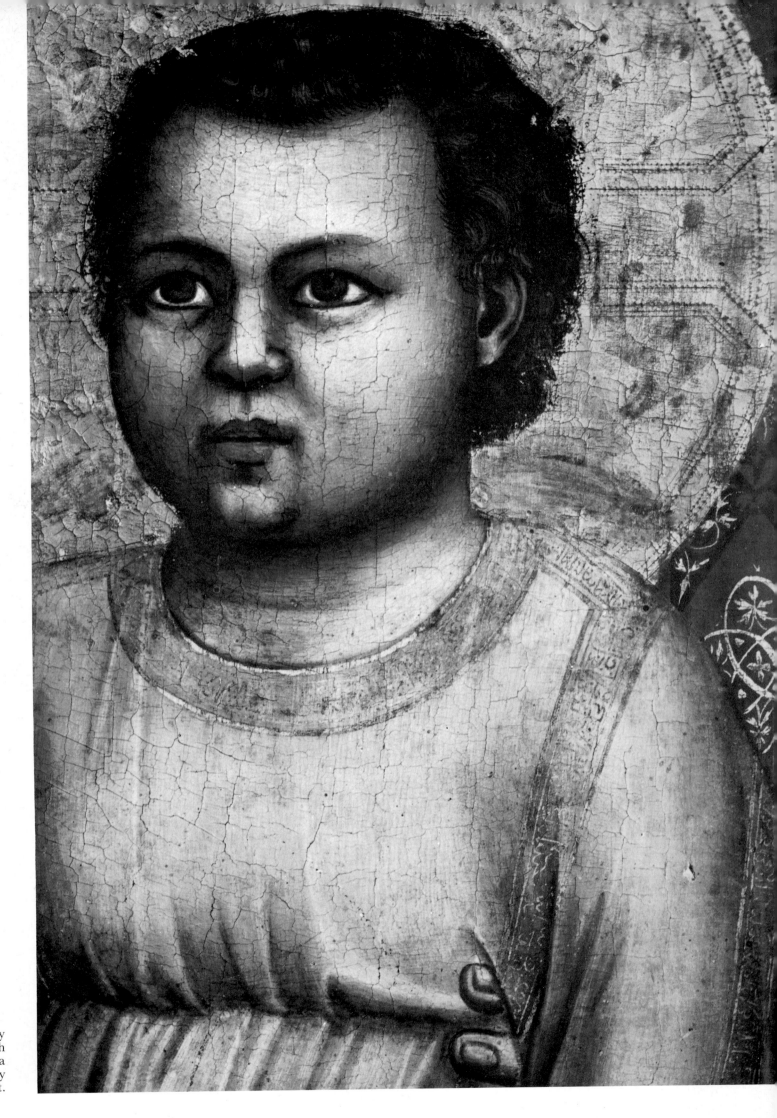

19 Giotto. The Child, detail of *Virgin and Child*. Florence, Uffizi.

No Infant Jesus painted by any other artist expresses with as much force as that of Giotto the power of a humanity assumed in its totality by Christ.

Good, he re-embodies Evil. The faith of preceding ages had envisaged Evil as an absence of being rather than as a specific being; Giotto, however, gives it human semblance in the face of this Judas, which incarnates Evil just as Christ himself incarnates Good (*pl. 28*). The tragic element in Giotto's work derives from a confrontation between the rival forces of uncontrolled energies unleashed upon the world by the Evil One. And yet the artist treats the theme of the evildoer only cursorily; his executioners are unimpressive, his *Hell* is the weakest part of the Arena frescoes, and the power of the *Massacre of the Innocents* lies in the suffering of the victims rather than the cruelty of the executioners. But before Giotto, the brilliant unknown artist who drew the cartoons for the mosaic cycle of the Last Judgment in the Baptistry at Florence (*pl. 22*) had anticipated the Dantesque vision of Hell, providing a link with the satanism of the thirteenth-century French sculptors which had hitherto been unknown to the Italians.

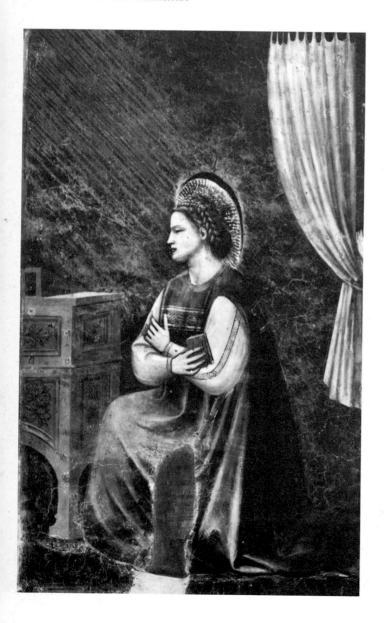

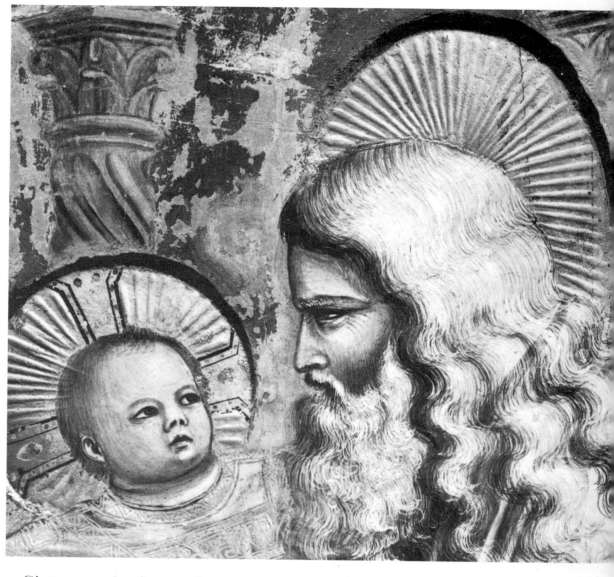

Giotto was the first to demonstrate the possibilities of painting, by showing that, because it disposed of greater powers of imaginative invention than sculpture, it was far better suited to the task of embracing the whole of mankind and the universe. From then on, painting was to become an inexhaustible source of fresh imagery. Giotto laid down the original principles of this form of art, and the subsequent history of painting lies essentially in the extent to which it conformed to or transgressed these principles. From a given surface, Giotto deduced the spatial definition which would provide the field of action. He did not seek space for its own sake, as the Renaissance painters were later to do, but was content that it should be a scenic space, adequate to contain the unfolding of the drama. The first to experiment with perspective, he assigned it several vanishing-points, not so much through archaism, as through instinct, to prevent the eye from being swallowed up by a depth which, as in Quattrocento painting, would attract it at the expense of the essential factor: the action. Giotto was

◀ 20 Giotto. *Virgin Annunciate*. Padua, Arena Chapel.

21 Giotto. *Simeon*. Padua, Arena Chapel.

Giotto drew from his knowledge of antiquity the inspiration which allowed him to restore, in all its authority, the human presence excluded from painting for centuries.

22 *The Last Judgment*. Mosaic in the
cupola of the Baptistery, Florence.

The anonymous contemporary of
Giotto who composed the cartoons
for the mosaic cycle in the
Baptistery was inspired by an
expressionist violence which heralds
Hieronymus Bosch.

23 Giotto. Servant-girl, detail of *The Apparition of the Angel to St Anne*. Padua, Arena Chapel.

antagonistic forces create the rhythm which merges them in one destiny, making them interdependent in the unity of action. For the first time since antiquity, the human being is re-created in terms of his physical existence; the body rediscovers its volume and opacity in three-dimensional space. The human being becomes an independent reality, an active force spreading within the drama.

However, Giotto's figures never act simply for the sake of acting; their bodies, held back in a defensive attitude, lend themselves only to the minimum motion required by the drama. Yet a tremendous variety of gestures and attitudes entered into painting with the advent of Giotto: his mind fashioned the lively characteristics he observed into an abbreviated form which translated each gesture into the essential gesture, rich in all the potentialities of the action it implied. This virtue of concision, that had once typified Greek monumental sculpture, was, after Giotto, attained by only a few great classicists with the gift of discerning the essential in the multiplicity of appearances.

In the antique manner, Giotto used draping to convey action. Drapery, which for centuries had remained folded flat against the wall surfaces of cupolas or altars, suddenly regained the suppleness of life when brought out into the open. As Giotto's skill developed, so his draperies became wedded more intimately to the bodies they clothed, gaining in expressive effectiveness. At Florence, in the Peruzzi and Bardi Chapels, the drapery attains a musical cadence: the truth of a gesture is limited by its elegance, but Giotto, in the full splendour of his genius, is able to seek for a beauty which lies beyond drama.

In this swift journey through the realm of painting we may safely ignore the whole Florentine school of the Trecento, with the exception of Giotto. There was one painter, however, contemporary with Giotto and living in Florence, who provided plenty of material for the Florentine chroniclers with his reputation as a lazy, facetious dauber. This was Bonamico di Martino, called Buffalmacco, who played practical jokes on monks, nuns and even bishops; Boccaccio and Sacchetti both took pleasure in accumulating a fund of salacious stories concerning his escapades. What we are told of his revolutionary approach to painting is most intriguing: the indolent Buffalmacco improvised directly on to the wall, wielding his brush boldly in search of form. This nonchalant approach must have scandalized his fellow painters at a time when Giotto was expending so much thought and care in producing works in which the contours of the design were incised with a sharp needle or sometimes even

Everyday gestures, excluded from art for centuries, were reintroduced into painting by Giotto.

an innovator in that it was from nature that he borrowed the elements of the framework within which human life was to unfold. But although he thoroughly refurbished the repertoire of signs used by painters hitherto, he continued to observe the conventional hierarchy of forms by which a man was bigger than his home and as tall as the mountain he was climbing; in other words, he distinguished the secondary from the principal according to a moral order rather than a natural order.

The interplay of the active figures produces the picture's grouping, and thus its composition; the

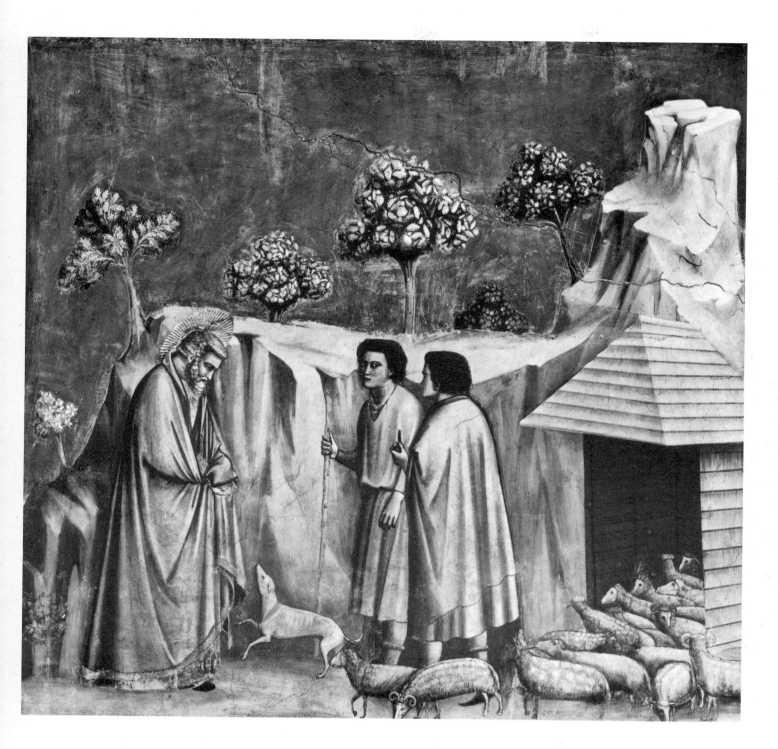

24 Giotto. *St Joachim welcomed by the shepherds*. Padua, Arena Chapel.

intaglio-engraved, following the strict principles of *buon fresco* which had transformed wall painting into an art as studied as that of architecture. The 'dauber' Buffalmacco anticipated modern painting by centuries. The fragmentary remains of his frescoes at the Badia a Settimo Church in Florence do not, unfortunately, allow us to come to any decision regarding the truth of the old legends about this painter.

Andrea Orcagna, architect, sculptor and painter, crystallized the Giottesque principles, around the middle of the century, in his Florentine workshop,

and made them the basis of a prosperous enterprise. His brother Nardo di Cione was more open to innovation than he was: the saints depicted by Nardo in his *Paradise* in Santa Maria Novella show that, unlike Giotto, he was responsive to feminine grace. In his frescoes of the *Passion* in the Badia he emphasizes the pathos of the drama: the Christ of *The Meeting of Christ and the Virgin* (*pl. 26*) casts a long, sad glance over the holy women held back by a ruffianly soldier's brutal gesture; this Jesus is perhaps more human than Giotto's, but for that very reason less Christological. As for the soldier

The dog recognizing his master, and the sheep with their individual movements, like the attitude of the mule in the *St Francis giving his cloak to a poor man* (*pl. 18*), represent the humble life of domestic animals, brought back into art by Giotto in the shadow of man's own life.

33

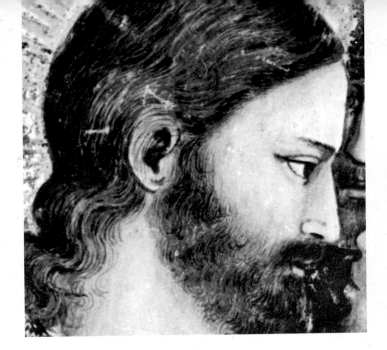

25 Giotto. Head of Christ, detail of *The Arrest of Christ in the Garden of Olives (pl. 28)*. Padua, Arena Chapel.

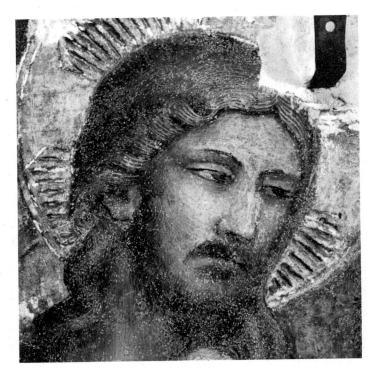

26 Nardo di Cione (active *c.* 1343–65). Head of Christ, detail of *The Meeting of Christ and the Virgin*. Fresco. Florence, Badia Church.

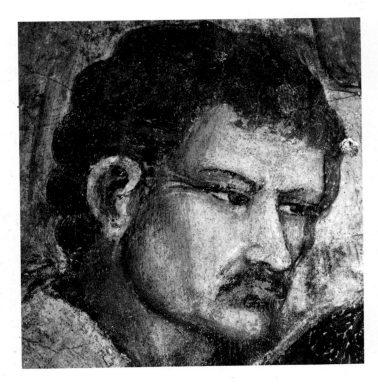

27 Nardo di Cione. Head of a soldier, detail of *The Meeting of Christ and the Virgin*. Fresco. Florence, Badia Church.

28 Giotto. *The Arrest of Christ in the Garden of Olives*. Padua, Arena Chapel.

Giotto goes beyond the simple illustration of his subject in *The Arrest of Christ* and paints the confrontation between Good and Evil. Nardo's interpretation of the Passion casts light on that of Giotto, being more realistic and lacking the same theological significance; Nardo's Judas is less of a caricature and closer to life, while the mournful look of his Christ is that of a suffering man rather than the divine judge.

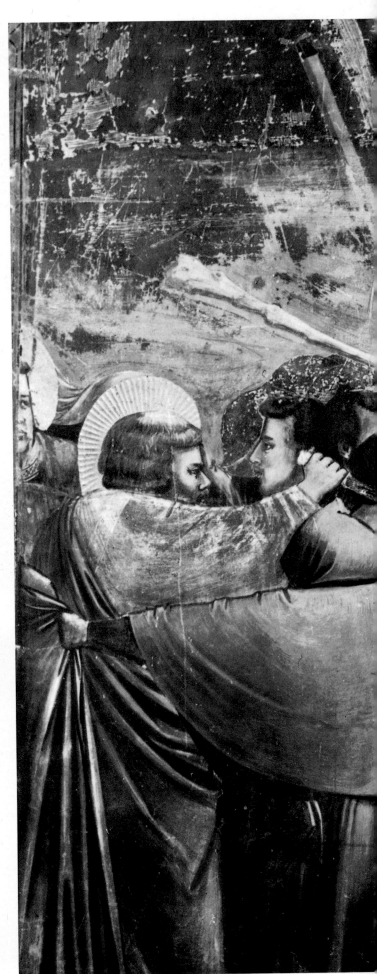

34

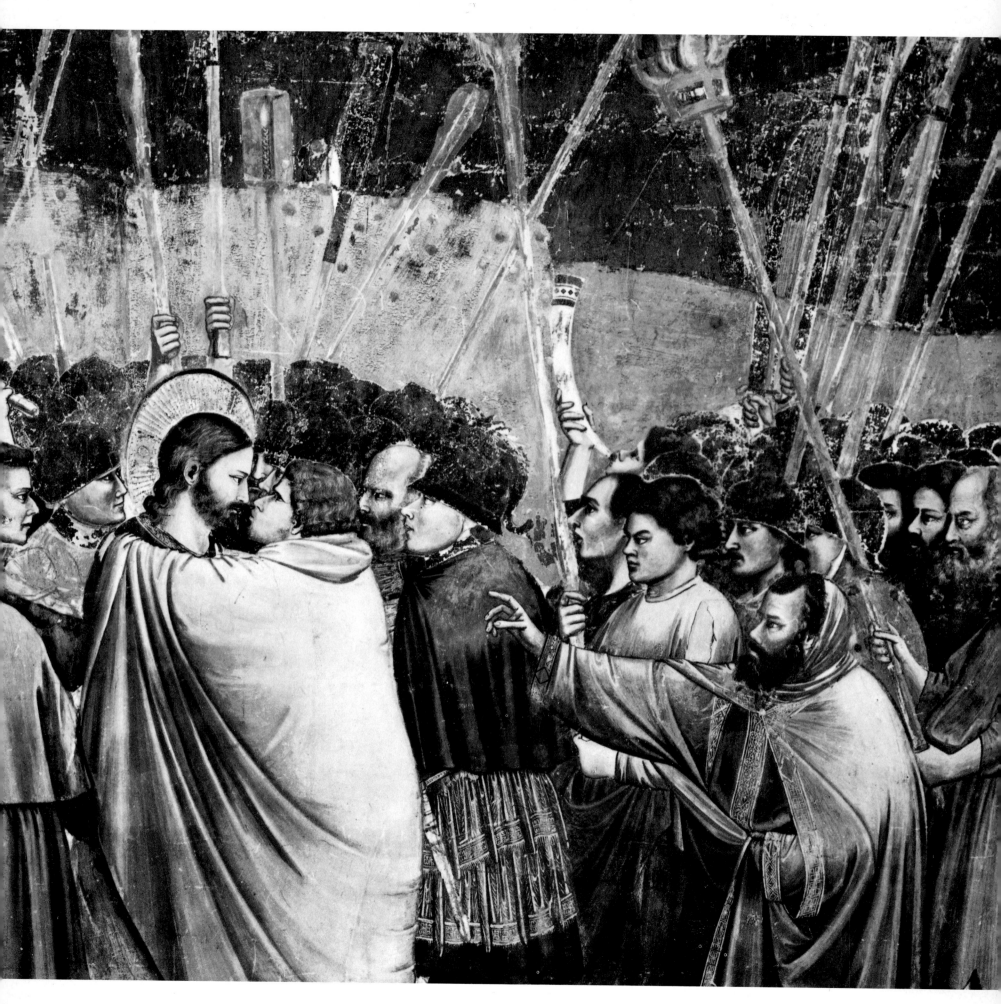

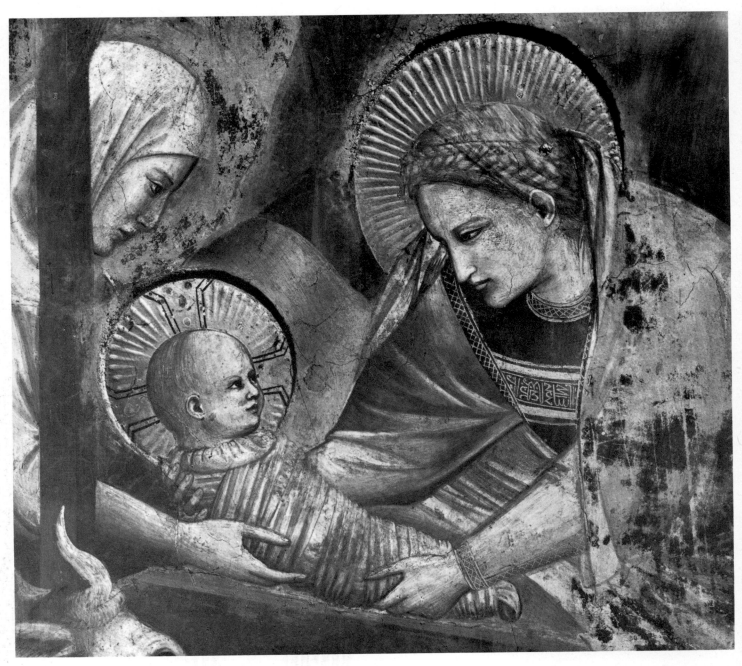

In Giotto's painting, the gesture with which Mary offers her Son to the shepherds represents a considered action. The Sienese Barna introduces a more instinctive emotion into his interpretation of the event: the Virgin literally tears the Child from her breast to offer him to the men who will one day become his executioners.

brandishing a scimitar (*pl. 27*), his gallows-bird look is more lifelike than anything else to be found in painting before Caravaggio; here is an individual face, taken from life and transposed, unembellished, in all its singular truth. This realism denotes an impulsive temperament entirely alien to that of Giotto, for whom there was no truth outside general truth.

Siena, too, was a law unto itself, a city caught up by some strange complex that forced it to live in a kind of spiritual isolation, depriving it of the stimulus that foreigners and even enemies bring with them. For Siena the enemy was Florence, and, although the Sienese hurled the Florentines back at Montaperti in 1260, they never relaxed their guard. Siena remained a town under siege, and it was destined to see its grandeur culminate some three centuries later in one of the most celebrated sieges in history, when a French captain, Blaise de Montluc, galvanized its expiring forces to a point of absurd heroism. The inhabitants of this fiery city were easily drawn to excesses, and while the sons of a few families achieved dubious fame by squandering their inheritance on feasting and carousing, others were scorched by the flame of mysticism. Poetry offered its resources to these young men who, in one way or another, had turned their backs on reality, and it became the only form of escape open to the beleaguered, inspiring them to celebrate the world of Heaven, lending its supple rhymes to pride and humility alike.

This strange town gave birth to a school of painting which remains a paradox in terms of Western artistic development. As against the

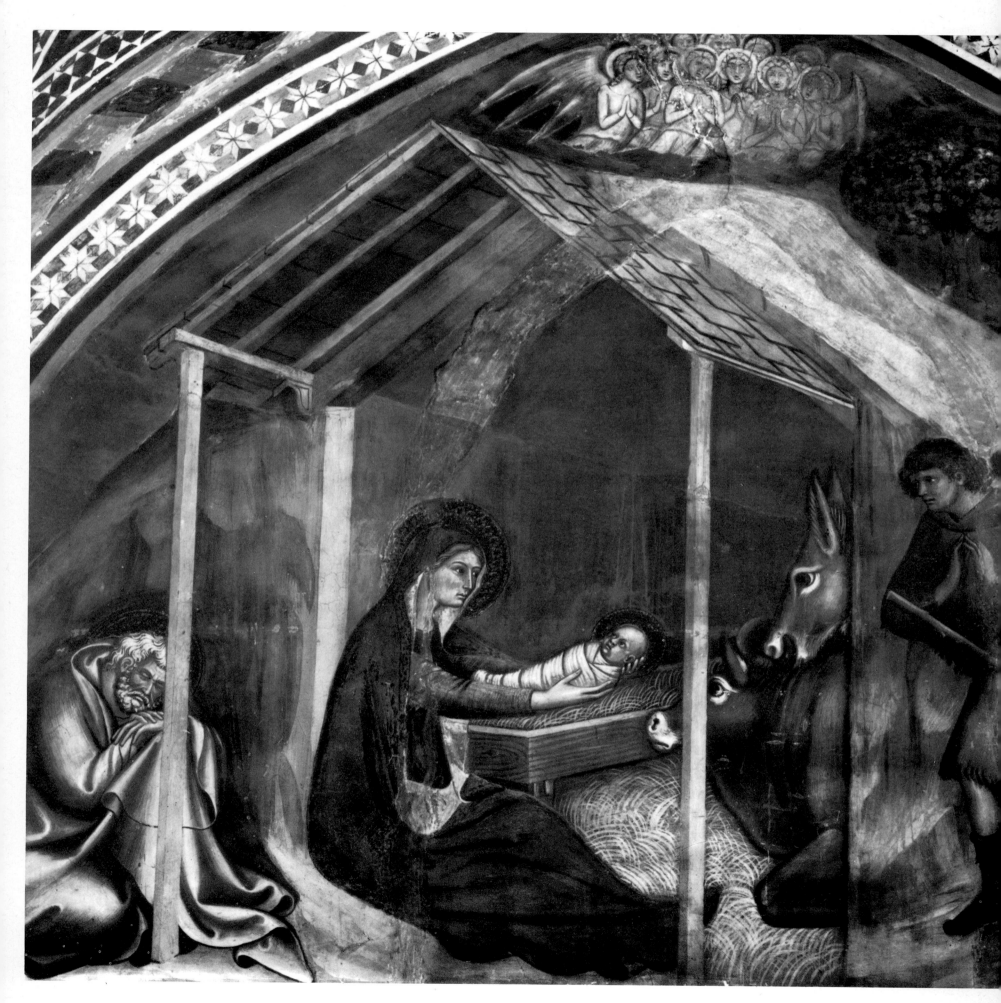

essentially progressive aesthetic to which Florence, its rival, brought the impetus of its faith in the future, Siena pursued a policy of ultra-conservatism worthy of Chinese civilization. Indeed, the work of the early Sienese masters presents many analogies with the art of China, a fact noted by Berenson some sixty years ago when, discovering Sassetta and thus adding a last essential figure to the panorama of great masters of the Quattrocentro, he opened a new chapter in art criticism. The curve of Sienese painting, which eventually reaches full circle, embraces two centuries, starting from Duccio and Simone and ending at Sassetta and Naroccio. During these two hundred years, these artists exploited the self-same style whose essence Duccio had originally rescued alive from a dying artistic civilization, the Byzantine civilization, perceiving instinctively in that essence the distant effluvia of Alexandrine art. From this desiccated plant, the Sienese coaxed forth parasitic shoots that blossomed on the very fringe of life.

The privileged field of action of Florentine painting was the fresco. Duccio took a first timid step towards releasing the easel painting from the hidden world of the miniature and the mysteries of the icon; on the limited surface thus revealed, the painting became narrative and analytical, dedicated to tenderness, suffering and death. Throughout the fourteenth century, the Sienese lament continued unabated, and Sienese painting delivered a message of anguish which can be read in all the glances, in all the unsmiling faces burning with fever, in these convulsive gestures ruled by despair rather than action. Suffering appears here in the form of disconsolate grief rather than the physical struggle with adversity that, in Giotto's art, makes a hero out of the most miserable man. Anxious mothers hug their children to their breasts, as though trying to hide them from a threatening world. Barna da Siena's Virgin (*pl. 30*) tears the Child from her heart in a despairing gesture as she holds him up for the adoration of men who will soon become his murderers; with this painter, Christ is no longer a redeemer but a man overwhelmed by his destiny, a wind of panic blows through the Gospel, and the Passion degenerates into an apocalypse. The most expressive symbol of this tormented city is the Virgin of Simone Martini's *Annunciation*, twisting her whole body round as she shrinks at the approach of the life which is rushing into her. Gothic art brought these painters a style that lent itself to their spiritual malaise, rather than an injection of vigour.

The influence of Florence might have saved them from themselves, for Ambrogio Lorenzetti, strongly

influenced by Giotto, moulded his figures and objects in realistic outline. A brief pause in the struggle between the different Sienese class groups allowed Ambrogio to conceive the hedonistic dream of his allegory of *Good Government* (*pl. 31*) in which peasants garner their corn, young girls dance in the streets and Giottesque individuals with relaxed features are wrapped up in their affairs. In this great panorama, Ambrogio depicts rosy cheeks, well-nourished bodies, eyes heavy with desire; his wondering gaze is filled with the beauty of towns and the charms of country scenes. For the first time in Western painting, nature is represented for its own sake, and the man who lives in it must be content with the modest status to which he is entitled when measured against the scale of the universe: along the walls of the Palazzo Pubblico in Siena, these ants swarming over the earth's crust already evoke Bruegel's manikins toiling away at their humble daily tasks. Ambrogio, who was interested in geography and cartography, seems to have heard some indefinable cosmic summons, a summons that the happy chance of a civic commission allowed him to heed momentarily, but that others were doomed never to hear. In Siena, all was tragedy, and the pleasure-loving Ambrogio was carried off, as was his remarkably dissimilar brother Pietro, by the Black Death in 1348. One might almost say that great Sienese painting died of the plague.

The situation in the provinces occasionally allowed a greater freedom and favoured individual inspiration. In Rimini, Giotto's influence was merely frozen into a grimace by Baronzio's Byzantinism; but, in Bologna, Vitale absorbed the same influence while modifying its austerity and embellishing it with the fresh colours of life. Bologna, being a university city, within easy distance of Florence, linked by the great Emilian plain with northern Italy and, beyond that, with the Gothic world, was open to influences of all kinds. From Gothic art, Bologna was able to derive a sense of freedom to supplement the influence of Giotto, an achievement that was beyond the Sienese, whose closed minds drew from Gothic only the constraint of a new style to add to the archaism of Byzantine style. Vitale's manner, a distant echo of the refinement of the French miniaturists, is that of an elegant and profane art, using a rich, creamy relief and joyous colouring that anticipates the researches of the Lombard school. His *Madonna dei denti*, with her eyelids veiling a languorous gaze and her suggestion of a sensual smile, allows a hint of the equivocal charms of the eternal feminine to pierce through the formally correct iconographic theme.

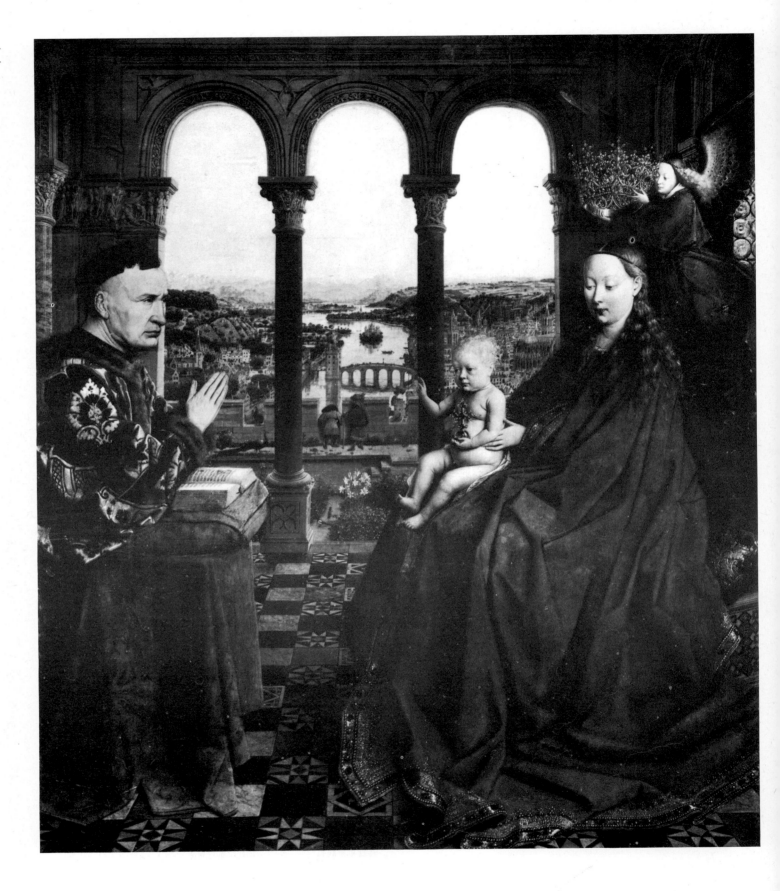

32 Jan van Eyck (*c.* 1390–1441).
The Madonna of Autun. Paris, Louvre.

3 Mirror of truth

In 1458, the townsfolk of Ghent made preparations to receive in great pomp Philip the Good, Duke of Burgundy, who was due to pay his first visit in ten years. The town's various guilds and confraternities, and especially the chambers of rhetoric, vied with each other in organizing splendid festivities and spectacles. The prince's entry was greeted by a series of *tableaux vivants* which drew upon the most glorious episodes of the history of the world. The most grandiose of these *tableaux* celebrated the mystery of the Redemption: on a three-tiered platform fifty feet long and twenty-eight feet deep, living figures re-created all the scenes depicted in the *Adoration of the Lamb* altarpiece that had been begun by Hubert van Eyck and finished by his brother Jan in 1432 for the church of St Bavon at Ghent. Thus the theatre imitated art, and life asked painting to lend it its colours. It is true that painting had never made, and would never again make, so great an effort to combine with nature, to merge into it so completely as to leave no further ambition than to be as pure an image of it as that reflected by the mirror.

The van Eyck brothers were undoubtedly the greatest innovators in the whole history of painting, conceiving a new aesthetic and then discovering, to express it, means so perfect as to remain for ever out of the grasp of succeeding generations. This secret that the van Eycks took to the grave with them was that of a stupendous technique based on a perfected process of oil-painting. This permitted the superimposition of infinitely thin, translucent layers of pigment, and thus transformed the plain, dull surface presented hitherto by the picture's glazing into a fluid of unfathomable depth capable of suggesting any inert or living matter – velvet, silk, stone, marble, jewellery, flesh, and, above all, that evanescent element, the atmosphere.

Oil-paint had existed before the van Eycks, but had been difficult to use because of the time it took to dry, a problem they partially resolved by using a siccative and also, no doubt, by improving the paint's binding quality. Jan invented a procedure which was to provide the basis for all the subsequent explorations that painting has undertaken; what he could not hand on was his genius, based as it

undoubtedly was upon an exceptional visual acuity which allowed him to distinguish the peculiar nature of things and to discern the best means of conveying their image. No amount of scientific investigation has succeeded in analysing his technique: the researches undertaken at the central laboratory of the Belgian museums, when the Ghent Altarpiece was restored there in 1950, have confirmed only that the painting was executed 'in depth', by superimposed coats, some of them in oil-based medium, others in tempera which may have been applied as scumbling, an astonishing possibility.

Means always reflect the ends that inspire them. If the van Eycks perfected a new technique which was to permit the most perfect mimesis that ever reigned in painting, it was because nature had begun to exercise a profound appeal upon the soul of Western man.

Giotto's ordered world still belonged to the universe of the cathedral, that universe in which everything was regulated by a single thought of God's. His work was deeply imbued with 'Christocentrism', that concept, defended so ardently during the thirteenth century by St Bonaventure and Robert Grosseteste, which made of the total Christ, *Christus integer*, the principle of a vision of the world through the eyes of faith. As we have seen, Giottesque humanism was a divine humanism centred entirely upon the person of Christ, and the cycle of St Francis at Assisi was itself a Christological cycle, for Francis had adopted the Pauline doctrine: 'I determined not to know anything among you, save Jesus Christ, and him crucified.' Jesus crucified was indeed the only knowledge admitted by this saint, who was so hostile to books and theologians. Giotto reflected the mainstream of thirteenth-century thought, that of Albertus Magnus and St Bonaventure, rather than that of St Thomas Aquinas (whose dialectical universe brings to mind, rather, Andrea di Bonaiuto's allegorical paintings in the Spanish Chapel in the cloister of Santa Maria Novella, Florence, works which reflect some of the abstract nature of scholastic thought). With Giotto, however, the notion of an 'external world' is absent; all creatures partake of the Creator and are meaning-

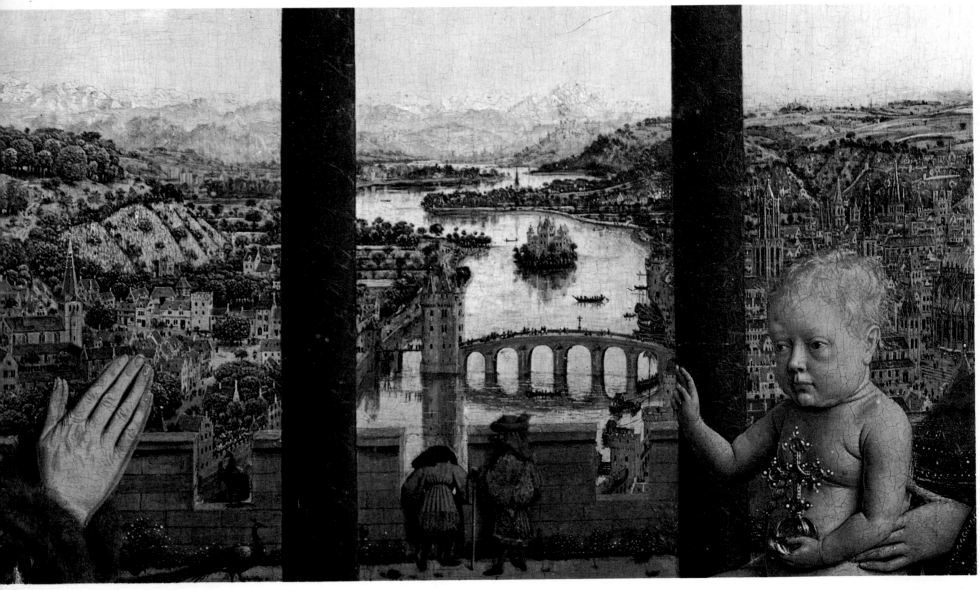

33 Jan van Eyck. Detail of the landscape, *The Madonna of Autun.* Paris, Louvre.

Thanks to an acuteness of visual perception which has remained unique in art, Jan van Eyck was able to concentrate a whole universe within the compass of a few square inches. At a moment when the Middle Ages were giving way to a new era, he dedicated painting to the quest for appearances.

ful only in relation to him, appearances are simply signs by which God reveals himself, the real world does not exist as an object.

A great controversy existed in the Middle Ages relative to the problem of knowledge; this was the question of universals. Those known as 'realists' granted general ideas a real existence independent of the mind and even independent of tangible objects, and considered that the universal existed before the thing, *ante rem*, either in the form of an eternal essence or as a concept of divine intelligence; the 'nominalists' claimed, on the contrary, that concrete reality existed only in individual beings, dismissing 'universals' as mere words. It is perfectly clear that Giotto, confronted with the external world, thought in terms of kinds and species, not of individual things: he painted not a tree but 'tree-as-idea', not a horse but 'horse-as-idea', not Judas but the spirit of evil. His creative imagination constantly retraced the individual thing back to the concept from which it derived; he admitted the

beings and things of nature into his work not for their own sakes but, as with thirteenth-century cathedral porches, in so far as they agreed with the idea to be expressed.

During the course of the fourteenth century, nominalism finally triumphed over realism. The empiricism natural to the English temperament manifested itself in the thought of the theologians of the school of Oxford, notably William of Occam, for whom there were no essences distinct from individuals and to whom the object to be known appeared contingent and singular. Occam proposed that an attitude of probabilism should succeed that of certitude in metaphysics, and suggested that the real should be sought after and 'tested' in nature rather than in philosophical speculation.

This gradual progress of thought, moving in the direction of the knowledge of nature as such, began to affect art during the second half of the fourteenth century. An unknown artist, perhaps Girard of Orleans, painted Western civilization's first por-

35 French school, 14th century. *King John the Good*. Paris, Louvre.

34 Jan van Eyck. *Baudoin de Lannoy*. Berlin-Dahlem, Gemäldegalerie.

Shortly after 1350, an unknown artist, with the king of France as his model, painted the first realistic portrait in the history of Western civilization. Van Eyck took up this new idiom, and endowed the figures he painted with an intensity of physical presence which no other artist has ever been able to emulate.

36 Pol, Hennequin and Hermant de Limbourg (active 1400; d. before 1416). View of Mont-Saint-Michel, illustration from *Les Très Riches Heures du duc de Berry*. Chantilly, Musée Condé. The Limbourg brothers were certainly the first to represent a specific building realistically.

37 Jan van Eyck. Detail of *The Marriage of Giovanni Arnolfini and Giovanna Cenami*. London, National Gallery.

Intent on apprehending space in its totality, Jan van Eyck suggests the fourth wall of a room, the one situated behind the artist, by reproducing its image on the wall facing the spectator, in a convex mirror which also reflects the backs of the figures whose portraits are being painted.

trait, that of King John the Good of France (*pl. 35*), reduced to being simply an individual, captured in his temporal reality, without embellishment and stripped of any aura of royalty. This isolated work provides evidence of the new tremor of feeling that was passing through French painting at the time. But the rest of the evidence has disappeared, in particular those visions of forests and wild life which covered the walls of castle halls and recalled to the nobility the world such as it appeared to them: a universe in which they could measure their strength against that of the wild animals. The frescoes in the Garde-Robe of the Palace of the Popes at Avignon are the only surviving examples of this art, but it is uncertain whether they are French or Italian.

Some time prior to 1348, as we have seen, Ambrogio Lorenzetti had decorated the walls of the Palazzo Pubblico at Siena with landscapes peopled by animals and peasants (*pl. 31*). In northern Italy, the vigorous advance of medical science gave rise to the need for illustrated manuals of plants, herbals or *Tacuina sanitatis*, which were executed with varying degrees of skill and all show a new curiosity in the products of nature. Fauna aroused just as much curiosity as flora, and during the fourteenth century all the princes of Europe, and especially those of northern Italy, kept private zoos and allowed the animals to wander around their apartments, including even such exotic beasts as cheetahs which it was fashionable to import from the East. Artists began to attempt to capture in their drawings the living beauty of wild and domestic animals: the library at Bergamo has preserved a 'zoological' manual compiled by one such artist, Giovannino dei Grassi, who was one of the original architects and decorators of Milan Cathedral, and this tradition was revived in the fifteenth century by Gentile Bellini and Pisanello. In France, an artist whose identity has never been established illuminated, around 1380, *Le Livre de la Chasse* for Gaston Phoebus, and the '*queste en lisière*' (beating the borders for game) of folio 62 V° already shows the lively appreciation of nature in summer which was to receive glorious expression in *Les Très Riches Heures du duc de Berry*.

This manuscript, illuminated between 1411 and 1416 by three brothers, Pol, Hennequin and Hermant de Limbourg, is the first work of art in which the seasons are represented as other than abstractions. Each artist has faithfully translated the image of nature appropriate to the particular month he illustrates in this calendar, and the miniatures in the other part of the book, still imprisoned in the Italian style of the Trecento, prove by contrast the sense of liberation that the artists must have

38 Jehan Fouquet (*c.* 1420–*c.* 1481). Detail of *The Martyrdom of St James.* Chantilly, Musée Condé.

Jehan Fouquet's keen visual sense is shown here by the accurately observed attitude of the executioner poising his sword so that the saint's head will be severed by a single stroke.

39 Vif Désir finds Requête once more, folio 31 of the manuscript of *Le Livre du Cuer d'Amours Espris.* French school, 15th century. Vienna, Nationalbibliothek.

The unknown artist (perhaps King René of Anjou) who illustrated the *Cuer d'Amours Espris* anticipated Giorgione and the Venetians in expressing all the nuances of light and shadow dictated by the sun's course.

46

experienced in painting a subject in which they could break new ground: their representations of castles are so accurate that an archaeological interpretation which I once formulated of the miniature representing Mont-Saint-Michel (*pl. 36*) allowed me to conclude that one of the three brothers must have made a pilgrimage there around 1390 and kept a sketch made on the spot!

The art of the van Eyck brothers may well have sprung from this intimate world of the miniature, if it is true that the so-called *Turin Hours* represents the actual work of the van Eycks rather than, as some believe, a belated emulation of their art. Tragically, part of the book perished in the fire at Turin Library in 1902. Although this disaster may have benefited the game of conjecture so dear to scholars, it certainly deepened the mystery surrounding the origins of the van Eycks. Almost everything that tradition has passed on to us concerning these artists has been challenged by now, and the very existence of Hubert, supposedly the elder of the two, has been called into doubt: rather than sifting the evidence on this point until there is nothing left but dust, it might be more sensible to put together the few pieces of information we do possess so as to draw the appropriate historical conclusions. A positive attitude of this kind is, in any case, justified by the fact that the *Three Maries at the Sepulchre* (Rotterdam) constitutes a harmonious link between a few of the pages of the *Turin Hours* and certain portions of the Ghent Altarpiece, attributable in both instances to Hubert.

It seems that Jan van Eyck developed the basis of his incomparable art during the prolonged execution of the Ghent Altarpiece, in the course of which he had to pay a visit to Portugal, one souvenir of which was incorporated into the polyptych in the shape of its Mediterranean flora. This work constitutes one of the most important iconographic enterprises of Christian art, for the role assigned to the image here represents a complete reversal of the tradition followed by Christianity since its inception. The Ghent Altarpiece remains the boldest, most paradoxical endeavour ever made to paint the supernatural world in terrestrial guise; and in it, the physical world, having asserted its presence, reveals all its individual elements for the artist's marvelling eye to explore. As in the thought of William of Occam, the universe is apprehended not as essence but as a sum of individual beings, each of which is to be approached as an independent value by sympathetic intuition acting directly. Responding to man's awakened ambition, the world opened itself up as a limitless field of experiment, suddenly entering with all its infinity into painting,

40 Jehan Fouquet. *St Margaret and the envoys of the prefect Olybrius.* Miniature. Paris, Louvre.

The peaceful countryside of France, the innocent charm of young girls, as expressed by Jehan Fouquet, spring from the same poetic vision which was to inspire Corot four centuries later.

47

from which it was, as it were, excluded again only in our present era. That transformation set in motion the pursuit of appearances which continued until impressionism, and also the passion for creating likenesses, the vanity of which was deplored by Pascal. Eyckian objectivism thus attained its greatest intensity at its very outset, and apart from a few Dutch painters of still-lifes, working in a far more restricted field, no artist was ever again able to endow the object with the same hallucinatory presence. In this figurative appearance, the object, finally stripped of all symbolic veneers, reveals itself to us as heavy with real significance, more so than the real itself; transposed into the 'vanity' of painting, the object enters the sphere of the intemporal.

Although the world which van Eyck reveals is apprehended in its physical truth, it is none the less experienced through the feelings of a profoundly Christian soul. A kind of inner irradiation seems to emanate from all things, as though it were light which gave them substance. In contemplating the meadows of the *Adoration of the Lamb*, I cannot help thinking of that old Augustinian doctrine – revived by Robert Grosseteste and other medieval theologians – which viewed knowledge as an 'illumination' of the soul, animated by God. In his *De Luce*, Grosseteste holds light to be *corporeity* itself, the primary form that unites with matter to constitute bodies, and it is evident that the object in a painting by van Eyck owes its whole being, its matter, its colour to the light which, rather than striking things as an external agent, appears to well up from the depths. This light originates in the brilliance which 'illuminated' the illustrated books of the Middle Ages, in which it preserved itself like a secret, guarded safely against the day, in those precious images bathed in lakes of gold. Thus, while Italian painting was originally mural, that of the northern schools was first inspired by the miniature. The advance of objective knowledge soon led to the abandonment of the theory of illumination; from the fourteenth century onwards, philosophers followed St Thomas Aquinas in believing that knowledge resided in a capacity natural to man, and that the gift of illumination was simply the gift of natural light made by the Creator to his created beings. But van Eyck, grappling with this unknown world which was slowly emerging in the closing years of the Middle Ages, seems to have conceived of truth as being created in the radiance of increate light.

The transition from the miniature to the painting involved essentially the transformation of the surface into the illusion of three dimensions. At the time when the Italian Renaissance was considered the sole repository of truth, van Eyck's failure to make proper use of *perspectiva artificialis* was put down to the awkwardness of a primitive. A profounder insight would have revealed that van Eyck's methods resulted from a different perception of space from that of the Italians, in that his aim was to apprehend space in its totality and not as a void opening out from the human eye. He takes up a hovering position from which he overlooks the world: in the *Marriage of Giovanni Arnolfini and Giovanna Cenami*, a mysterious work which certainly contains the indecipherable symbol of his art, he sets a convex mirror in the background (*pl. 37*) to reflect the side of the room whose wall has presumably been removed so that he can see through into the room. The contraction of the resulting image gathers the space together in a 'nuclear' density of quasi-metaphysical power, almost bringing to mind those modern scientific theories which calculate that, if all interstitial empty space were suppressed, the total matter of the world would be reduced to the volume of a locomotive or a box of matches. The space which the Italians of the Quattrocento enclosed within their visual pyramid is an anthropomorphic concept. In Eyckian space, the earth seems to unfold itself under the sovereign gaze of God contemplating his work (*pl. 33*). (Later, with Bruegel, this universal space became secularized and turned into a world seen through the eyes of a philosopher.) How fascinating it would be if we still possessed that 'map of the world' which Jan van Eyck once painted for the Duke of Burgundy and which must surely have embodied his conception of the universe!

Jehan Fouquet reached manhood at the moment when France was at last emerging from the anarchy and bloodshed that had afflicted her for a hundred years. His luminous work is a hymn to the joy of living in a liberated France, growing green again under the warm sun of victory. On the day of deliverance, France discovered the painter who was destined to celebrate the beauty of her reconquered lands, and the love of the native earth and sky. All the great landscape-painters of the fifteenth century painted nature. But Fouquet painted France: verdant plains watered by great majestically flowing rivers, the earth as harmonious as a goblet in which the air's liquid light is trembling, towns floating on the plains like ships with countless masts, white châteaux and manors anchored to the sides of hills. All this is truly France as reflected in the two provinces, the Ile-de-France and Touraine, which form the country's heart. The French countryside, no longer trampled, pillaged and burned, begins at last to bask in peace, though no human life peoples its lush stretches, and nature lords it there alone.

Men can indeed be seen in the foreground going about their business, which seems to consist mainly in killing each other, but they are mere passers-by, history's walkers-on crossing the proscenium of the theatre of eternal nature. It would seem that, before Bruegel, Fouquet already sensed the epic contrast between nature and man, the immutable and the ephemeral.

Fouquet's miniatures are the microcosm of nature and French society in the fifteenth century. The artist has witnessed war and peace, knows how men kill each other, how they strike blows and parry them; he perceives the organic unity of the pitched battle, that monstrous being formed of countless entangled destinies. He is Mantegna's equal in his knowledge of anatomy, and has studied the dense and beautiful volumes of the horse more closely than Paolo Uccello. He has penetrated the silent life of objects: a ray of light making the wine in a glass sparkle like a ruby suddenly fills us with an awareness of the magical proximity of the real. And he is familiar with the gestures of men at work: an impassive observer, he has watched with a careful eye the posture of the executioner calculating rather ostentatiously the strength and the correct sword angle required to sever the neck with a single painless cut (*pl. 38*); yet he is equally aware of the tender commotion surrounding the birth of the child in the warm intimacy of a room lit by the whiteness of the sheets wrapped around the woman who has been confined.

Sometimes one of these passers-by steps out from the narrow frame traced on the parchment, and his image looms out at us on the scale of the world we live in. In passing from the universe of the miniature to that of painting, these beings who had hitherto existed solely in terms of their gesture or function suddenly acquire a powerful individuality. These portraits share Piero della Francesca's monumental form and Jan van Eyck's existential intensity (*pl. 34*), but possess an added 'naturalness' which is uniquely French. The essence of Fouquet's genius lies in this search for a classicism which orders nature only so as to express its truth more clearly. Were they to spring to life from the book in which their images lie imprisoned, the personages of Fouquet's miniatures could enter our own world just as they are, so little have they been affected by the decadent stylization prevalent in the art of their time.

Thanks to Fouquet's truthful testimony, we are able to imagine the world of peasant, townsman, prince and warrior at the centre of which lived Joan of Arc. He painted the 'shepherd-maid' herself in the guise of one of the saints whose voices she heard, a girl working her spinning-wheel and keeping an

41 Antonello da Messina (*c.* 1430–79). *Virgin Annunciate*. Palermo, Museo Nazionale.

The Flemish technique of oil-painting, which he doubtless inherited from Petrus Christus, allowed Antonello to give a greater intensity to the human face.

eye on her sheep while a noble cavalcade advances towards her. In this legendary encounter in the shadow of a fortified castle (*pl. 40*), one is tempted to see, in place of the Roman prefect Olybrius approaching St Margaret, some ambassador sent by the Dauphin Charles to the Maid of Orleans to implore her to come to the rescue of the kingdom.

The country which gave birth to Joan, the most astonishing prodigy in history, simultaneously produced the level-headed genius Fouquet. This contemporary of the miracle-worker was himself so little drawn towards mysticism that he preferred to confine the invisible within the dimensions of the visible: his angels are choristers, the Virgin's features are those of the king's mistress and the figures of the Trinity are deacons celebrating the liturgy. Yet this positive character had certain traits in common with the young woman whom Alexandre Dumas called the 'Christ of France': good sense, optimism and good health. Fouquet shared the same climate as Joan, just as Rogier van der Weyden and Geertgen tot Sint Jans shared that of St Lydwine of Schiedam, and he represented a complete break with the flamboyant romanticism which was rampant throughout northern Europe as a result of the aesthetic domination of Flanders. This was the moment when the court of Burgundy, embracing all the chimeras of the Middle Ages, oppressed these ancient dreams under a vulgar display of wealth and a bombastic naturalism. In this sense, Fouquet is not a child of his century, for amid the confusion of the expiring Gothic age, his work stands out like a promontory facing a new world. His paintings have a greater affinity with the work being produced by his contemporaries in the Italian Renaissance or with that of van Eyck than with anything else of his own period. Not that one should deduce any particular influence from this fact. Fouquet's classicism, far from being a gilding laid over a medieval illumination, comes straight from the heart: it is a moment in that French tradition which, above all the vicissitudes of evolution and of styles, comprises a never-failing perception of harmony. That same tradition, which gave the Middle Ages their masterpieces of monumental sculpture, remained a royal prerogative and, during the fifteenth century, followed the monarchy from the region of the Seine to that of the Loire.

Fouquet's century was one of unparalleled instability and tragic violence, and its art translates the resulting tensions of force and anguish. It is, then, a miracle in itself that France, which was enduring greater physical and spiritual agonies than any other nation, should have given Europe this lucid genius.

Fouquet's genius found no inheritor, any more than did that of van Eyck – a further point in common between them. However, in Provence, a mysterious and unidentified artist revealed his sensitive awareness of nature in his illuminated illustrations for the manuscript of *Le Livre du Cuer d'Amours Espris*, that strange dream of chivalry and courtliness written by René of Anjou, titular King of Naples (*pl. 39*). This unfortunate monarch, the vassal of the King of France and the companion of Joan of Arc, had preferred the cause of the fleur-de-lis to his own interests and thus lost his domains. It had been thought at one time that René, who was known to have been a painter, had illustrated this strange book himself; later, this tradition was dismissed as a legend, but now it is being revived once more, an example of the kind of merry-go-round on which historical criticism often finds itself embarked when it lacks adequate documentary evidence. Dr Paecht, examining *Le Livre du Cuer d'Amours Espris*, has recently presented fresh arguments in favour of the original legend.

This little book's sixteen miniatures present a visual poem on the theme of light that is unparalleled in painting before Claude. It celebrates all the hours of the day, from dawn to nightfall, with a marked preference for the twilight hour, when darkness and light vie for supremacy, and the shadows lengthen along the ground. The artist who created it knew that no shadows are absolute, and a dull gleam shimmers even in his nights. This love of light assorts so well with the poet-prince's purity of spirit that it is pleasant to imagine that he was in fact the artist who painted these unique works.

In Italy, Antonello da Messina was the first to develop the Eyckian technique of oil-painting that had probably been introduced into Sicily itself by Petrus Christus, Jan's immediate follower. The surviving fragments of his output (*pl. 41*) indicate that he understood how to use this new technique as a means of strengthening even more the sense of human presence which was the aim of Quattrocento art, but that he did not have an equally deep perception of nature. It was at Venice that the Eyckian world was belatedly reincarnated, the magical process having been transmitted by Antonello himself, and it was sixteenth-century Venice that was destined to carry oil-painting to its highest peak of expressive power.

Under the direct impact of Mantegna and the distant influence of van Eyck, Venice, in the person of Giovanni Bellini, freed itself from Byzantine constraint, not by rejecting it out of hand but by incarnating the object of Byzantine contemplation

42 Giovanni Bellini (*c.* 1430–1516). *Virgin and Child*. Milan, Castello Sforzesco.

43 Giovanni Bellini. *Virgin and Child*. Venice, Accademia.

The transition from the Quattrocento to the Cinquecento can be followed in the work of Giovanni Bellini; he passes from observation to harmony, from the personal to the impersonal, from sharply defined drawing to bland modelling.

in the various guises of the visible world. Art became a mirror of the world in order to reflect eternal truth. Uniting in himself the two opposite tendencies, Bellini took as his point of departure a very strict observation of single entities which he then gradually raised to the height of concepts. This pursuit of the transcendental is particularly noticeable in his series of Madonnas (*pls 42–3*). Marian iconography had been the essential theme of Byzantine art and the one to which it had given the highest spiritual meaning. By the persistence with which he, like

Raphael, returns incessantly to the theme in order to perfect it, Bellini reveals to us that his ultimate aim is harmony, the harmony which, according to the philosopher Philolaus, is the unification of the multiple and the agreement of the discordant. But he approaches this summit gradually. At first, detecting the singular aspect of each form, he emphasizes its articulations; later, though, it is the reciprocal element within the form that he perceives. Consequently, instead of placing the accent 'harshly and crudely', in Vasari's words, on demarcations,

he seeks out transitions. But what relates him most closely, perhaps, to van Eyck is a comparable poetry of light; he captures its emanations in this Venetian countryside where, filtered by the moist atmosphere, it loses the sharp cutting edge it possesses in Tuscany and bathes everything in radiant clarity. Two landscapes provide particularly significant examples of his work. The National Gallery's *Agony in the Garden* (*pl. 45*), which hangs adjacent to a painting of the same theme by Mantegna, makes us spectators of the genesis of a world. In the Bellini, the atmosphere of our own

planet envelops a landscape which in Mantegna's picture is a wilderness of rock and lava, and the landscape becomes an integral part of the picture; we are present at the moment when man is about to surrender himself to the musical harmony of the universe, and to abandon all thought of dissecting nature. The figures of the apostles still have something of the stiffness of statues, but one can guess that they will soon awake from their long stony sleep, to be reborn at the dawn which is breaking on the horizon, the dawn of the sixteenth century.

The Naples *Transfiguration* (*pl. 44*) is harmony

attained. This is one of those admirable late winter landscapes which Bellini enjoyed executing in the knowledge that this is the season of the year when the days are suffused by the most beautiful light. The sky, quilted with great silvery rain-clouds, is one of those hazy constructions radiating brightness which Bellini never tires of repeating and which, in nature as in his pictures, take possession of our gaze, thirsty as we are for light, and absorb us in contemplation of their splendour. In the middle ground, a passing peasant urges his cattle forward in a slow, peaceful rhythm. The motionless attitudes of the figures in this biblical scene correspond perfectly to the picture's theme, the expression of contemplation itself. Indeed, this sense of immobility, of opposition to progress, characterizes all Bellini's work, which remains as immutable as Byzantine art. For the last time, the world appears transfigured by the eternal truth which illuminates it. Both van Eyck and Bellini made this discovery of the physical world under the stimulus of an act of faith in divine creation. But the morrow was to bring Giorgione, and with him there would be the earth we live upon, and nothing but the earth.

45 Giovanni Bellini. *The Agony in the Garden*. London, National Gallery.

Giovanni Bellini heralds the modern landscape. Before Giorgione and Titian, who were his pupils, he expressed the most delicate nuances of the Venetian light; no painter after him has been able to capture the moment of dawn as he did in the London *Agony in the Garden*.

46 Rogier van der Weyden (*c.* 1399–1464). The Angel of Justice, detail from *The Last Judgment*. Beaune, Hôtel-Dieu.

54

4 Between heaven and hell

The polyptych of the *Last Judgment*, painted for the Hospice de Beaune by a whole workshop under the direction of Rogier van der Weyden, is, together with the *Adoration of the Lamb*, the most important production of early Flemish painting. But the world it reveals to us is quite different from that of the Ghent Altarpiece, that vision of paradise, conceived as a May festival to which the Universal Church is invited, in which peace and joy reign supreme. Van Eyck's optimism, like that of Fra Angelico, reflects the fresh breeze of the Renaissance breathing life into the world of faith, whereas Rogier's art is filled with the malaise of a civilization which feels its foundations shake beneath it. In the Beaune painting, a grimacing, terror-stricken mob of humanity jostles its way towards hell, rushing headlong of its own accord, repulsed by the light. According to the theologians, indeed, God does not damn; man condemns himself. But there is no such crowd on the opposite side of the composition, where only a few naked souls are advancing timidly and uncertainly towards a paradise whose narrow gate is guarded by a grim angel; they look back towards God, questioning his justice, as though, filled with the sense of their unworthiness, they dare not believe in their good fortune. It is true that the austere figure of St Michael (*pl. 46*) is hardly encouraging: he is holding a pair of scales in his hand, and the pan holding the vices is tipped down, thus signifying that the individual soul upon whose destiny judgment has just been pronounced is consigned to eternal torments. The twelfth and thirteenth centuries were more merciful: on the tympanums of their cathedrals, the scales were always tipped in favour of the good, despite the Evil One's cunning attempts to alter the balance. But in the paradise shown us in the Beaune Altarpiece, there are many called and few chosen. Placed originally upon the altar of the great hall of this asylum-chapel, the painting was intended to prepare the sick for a Christian death, in an era when souls were cared for more effectively than bodies. More than one dying man must have breathed his last in fearful contemplation of this scene in which hope is doled out so parsimoniously.

Throughout the fifteenth century, while the Dance of Death leered down from the walls of cemeteries, European art was filled with more or less dramatic interpretations by painters and sculptors of the theme of the Last Judgment. A softer echo of the Beaune polyptych is to be found in Danzig: this triptych, handed over by Memlinc in 1473 to the representative of the Medici bank in Bruges, was embarked for Florence the same year, but the ship was boarded at sea by the German pirate Peter Benecke, and this image of sovereign justice, the most precious treasure in the whole cargo, was offered by Benecke to the Marienkirche in Danzig. A more merciful *Last Judgment* is that by Stefan Lochner, in which the elect form a dense crowd at the entrance to paradise and are welcomed by swarms of angels. And in the composition which Fra Angelico conceived and had painted for the church of Santa Maria degli Angeli in Florence, the angels and the blest, reunited at last, dance a joyous round in the middle of the verdant celestial meadows.

During the heyday of medieval theology, Christians were entirely absorbed in the supernatural and made no clear-cut distinction between this world and the next. The faithful shared their lives with the heavenly host in a familiarity to which the piety of present-day Italian, Spanish or South American crowds still bears witness. The thirteenth century had witnessed a kind of second Incarnation in mystical art and literature. The sacred personages of Christ, the Virgin and the saints had assumed shape; the faithful lived in their presence, at a time when the sole aim envisaged for human life was the path of salvation.

This essential unity between the natural and the supernatural was destroyed in the following century. As times changed, man began to feel that his appointed destiny was no longer one of harmony but of power; his mission was to conquer the world and to conquer himself. The flow of transcendental certainties which had bathed his soul now made way for a superabundance of conquering energies which impelled him thenceforward to seek out fugitive certainties in thought and action; at the same time, the life of the individual, limited to itself, now appeared nothing more than a constant striving without ultimate reward. Man fell from the paradise of essence into the hell of existence.

The pioneers of the Italian Renaissance whole-heartedly accepted this reversal in the order of things, in which man displaced God as the centre of the world, and Konrad Witz, alone among northern European artists, affirmed man's autonomy with the same expressive force as the Italians, even adding his own note of brutal cynicism (*pl. 48*). But in general the peoples of the North, the 'Gothic' peoples, now felt themselves to be orphans of God.

Their souls were oppressed by what Jakob Boehme was to call, much later on, the 'wrath of God'.

Tormented by the anguish of being damned, some spirits sought consolation in fantasy, and dreamed of a paradise in which human beings would finally be relieved of the weight of matter. To such people, angelic nature seemed, in opposition to the humanist ideal, to be the nature closest to pure being. The Germanic mystics of the fourteenth

48 Konrad Witz (*c.* 1400–*c.* 1447). *Sabothai and Benaiah bringing water to King David*. Basle, Kunstmuseum.

Driven to extremes, fifteenth-century Germany either overemphasized the power of the human body or, on the contrary, dematerialized it; while the artists of southern Germany depicted steel-limbed giants, those in the north painted the most ethereal angels in the whole of Christian art.

49 Attributed to Enguerrand Quarton (*c.* 1410–66 or later). The Virgin, detail from the *Pietà* of Villeneuve-lès-Avignon. Paris, Louvre.

This sublime work is the loftiest example in the figurative arts of the expression of a theological idea in emotional terms, attaining its power of suggestion through perfectly realized form.

century, determined to free themselves from the constraints of nature so that they might better enter into perfect union with God, prepared the way in Germany for the angelism which flourished in painting during the first half of the following century, particularly in Westphalia and the Rhineland. Konrad von Soest discovered the nature of angels in that of birds, depicting in a state of weightlessness beings whose faces were those of infants in the cradle, while unreal adolescents with tapering hands, long wavy hair and supple bodies lent their image to the supreme incarnation of purity, the Virgin Mary (*pl. 47*). The recrudescence of the Marian cult in the fifteenth century expressed the anguish of the sinful soul instinctively seeking the maternal breast as protection against divine wrath; the 'legend of Our Lady' is full of stories of the bandits, assassins and debauchees who have wormed their way into paradise thanks to some *ave Maria* recited daily or on the deathbed, a pious fraud condoned by the Virgin so as to thwart inexorable justice. Villon, poet of rogues and vagabonds, is also full of devotion for Mary. Only Chinese painters have been as successful as Konrad von Soest (and the Master of the *Little Garden of Paradise* of Frankfurt) in suggesting by means of form and colour what is essentially formless and colourless, the entities which are called – inaccurately – creations of the mind.

This angelism permeated a whole area of German painting, touched Italy with Fra Angelico and Sassetta, became vulgarized at Cologne with Stefan Lochner, and, reduced to affectation, was introduced into Flanders by Memlinc who was himself of Rhenish origin. But while a few poetic spirits abandoned themselves to such fantasy, others felt, deep in their souls, the tragedy of shattered faith.

Angel, devil and tormented man provided the three themes for northern painting during the fifteenth century. God lost his serenity and became the 'Man of Sorrows'; the August Face reflected the drama of the Passion, that terrible indictment of sinful man. Prompted by this sorrowful awareness, Rogier van der Weyden (*pl. 46*) developed a style which influenced the whole of Europe and swept the Eyckian style ruthlessly aside. He resuscitated the fourteenth-century tradition of ascetic thinness, and his vacillating, elongated, stiff and almost ataxic bodies seem exhausted by some tragic spiritual conflict; cast into hell, they become mere disjointed puppets. Nature, invoked by van Eyck in all the freshness of a world's first dawn, seems in Rogier's work to have been sterilized by some evil genius and reduced to a lifeless backcloth: space is introduced

clumsily and timidly, in depth, through oblique openings; the repeated fold marks of the draperies represent the graph of an anguish which is never permitted the relaxation of a curve or the gracefulness of an arabesque. This new yet prematurely old style infiltrated itself everywhere except into Florence, and influenced even so serene an artist as Giovanni Bellini.

One French artist, however, the Master of the *Pietà* of Villeneuve-lès-Avignon – who may almost certainly be identified as Enguerrand Quarton – was to bestow upon this style a formal grandeur worthy of the contemporaneous creations of the Renaissance, attained through a spiritual loftiness which makes this picture the noblest work that the virtue of sacrifice has ever inspired in art (*pl. 49*). Here is a perfect example of the instinctual capacity of French sensibility to internalize feelings in order to experience them in depth. The silence of the Avignon *Pietà* is more eloquent than the harrowing cries of Rogier's *Deposition* which expresses pain through the medium of its physical effects, as Rubens was to do later on. The master who conceived this 'Pity', leaving behind him the tumultuous times in which he lived, foreshadowed the introspective piety that was to characterize the French mystics of the seventeenth century. But, above all, this work is surely the supreme example in figurative art of an expressive tension finding its suggestive value in a highly perfected form; in this respect it provides a strong contrast with Rogier's imagery which, moving though it is, registers itself in an uncertain form, in a style that lacks self-confidence.

The fifteenth century witnessed the appearance in art of the spirit of Evil. Conceived hitherto as an abstraction, Evil suddenly assumed flesh and the mask of a human face. German painting, surfeited with angels, was now able to satisfy hidden urges towards cruelty and atrocity. The scene of the Passion served as a pretext: a satanic aura emanated from Christ's tormentors, while the sublime victim himself, spurned and tortured, suffered the ultimate degradation of being stripped of all human dignity. The highest image of God, that of the Trinity, grew distorted: the beautiful theological iconography of the Gothic Trinities, with its purity of conception, became transformed into a group of figures with a direct appeal to the emotions. In the case of certain Bavarian masters of the end of the fifteenth century (*pl. 50*), the intrusion into their work of this frenzied emotionalism constituted an attack upon the Godhead, injecting it with a miasma rising from hell.

Although this convulsive style was entirely alien to France, it was in the region of Paris, nevertheless,

50 Bavarian Master (15th century).
The Holy Trinity. Blutenburg church.

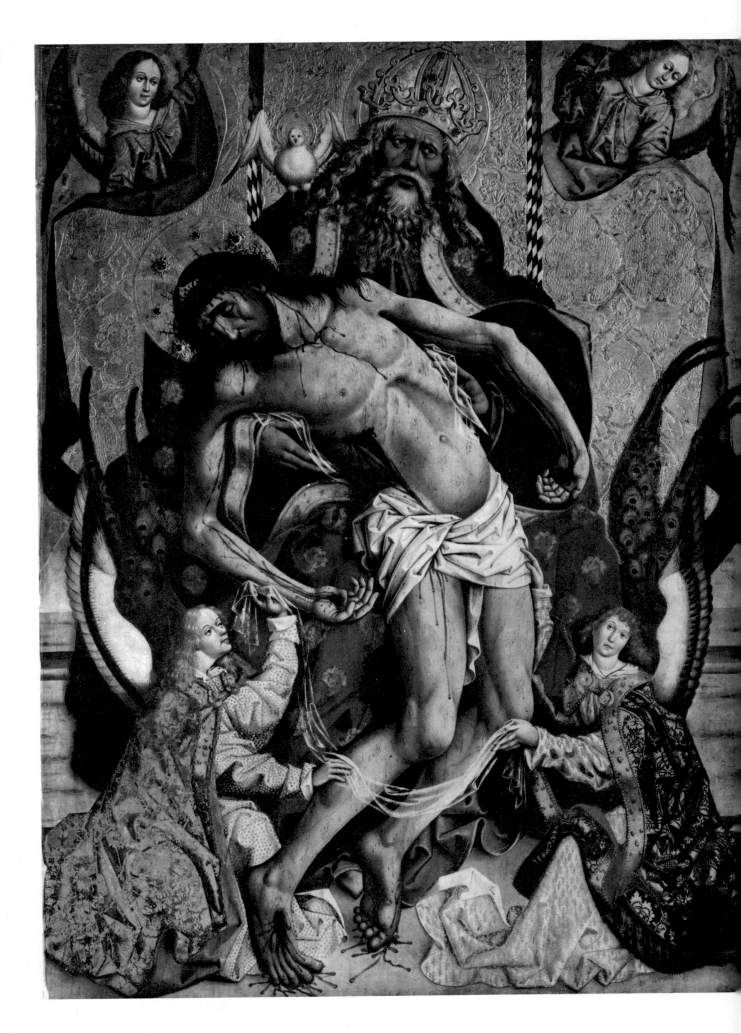

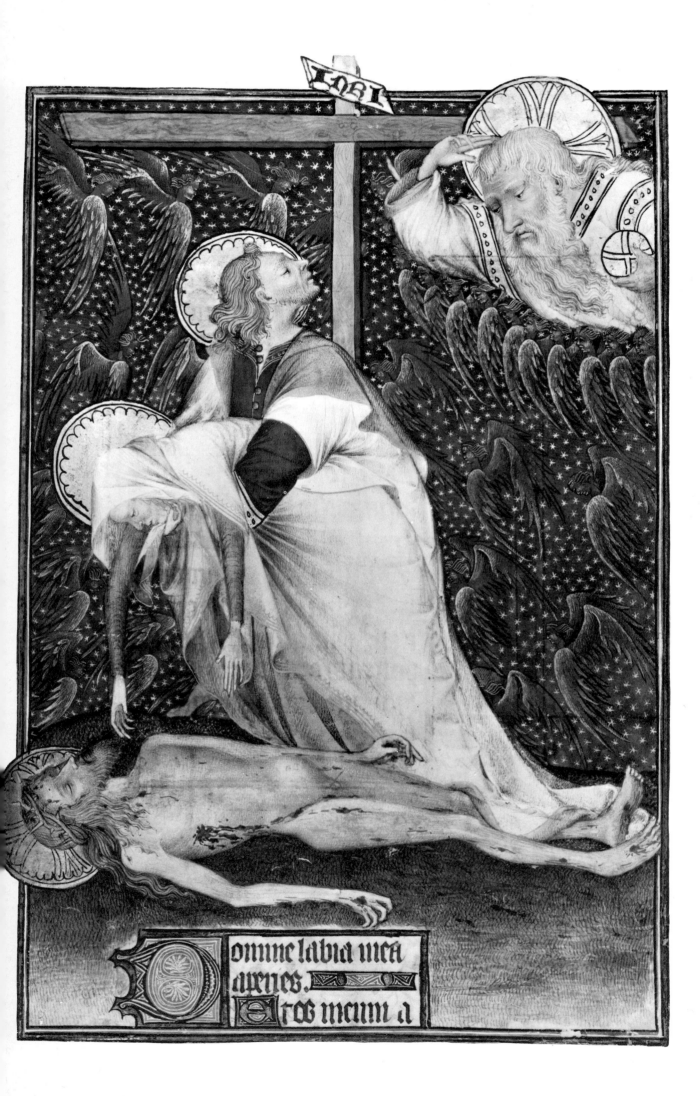

51 The Deposition, miniature from
Les Grandes Heures de Rohan (*c.* 1418).
Paris, Bibliothèque Nationale.

The intensity of the feeling of
suffering experienced by certain
fifteenth-century artists evoked a
violence of expression which
remained unparalleled until the
twentieth century.

that an unknown master, perhaps of Germanic origin, illumined the manuscript known as *Les Grandes Heures de Rohan*, some time around 1418. The archaic nature of this work is emphasized by the schematic page layout, the reverse perspective, the conventional attitudes of the human figures, the Gothic linearity. Although nature is strangely absent in these paintings, they are nevertheless governed by the sinuous style of *Les Très Riches Heures*. But here that style is contorted by an anguish which shows in the grimacing faces and twisting forms, and gives a monstrously bloated aspect to certain figures that loom up on the surface of the page in menacing close-up. In the *Deposition* (*pl. 51*), St John, supporting the lamenting mother as she leans over the body, looks back towards God the Father less to implore his mercy than to admonish him who, from all eternity, had determined upon this drama. Painted in an unhappy historical period, in which the fair realm of France was dominated by the spectre of death, this work seems to have been engendered in an apocalyptic atmosphere. It is intriguing to speculate upon the identity of this artist of genius who preceded Grünewald by a century, and upon the character of Yolande d'Aragon, wife of Louis II of Anjou, who was bold enough to commission such a revolutionary work at a moment when fashion favoured the refined elegance of the miniatures produced by the workshops of the Master of *Les Heures de Boucicaut* or the Master of *The Bedford Hours*.

In Germany, Martin Schongauer assumed Rogier's mantle, evoking the same bottomless misery of lost souls in the same tortured style whose crabbed, flawed pattern he exaggerated to create the painting style of the period known in Germany as the *Spätgotik*, though the painters of the German Renaissance later gave this belated Gothic style a rhythm and breadth that considerably altered its impact. At the same time, in Flanders, Memlinc softened the style's harshness; although the faces of his Virgins or donors are not exactly wreathed in smiles, at least they no longer register disquiet. These pictures, taken as a whole, give the impression that the elect are destined to enjoy the kind of comfort appropriate to bankers and merchant drapers whose moderate religiosity has placed them in good standing with an Eternity where their pious foundations have earned them a credit balance.

Indeed, a certain relaxation of the harsh style of the fifteenth century became evident throughout Europe at this moment, in Italy (Perugino), Germany (Hans Holbein the Elder), France (the Master of Moulins) and Spain (Juan de Flandes), a calm preceding the storm which was to see the

Church rent by schism, the destiny of the Christian called into question, and man, shorn of the concept of free will, become a slave of sin.

The extraordinary art of Hieronymus Bosch no doubt expresses a premonition of this drama, an intuition of the overthrow of a whole world. Certainly, his imagery introduced an entirely new dimension of the invisible into the domain of art, and with this concern with the immediate rather than the beyond, the depths rather than the heights, the unconscious made its entry into painted imagery. In liberating all the forces of the imagination, Bosch extended enormously the scope of painting, limited hitherto to the illustration of religious or profane life, and opened the way to the endless speculations of future commentators. Unquestionably, the artist must have experienced a demiurgic satisfaction, similar to that which animated the twelfth-century Romanesque sculptor, in creating this antiworld of which the Prince of Darkness is monarch.

The weird hordes which torment the human beings in paintings such as the *Temptation of St Anthony* (*pl. 52*) are composite creatures from Satan's bazaar, the spawn of inert and living forms and even of objects invented by man; these monsters, the apostles of anti-Creation, dedicated to the degradation of the divine work, lure into their ranks sinners seized by a furious urge towards self-destruction, sinners who are mad without knowing it. At the moment when Bosch was painting his fantasies, a number of writers were seeking to find a deep meaning of some kind in dreams and in madness, and to discover in irrationality a sort of advanced point of the intellect on the road to the unknown. The fool, essential character in the medieval *sotie* or satirical farce, plaything of the court – he who is free to say anything at all – seems to have been invested with a kind of prophetic frenzy. The fifteenth century commenced with the 'Dance of Death' and ended with a 'Ship of Fools'; folly took over from death in keeping watch over human anxiety (*pl. 53*).

Historians have shown such passionate interest in Hieronymus Bosch's imaginary world that they have tended to ignore his bold technical innovations. Even though it had lost the mysterious depth of the van Eycks' process, Flemish handling continued to produce a sort of enamel-like glaze, painstakingly executed by craftsmen to capture objective definition as closely as possible. In Bosch's pictures, the figures, especially those in the foreground, are still painted 'in the Flemish manner', but in the backgrounds (*pl. 56*), the scenery, the sky and the water, the artist innovates by using a thinner handling consist-

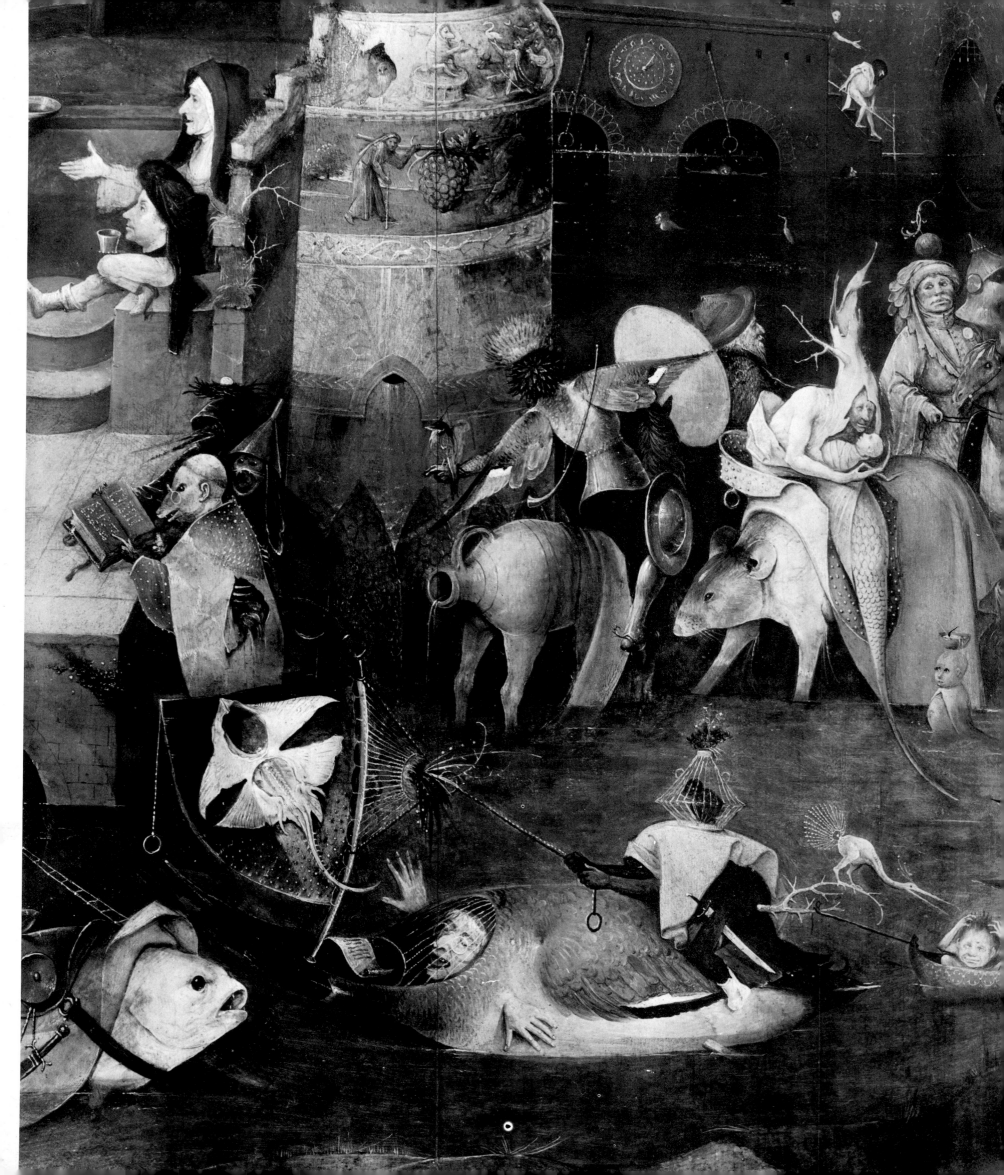

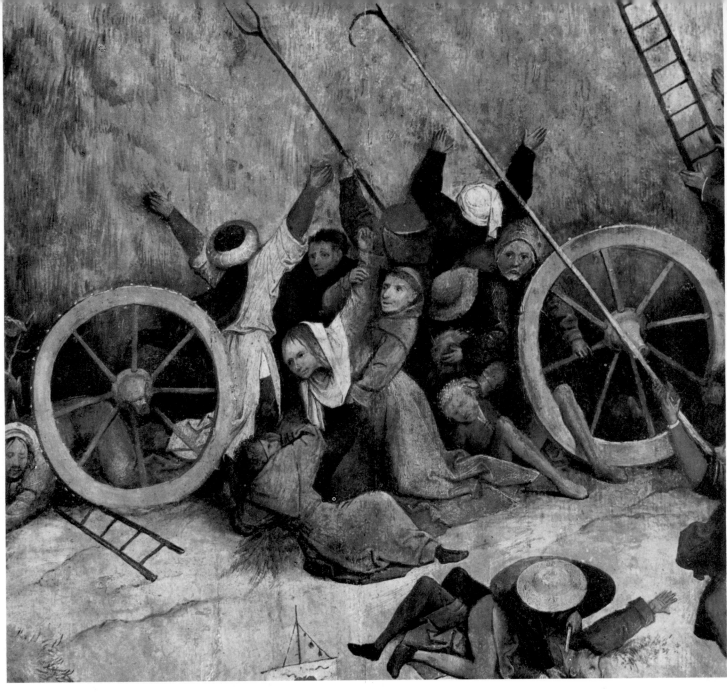

53 Hieronymus Bosch.
The Hay-wain. Madrid, Prado.

Anticipating Bruegel, Bosch invents the universe-picture, teeming with life; but beneath the appearances of reality his is a fantastic universe.

ing of very fluid tinted glazes: on these occasions, he abandons the local colour-tones, imprisoned within precisely outlined forms, that were traditional in the Flemish school, preferring broken, shaded-off, transparent, fugitive, moist tones which flow freely from the brush to blend all the elements in the picture into a harmonic unity. This shimmering brushwork was not understood by any subsequent artist except Bruegel, who seized its full possibilities.

The world of Grünewald is entirely different from that of Bosch, and the figures he painted are possessed by a different madness, that of the Cross. Since Grünewald's identification as Mathis Nithart (alias Gothart), it has been possible to glean some idea of his personality through a revealing document, the inventory of the deceased's belongings. After his death, which occurred in the Saxon town of Halle, a stronghold of the Reformation, his house was found to contain twenty-seven bound sermons by Luther, a nailed casket housing a bound New Testament, a number of Protestant pamphlets and

an Anabaptist creed. But it also contained all the costumes and regalia he had worn at the court of Mainz, where he had spent several years as official painter and artistic adviser to Archbishop-Elector Albert of Brandenburg who had manœuvred with such duplicity between Rome and the Reformation. Mathis had taken these symbols of luxury with him when his support for the Peasants' Revolt and for the Anabaptists forced him to flee from Mainz in 1526. The evidence of his life shows us an impassioned spirit, involved in the great social and religious struggles of his epoch, a partisan of the terrible Anabaptist fanaticism which shook Germany and almost plunged it into anarchy.

We owe to this man, wrongly named Grünewald since the seventeenth century, one of the most astonishing achievements in the history of painting: the altarpiece for the Antonite monastery of Isenheim, now in the Musée d'Unterlinden, Colmar. Our own era which has, at Huysmans's instigation, rediscovered this forgotten work and made it famous, has perhaps misinterpreted it in detecting

in it a hellish paroxysm of German expressionism. This polyptych, with alternative images provided by the folding panels, evokes neither heaven nor hell, but the terrible spiritual conflict which arises when the soul, aspiring towards God from the depths of its despair and confronted by the forces of suffering, sin and doubt, keeps a saving faith intact through all adversity; having triumphed over all temptations, the soul has conquered evil and at last attained the supreme Light, losing its identity in the bliss of divine unity. Too much attention has been focused upon the monsters depicted on these panels (*pls 57–8*) – which are certainly the most vividly terrifying monsters ever seen in a work of art – and upon the expiring Christ (*pl. 54*), a Goliath whose broken, swollen body is covered by the pustules which are a symptom of ergotic poisoning. The idea that this image represents some Germanic sadistic obsession betrays a lack of understanding of the high theological ideal that actuates it: the hideousness of this pustular body symbolizes all the ignominy of man's sins, which Christ assumed so entirely that the sheer weight of horror caused him momentarily to lose heart. Without doubt, too, the Antonites, whose mission it was to tend the victims of ergotic poisoning, specified when commissioning the altarpiece that Christ, as an example of supreme charity, should be represented stricken with the terrible disease.

This image of horror only attains its full meaning when considered in relation to his Christ of the Resurrection (*pl. 55*), which shows the metamorphosis of a human body into a glorious body, a metamorphosis which the chosen will be called upon to emulate. In the words of Huysmans: 'We are witnesses of the resumption of divinity as it blazes up together with life, and of the formation of the glorious body which vanishes in an apotheosis of flames of which it is both the source and the focus.' Grünewald's light is not the radiant limpidity that illuminated van Eyck's idyllic meadows, for it is not of a visual order: it emanates from fire, that primordial element from which God forged the worlds, as some medieval theologians believed. For man, it flows from the depths of the soul, from those depths where the divine example remains lodged, deaf to all incitements from the senses and the intellect, to rise again only at the call of the Word.

If the aim of Western painting was to express everything which had haunted man's mind and imagination throughout the ages, there remained one arena of thought into which it was powerless to penetrate: lofty mystical speculation, that ontological state of ecstasy which has always possessed a few individuals who, in their quest for pure Being,

have groped through the shadows in search of light. Grünewald alone (and not El Greco, as has generally been suggested) has succeeded in crossing this boundary and suggesting in forms and colours something of the struggle which the human soul undergoes as it wrestles with the Invisible. Grünewald's work, in all its strangeness, can best be understood in relation to the whole literature of medieval mysticism, mainly Germanic in origin, in which the soul of the visionary, hounded down by the demon, endures nameless physical and psychological trials that leave it at the doors of death, whence, having purified its own essence, it emerges ready to unite itself with the divine essence. Not surprisingly, medieval Christians had found these mystical experiences impossible to express in terms of art, except by symbols so obscure as to conceal their true significance, or else by even less 'significant' exercises in tenderness and affectation.

In providing the artist with a certain distance between subject and object, the spirit of the Renaissance allowed him to objectify the mystical phenomenon, and thus to interpret it in paint. Anabaptism, carrying to its furthest conclusion the Lutheran idea of justification by faith, taught a kind of illuminism, claiming that the believing soul was inspired directly by God, manifesting himself through apparitions and dreams. No doubt Grünewald sensed the mystical element suffusing the burning faith of this other-worldly sect. In any case, he fashioned an intensely personal aesthetic with which to express his feelings: agitated drawing which plunged away from the object rather than defining it, combined with a marvellously rich colour of unparalleled brilliance. To furnish this rainbow palette of his, he engaged in alchemy, as is attested by the inventory carried out after his death: the expert called upon by the Frankfurt magistrate to itemize his belongings on behalf of his adoptive son found, among the stocks of colours in the studio, extraordinary powders and stones which he was quite unable to identify.

With a nervous brush, Grünewald spreads shifting colours, in films as flowing and transparent as watercolour, which form a kind of iridescent veil over the surface of the paint. And yet this artist who dares give shape to the unknowable is equally capable of lingering delightedly to paint a rose, a wash-tub, a doe, the tall pine-forests climbing the mountain sides. His virtuosity excels equally in 'representing' the visible world and in suggesting the invisible world, and in so doing developing the brush's potentialities more thoroughly, perhaps, than any subsequent artist: and yet it would seem that he exerted no influence on his contemporaries.

54 Grünewald (before 1480–1528).
Christ on the Cross, central panel of
the Isenheim Altarpiece. Colmar,
Musée d'Unterlinden.

55 Grünewald. The Resurrection, volet of the Isenheim Altarpiece. Colmar, Musée d'Unterlinden.

Metamorphosed by sin into a tortured and hideous figure, the body of Christ is transformed into light, in the Resurrection. Endowed with a visionary genius and able to call upon a prodigious technique, Grünewald expressed, more effectively than El Greco or any other painter, the mystical soul at grips with the invisible.

56 Hieronymus Bosch. Conflagration, detail of *The Temptation of St Anthony*. Lisbon, Museu Nacional de Arte Antiga.

Perhaps it was inevitable that so extraordinary a body of work should have been doomed to temporary oblivion. What is surprising is that there actually existed someone prepared to subsidize this genius's audacities, a patron in the person of a certain Italian, Guido Guersi, Preceptor of the Antonites, who commissioned the Isenheim Altarpiece and doubtless specified the iconographic programme. Grünewald must have found himself inspired, at the Isenheim monastery, by some special current of mystical awareness; certainly, none of the other rare surviving works by his hand possess the same degree of transcendent spirituality and artistic excellence. The Isenheim Altarpiece shares with many of the greatest works of art the quality of having originated in a providential encounter.

To paint his nightmare visions, Hieronymus Bosch freed himself from the objective technique practised in the Flemish school since van Eyck and invented a transparent handling, fluid and supple, the possibilities of which were understood, after him, only by Pieter Bruegel.

57–8 Grünewald. The Temptation of St Anthony, panel and detail of panel from the Isenheim Altarpiece. Colmar, Musée d'Unterlinden.

Far more vivid than those of Bosch, which seem to have emerged from some kind of surrealist trick shop, Grünewald's monsters are the most frightening ever produced by Western art.

59 Antonio Pisanello (1397–1455).
Drawings of *Hanged men*. London,
British Museum.

5 The primitives of the intellect

While van Eyck, in Flanders, eliminated the subjective aspect of the object as far as possible, some Italian artists were following the opposite course. Having become acutely aware of the unique position in nature granted him by his faculty of acquiring knowledge, man was no longer content to see himself as a mere component of the universe created by God, for whom all things are as one; he wanted, rather, to distinguish himself from the world by using his intellect to objectify the rest of creation. The dream that consumed Quattrocento man was many-faceted: to conceive a thing by integrating it into himself, making of it an 'object' reducible to the dimensions encompassed by the mind; to force the infinite to inscribe itself within the limits set out by intelligence; to imprison the universal within the pure geometry of thought; to make matter subservient to ideals; to reduce the organization of the world to an architecture based upon numerical relationships.

This era witnessed an heroic endeavour to re-mould the world on a human scale; and, as with the sharply receding perspective in the pictures of that time, everything converged towards the horizon of thought. Space, too, became plastic: ceasing to be synonymous with extension, space itself became measurable and thus architectural, arranging itself into a perspective that directs the eye towards its depth with the strictness of a reasoned argument. The statue, that is to say a completed, enclosed space independent of its environment, became the ideal formula among this generation of pioneers who had finally broken with the Middle Ages; the sculptors now constituted the avant-garde, preceding by at least a quarter of a century the painters who, in their turn, began to envisage their pictures as a construction of strict volumes, thus rejecting painting's traditional concern with the modulation of values and colours.

Masaccio, who died at the age of twenty-seven, stood out from among his fellow artists, perhaps by virtue of that mysterious faculty which sometimes endows with a prophetic vision those doomed to die young, as though some law of life demanded that every man should fulfil himself within an allotted time span. Masaccio attained by instinct the aims that the Italian school was to achieve only after more than a half century of research. Renewing Giotto's ideal of concentrated strength, he anticipated the sixteenth century: his feeling for harmonious composition foreshadowed Raphael, and in his conception of the human body as being powerful and broad, filled with a dramatic intensity, he preceded Michelangelo. During his short career, Masaccio elaborated bodies which seem made from the rock's very substance, surrounding them with a contracted space, a kind of condensation of a universe from which they appear to remain aloof (pls 60–1).

The notion, fostered by Berenson, of an essential antagonism between the Middle Ages and the Renaissance, and of a consequent division of Italian artists into clear-cut categories, is untenable. Certain painters seem to hover between the two worlds: Fra Angelico, Paolo Uccello and Masolino in Florence, Pisanello in Verona, Sassetta in Siena. A few prophetic geniuses such as Masaccio delivered their message as though deaf to the voices of the world, but for the most part the motivating factor lay in a resolution of the contradictions which are the natural elements of a human life. The drama was forged from the confrontation between an individual and an 'environment' which continually presented ambivalences resulting from the gap between generations, the disparity of social systems and the incompatible aspects of a dying civilization and one in the process of birth.

Long considered Italy's most characteristic representative of international Gothic, and the last exponent of medieval civilization, Pisanello is known to have left his native city to execute commissions in Rome and Naples, and appears to have been fully acquainted with developments in Florence. The extraordinary subtlety of his art results from a tension between the medieval civilization that had moulded him and the humanist aspirations with which he sympathized. This tension is revealed in his drawings, which bear witness to an exceptional, and often cruel, acuteness of vision (pl. 59).

Nor was Fra Angelico necessarily a man of the Middle Ages simply because he was a monk and a model of piety. Not only was there as yet no overt

60 Masaccio (1401–28). *The Crucifixion*. Naples, Museo Nazionale.

61 Masaccio. Fresco of *The Expulsion of Adam and Eve from Paradise*. Florence, Santa Maria del Carmine.

contradiction between faith and the new ways of thought but, on the contrary, the humanists fondly imagined that all problems could be resolved in agreement: St Antoninus, Bishop of Florence from 1446 to 1459, even went so far as to quote Ovid from the pulpit! Combining within himself the lofty theological intellectualism of the Dominicans and the emotional intensity of the Franciscans, Fra Angelico was nevertheless an entirely modern painter, concerned to establish a scheme of relationship between the figure and its environment, and to discover the correct principles of relief in defining bodies (*pl. 62*). He was just as fascinated by questions of perspective as was Uccello, but he preferred curved spaces, symbolizing harmony, to the dizzy

After the Giottesque style was finally abandoned by painters about 1400, Masaccio revived it, re-creating, in terser terms, its expressive power based upon the power of the human body, and thus foreshadowing the dramatic art of Michelangelo.

rectilinear vistas of which the latter dreamed. And this great Christian was the first to paint a realistic paradise in which the ring of angels and the chosen were arranged in depth in a true space.

As for Paolo Uccello, he was perhaps the most tormented of all these artists, suffering from a fundamental dualism that resulted from a critical conflict within himself between the ethical standards of the Middle Ages and those of the Renaissance. Not that Uccello was a 'transitional' artist, but, although he was deeply attracted by the new values, he rejected any idea of subservience to them; his work constitutes a final salute to the dying Middle Ages, to the decadent world of chivalry and hagiography (*pl. 63*). The contradictory feelings about the relationship between man and God which troubled him are reflected clearly in his work, engendering two forms of religious art, one narrative and poetic, the other austere, biblical and grandiose. Purely humanist speculations upon form and space appear on the fringe of this religious faith, and the resulting tension, assuming dramatic overtones, makes Uccello, who defended his independence fiercely, one of the most attractive artists of his century.

The second generation of the Florentine school found itself faced with a crisis. Knowledge was identified with creation: for the Quattrocentro, the technical procedures which the Middle Ages had considered to be the essential feature of the work of art were now viewed merely as an 'application' of the creative process, which was in itself a strictly mental elaboration. The search for knowledge replaced the acquisition of skill as man's chief mental objective, and with this new supremacy of the intellect, perception was now identified with conception. The automatic intellectual process of converting anything perceived into a concept meant that nothing remained obscure, in a mental world in which light reigned as evenly and as brightly as it did in certain paintings of the period. The dark forces of the human psyche were to remain ignored in art for four hundred years. Quattrocento man was essentially a conscious man, and the art he created lacked lyricism, except when a self-centred intelligence became intoxicated with its own virtuosity. This quality endowed the Florentine artists with the freshness of primitives: they may be called the primitives of the intellect.

Alesso Baldovinetti, with his cold rationalism, confronted this problem very directly, as Leonardo was to do later on; for Baldovinetti, beauty could only be attained through the application of rigorous laws. His *œuvre*, like Leonardo's, was small and entirely experimental. Like Leonardo in relation to his *Mona Lisa*, he attempted in a series of closely

62 Fra Angelico (*c.* 1400–55). The Visitation, predella of *The Annunciation*. Cortona, San Domenico.

related pictures to match the perfection he had achieved with his *Virgin and Child* (the Louvre), not only his masterpiece but one of the chief glories of Florentine art. And he anticipated Leonardo's landscapes with his vision of the universal, schematized in a cartographic projection (*pl. 65*).

The whole of the Quattrocentro must be placed under the sign of energy. Man in this epoch had an insatiable desire to understand, and the intellect's power of exploration seemed limitless to him. The sole limit to a concept was deemed to be the one immediately above it, embracing a larger generality. Increasingly sharply defined intellectual experiments evolved from each other with implacable logic, following a quickened rhythm which testifies to an enormously energetic mental activity in these artists' workshops. However there were inevitable limitations to this craze for causality. Intelligence, transmuting everything it touched into abstraction, devoured the world without satisfying its hunger, and was soon reduced to feeding off itself. The immediate intellectualization of perception stifled intuitive inspiration at its source. Compared with genuinely open-minded creators such as Fra Angelico and Paolo Uccello, Andrea del Castagno appears as a dry calculator, imagining that he can simplify the problem of humanism by

Fra Angelico was not, as has been suggested, an artist attuned belatedly to medieval feeling but, on the contrary, a pioneer. Like Masaccio, he rediscovered the expressive value of the human body, adding to this a new perception of landscape.

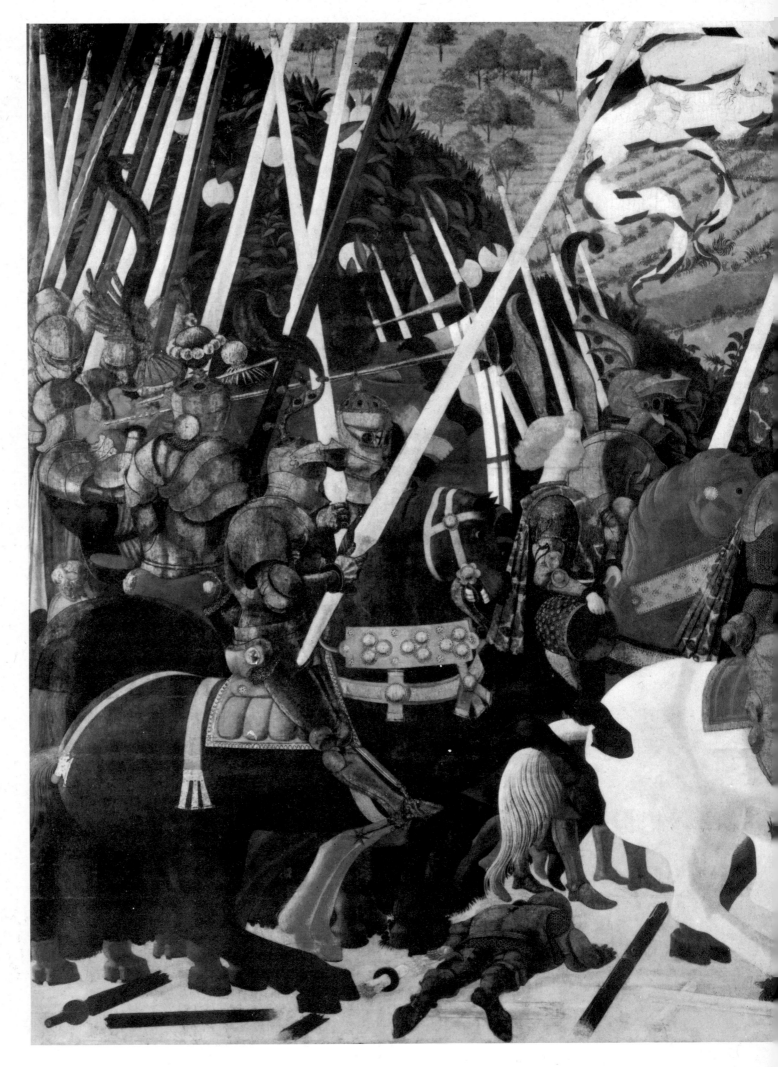

63 Uccello (1397–1475). *The Rout of San Romano*. London, National Gallery.

Through the theme of battle, Uccello affirmed the power of the human body in action, reduced by its armour and weapons to a geometrical concision.

74

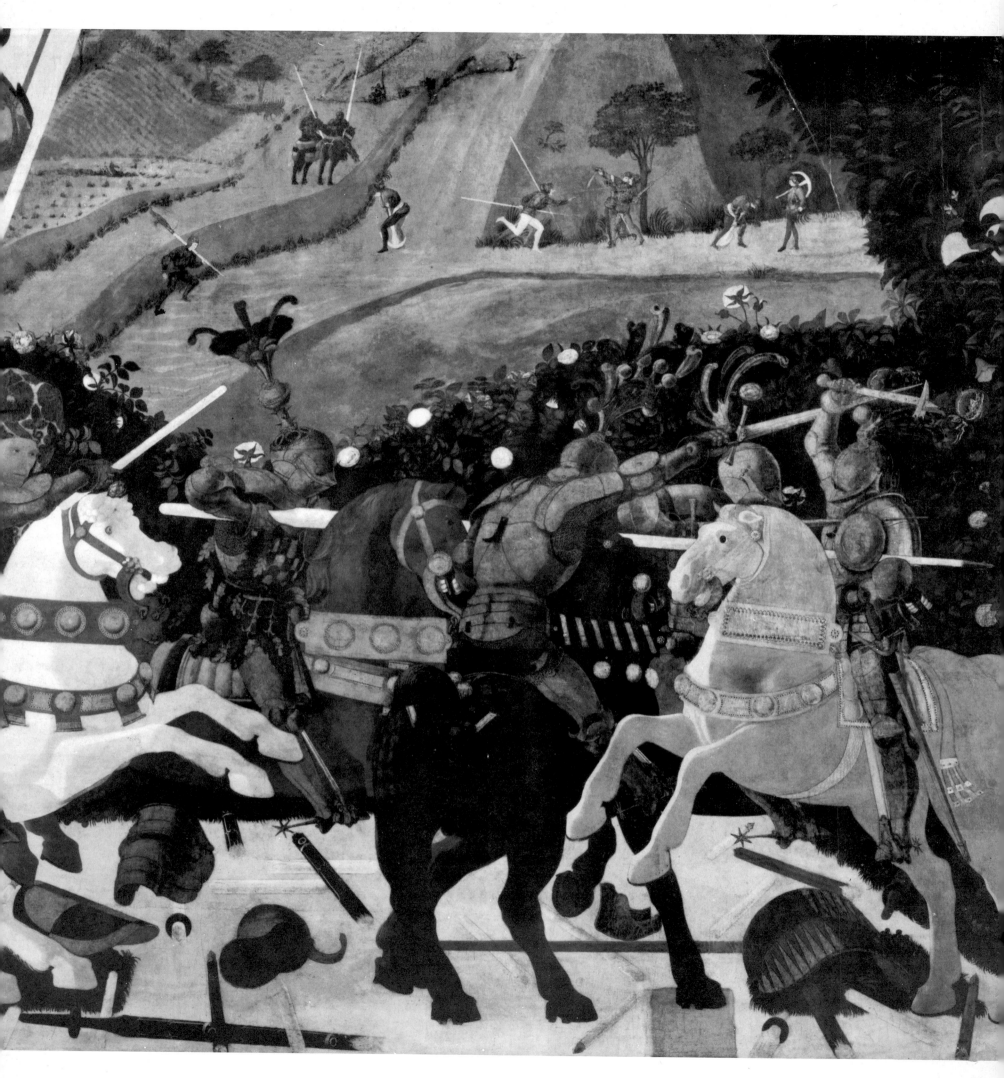

64 Andrea del Castagno (1423–57).
Equestrian fresco portrait of
Niccolò da Tolentino. Florence,
Cathedral.

Andrea del Castagno was the
supreme exponent of the ideal of
sculpture-painting which inspired
several Florentine painters during
the fifteenth century.

reducing the image of the world to man's dimensions, and hoping to increase man's presence by using paint to construct facsimiles of statues (*pl. 64*).

The Florentine school died of anaemia through granting exclusive rights to the intelligence and ignoring the virtues of the imagination. The amiable and facile eclecticism of Filippo Lippi, Pesellino, Gozzoli and Ghirlandaio is to some extent a phenomenon of academicism. The case of Botticelli typifies the intellectual sickness which was gnawing at the soul of Florence. This mystical spirit, attracted by lyricism and, to an even greater degree, by harmony, found himself condemned by this intellectualism to a state of constant agitation. The languid sadness of his Madonnas, the nostalgia of his portraits, the nervous style which gives a spasmodic rhythm to his compositions and exacerbates the sharpness of line and the leaping contours of the figures, reflect the death throes of Florentine art. Botticelli is like a man who discovers the charms of the world too late and reaches out to seize them just as they fade away.

To trace the later development of the Quattrocento's great voyage of discovery it is necessary to move away from Florence and examine other schools which owed their emancipation to that city. In Umbria, Piero della Francesca inherited Paolo Uccello's passion for perspective and Masaccio's sense of grandeur. No one affirmed the pride of Quattrocento man with loftier dignity than this strange artist.

The Quattrocento's pride in its conquest of the

intellectual process endowed it with a sense of godlike superiority over the forces of nature which found particularly appropriate expression in the equestrian statue: this image, the century's obsession and Leonardo's despair, symbolizing intelligent power taming brute force, represented the human demiurge and exercised a powerful influence over the sculptors of the period. A few painters, such as Uccello and Castagno, were also attracted by the subject, but others, including Masaccio, Piero della Francesca and Mantegna, preferred the image of man to stand alone, as though proud of the privilege of verticality. Piero's man, a statue planted in the ground, seems to revel as much in his *stasis* as medieval man did in his *ecstasis* (*pl. 67*). The *Annunciation* in the Perugia polyptych (*pl. 66*) offers us two statues petrified by pride, lost in the contemplation of their wholly autonomous existence, separated by an unbridgeable gulf of space. The instinct for relationship no longer inhabits these opaque bodies, cut off as they are from a nature which is, nevertheless, more realistic than that of Masaccio. But this nature, having ceased to possess an intrinsic value, has become nothing more than an object of domination. The will to power now permeating individual consciousness provided the impetus for the passionate belief in progress which was to dominate humanity, separating the individual from each object as soon as its conquest was achieved, excluding any possibility of sympathy between the thinking self and things.

The intellectual ferment of Florence worked on a powerful imagination to produce the greatest painter of the Quattrocento in the person of Mantegna. This precociously brilliant artist was only sixteen when he started work on the fresco cycle for the Eremitani Church in Padua which included four scenes from the *Life of St James*, destroyed together with the church during the Second World War. It would seem that in order to gain recognition for his genius the young man had to surmount opposition, starting with that of his adoptive father and master Francesco Squarcione, with whom he quarrelled in 1448, the same year that he signed a contract for the Eremitani commission, and whose house he promptly left in his urge for independence. The spiritual son of Donatello, whose living tradition he perpetuated in Padua, Mantegna was well acquainted with the scientific preoccupations of the Florentine painters, but, although enriched by their knowledge, he treated all the problems of foreshortening and perspective as a virtuoso, resolving them intuitively. To the Florentine discoveries he added a new concept which carried within it the seeds of the future in painting.

76

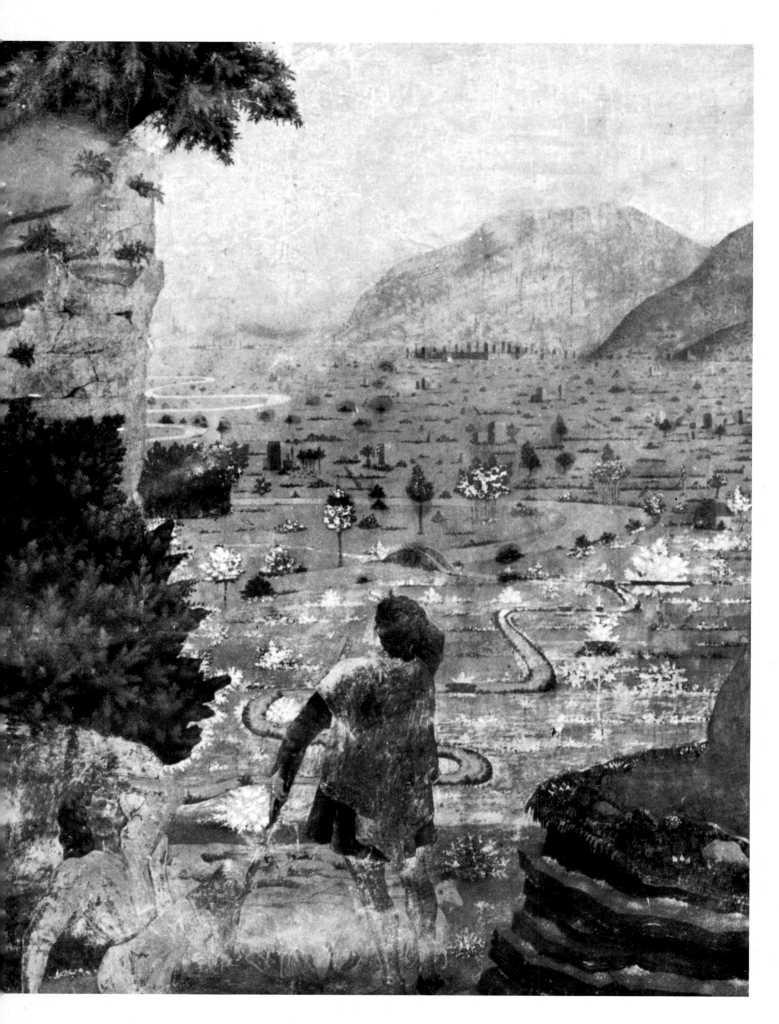

65 Alesso Baldovinetti (*c.* 1426–99).
Detail of the fresco of the *Nativity*.
Florence, Santa Annunziata.

Baldovinetti and Piero della
Francesca invented the cartographic
landscape, a sort of panoramic view
of the universe, which Leonardo was
to make use of in his *Mona Lisa*.

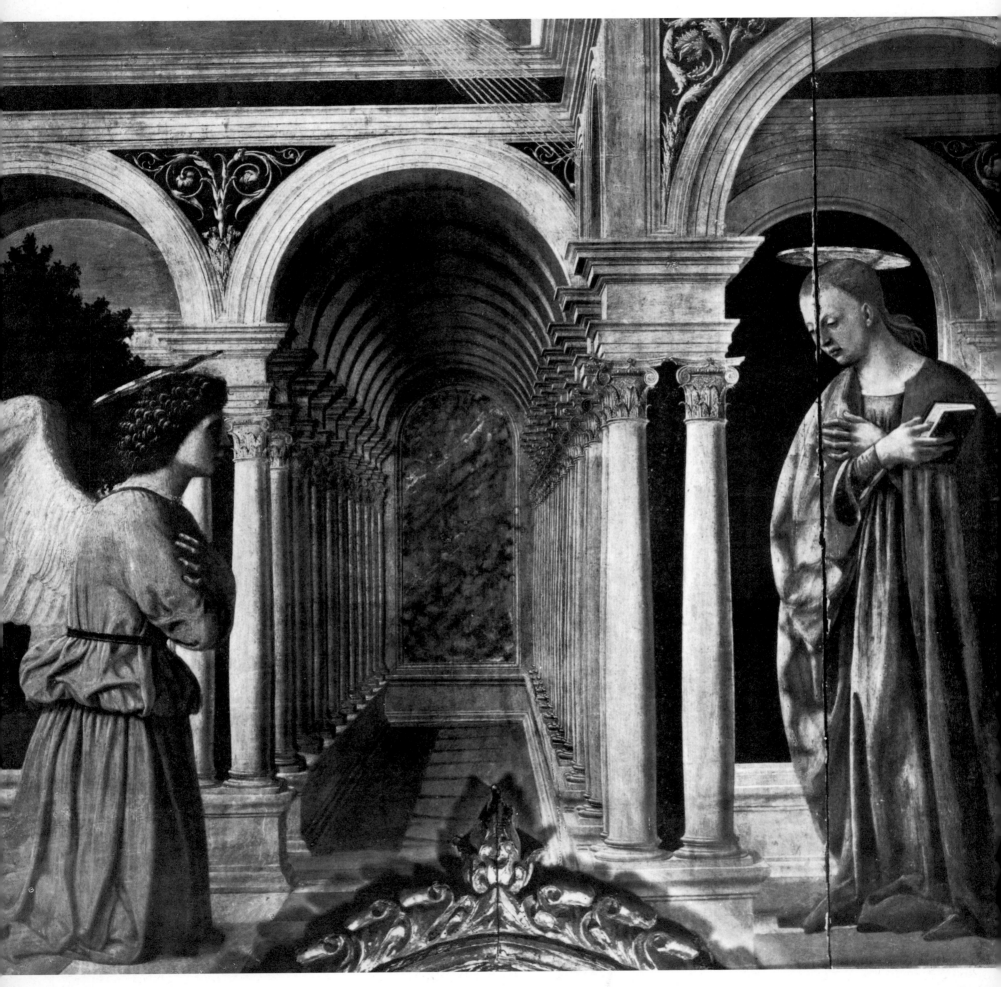

The Florentines' intellectualism made them visually adept at perceiving form (the soul of substance, as the body is its matter), for vision is the most intellectual of our senses: the operation of seeing transforms itself of its own accord into the operation of conceiving, and is always preceded to a greater or lesser extent by that of foreseeing. Mantegna, a northerner whose intelligence had not stifled his instinctive faculties, perceived beyond form the presence of the mysterious world of matter. He added to the spatial values of the Florentines what Berenson has called 'tactile values'; not content with the visual appearance of things, he set out to convey the illusion of material texture. Matter, which painters thenceforward applied themselves to evoking in all its subtle variations, first appeared to Mantegna in the guise that was nearest his own geometric vision of the world, that of mineral. Looking at a picture by Mantegna, one can almost feel the smoothness of the marble surfaces, the coldness of the metals, the hardness of the corals (*pl. 68*).

The use made by Mantegna of all these visual data went far beyond the stage of experimentation, for he achieved a synthesis of all the discoveries of the Quattrocento, creating a logical universe rich in varied forms and possessing laws to control the relationships between beings and things. Mantegna lived in intimate association with the natural world, as the backgrounds of his pictures reveal: a Lilliputian human and animal world teems there, all its gestures and attitudes accurately recorded. The man who painted the rabbits in *The Agony in the Garden* (*pl. 69*) is a poet sensitive to bucolic charm. With Mantegna we are very far away from the urbane painters of Florence, living in a world that is a pure mental abstraction. All forms perceived by this artist undergo a strange mutation and become lapidary. Mantegna's imagination is a spring which turns everything to stone.

The latinization which Mantegna attempted to impose upon the world he depicted provided an additional stimulus for the imagination to travel back in time. Obsessed with antiquity, he achieved in paint Alberti's dream of re-creating in modern society the institutions of the ancient world. No other painter except Poussin has possessed such a highly developed sense of history.

Even with these passionately lucid men of the Quattrocento, it was inevitable that eventually the obscure forces of the unconscious should reappear. Towards the end of the century, artists were often visited by the spirit of the bizarre. The satirical mythologies of Piero di Cosimo (*pl. 70*) and the senile inspirations of Giovanni de Paolo beckon us

67 Piero della Francesca. *The Resurrection*. Borgo San Sepolcro, Palazzo Pubblico.

Piero della Francesca preceded Michelangelo in celebrating the power of the human body. He portrays his revived Christ as a Hercules.

66 Piero della Francesca (1410/20–92). *The Annunciation*. Perugia, Accademia.

Filled with the loftiest sense of humanist pride, the figures of Piero della Francesca stand as though petrified in the solitude created by their will to power.

into an inverse world for which Piero della Francesca's spectral impassiveness has already prepared us. The fantastic exercised a particularly strong influence in the schools of northern and central Europe. These regions, while still under the spell of the legends of the Middle Ages, found themselves suddenly exposed to an art created by surveyors and geometers. The imaginations which for centuries had been perfectly attuned to the supernatural transformed the precise world of Florence into a chimerical universe. The school of Ferrara, which produced Cosimo Tura (*pl. 71*), Ercole dei Roberti and Francesco del Cossa, surpassed itself in this predilection for the fantastic. The impression of unreality conveyed by this art resulted from the skilful use of means going beyond the senses' normal perceptions: exaggerated foreshortenings and tactile values, extravagant projections, soaring architectures, impossible rocky constructions, human figures with convulsive gestures or paralysed limbs. The surrealist movement, which has promoted a return to favour of these strange painters, helps us to understand their neurotic psychology.

This strange phenomenon affected the whole of northern Italy to a greater or lesser extent, including Mantua and Venice. The cause of this uneasy passion may perhaps be traced to the German influence which penetrated northern Italy far more profoundly than the rest of the peninsula. Italy was not exempt from the flamboyant Gothic which had swept the whole of northern Europe at that time, and the tense, jerky style of the Ferrarese recalls that of certain Bavarian painters. The artists of Ferrara have the same relationship to those of Florence that Milan Cathedral has to the architecture of Michelozzo.

70 Piero di Cosimo (1462–1521). Detail of *Battle of the Centaurs and the Lapiths*. London, National Gallery.

71 Cosimo Tura (*c.* 1430–95). *St George and the Dragon*. ▶ Ferrara, Cathedral Museum.

In a spirit of protest against classicism, certain Italian artists imagined a fantastic world freed from its restrictive rules.

68 Andrea Mantegna (1431–1506). Detail of *St Sebastian*. Paris, Louvre.

69 Andrea Mantegna. Detail of *The Agony in the Garden*. London, National Gallery.

Mantegna is the first universal painter, including in his work not only an imaginary world inspired by a re-creation of antiquity but also nature in its most familiar details.

6 The creators of classicism

The moments of classicism are always brief, but certainly none can have been so fleeting as the Italian classicism which reached its creative peak between 1508 and 1512, when Michelangelo and Raphael were both working within a few yards of each other at the Vatican. The history of art has never paid sufficient tribute to the few patrons who have just as much right to be considered pioneers as the artists they sponsored. Whether or not Julius II was in fact as uncouth as he has been made out to be, his cultural awareness clearly extended to a sense of grandeur and an intuition for what might best serve his glory, and it is to his credit that he allowed each artist to accomplish his artistic destiny. One can only imagine the bewilderment that would have overcome Michelangelo had he been called upon to undertake the apotheosis of peace in the Stanza della Segnatura, or Raphael's dismay at having to interpret the sombre universe of the Old Testament on the ceiling of the Sistine Chapel. The pope's confidence in Michelangelo was so great that he allowed him to choose his own themes, thus initiating a revolutionary change in the status of the artist, who was thenceforward held in esteem as a creator of ideas as well as of forms. The Old Testament terrors which were to become one of the most powerful ingredients of the Protestant revolt snarl down from the ceiling of the Sistine Chapel solely by grace of Michelangelo.

The modern movement has based itself upon a hostility towards the aesthetic principles set out by Raphael and transmitted through three centuries as far as Ingres; when the fauves consigned all museums to the flames, it was above all Raphael's pictures that they had in mind. In André Malraux's *Les Voix du Silence*, Raphael rates only two illustrations, against fourteen for El Greco. (And there were none at all in the first edition, published as *La Psychologie de l'art*.) On the other hand, at the beginning of the twentieth century Salomon Rienach, in his *Apollo*, had allotted eighteen reproductions to Raphael and not a single one to El Greco. We should not allow ourselves to be guided by either of these extreme attitudes, but rather consider dispassionately whether Raphael brought anything really new to the art of painting. It can be affirmed quite objectively that he was more of an innovator than Leonardo.

Leonardo's supreme genius sought to crystallize in one simple formula the relations between the figure and its frame. The *Mona Lisa* (*pl. 73*) is already contained in Baldovinetti's *Virgin and Child* (*pl. 74*), a hieratic image of perfection, strictly circumscribed and standing out against a cartographic landscape which is in effect a plan of the universe. In the *Mona Lisa*, the figure and landscape lose this abstraction. The blandness of the modelling gives spiritual warmth to the figure and atmospheric moistness to the elements of nature; but this animation is still obtained in the Florentine manner, by *sfumato* blending of light and dark, and thus invariably through the medium of drawing rather than, as is the case with Giorgione, through the living quality of the colour.

In his aim to release the inexhaustible resources of painting, Leonardo, basing his technical researches on principles developed more or less directly from Pliny, made heroic efforts to perfect the means he had acquired in the workshop of Verrocchio, only to reach a deadlock which compromised the very future of his pictures. He might possibly have bent destiny to his will, had his mind not been so thirsty for knowledge in every field. Leonardo made painting the supreme gesture of a philosophy aiming to achieve understanding of nature through its re-creation, giving a new vigour, in terms of profane expression, to the ancient beliefs in the equal validity of the image and its double; the fascination still exercised on the public mind by the *Mona Lisa* is proof enough of his success in this aim. But for Leonardo painting was simply one mode of investigation among many, and one to which he devoted only a very small part of his time.

The four years during which Raphael and Michelangelo were both engaged in painting projects at the Vatican, working warily in concert, constitute one of the privileged moments of history: these two artists together assumed at this time an archetypal value in the future development of forms, achieving the ideal of humanist culture in the totality of its ambivalence.

Raphael's reputation has suffered because his

impressionable nature allowed itself to be inspired by the successive environments in which he lived. Such virtues of sociability are now considered reprehensible in an artist; in our own age genius is visualized as frowning and sullen, and is therefore more readily recognized in Michelangelo's instinct for revolt than in Raphael's conformism. Yet Raphael's creative genius was the equal of Michelangelo's; it is in means of expression rather than in quality that they differ.

Michelangelo was passionately attached to the city of his birth, anguished by its decline from power, deeply frustrated in his unrequited patriotism, his republican convictions unsatisfied, his religious hopes deceived. His withdrawn personality (which is revealed, incidentally, by a morphopsychological analysis of his face) could only exist in terms of defiance of his environment and rejection of the external world, leading eventually to an obsessive assertion of his self in essential conflict with the non-self. On the other hand, Raphael's profound nature, combined with the influence of the cultural atmosphere of his native Urbino, allowed him to find self-accomplishment in the harmony between self and non-self, seeing in things those aspects which might draw them together rather than separate them; in this he was aided by his affectionate temperament, perhaps intensified by the loss of his mother who died when he was eight.

During the first twenty years of the sixteenth century, the Rome of Julius II and Leo X was one of those places which, like the Athens of Pericles, were capable of provoking the spark of genius; and so a Roman miracle occurred in the same way that a Greek miracle had once occurred. It is difficult to imagine Raphael's destiny without Rome. At the moment when he was about to be summoned by Julius II he had progressed no further than had Leonardo, bringing his own style to the Florentine cantilenas of the Virgin, and already experimenting, on this restricted theme, in those melodic sequences of which he would later show himself the master in Rome. But his 1507 *Deposition*, painted on the eve of his departure for the eternal city, showed that the procedure was unproductive when applied to an expressive scene composed of several personages.

By the autumn of 1508 Raphael was in Rome, and Julius II had commissioned him to paint the Stanza della Segnatura. The decorative theme of this room (whose original purpose remains uncertain, though it almost certainly started out as a library) was entirely one of concord, and celebrated the reconciliation of ancient Wisdom and revealed Truth. This syncretism must have been familiar to Raphael who would have seen its realization, in an even bolder context perhaps, in his native city, in the castle of Urbino where a pair of 'chapels' bear the inscription: 'Behold these twin sanctuaries, scarcely separated. One is sacred to the Muses, the other to God.' No doubt the programme of the Segnatura was laid down by some cultivated person; nevertheless, in all times (except our own) the summits of culture have been attained when an artist has come forward who is capable of incarnating the spiritual life of his epoch. In the same sense as the great theological complexes of the thirteenth-century cathedrals, the Parthenon or the Buddhist grottoes, the Stanza della Segnatura is one of those fortunate instants when thought takes shape, thanks to the visual eloquence towards which Italian art since Dante had been tending.

A comparison between the Segnatura paintings and the Old Testament frescoes in the Sistine Chapel, in which the first Florentine painters of the late fifteenth century had striven in vain to achieve a monumental style, makes Raphael's originality strikingly apparent. The eye wanders and the mind becomes perplexed when confronted by such confused aggregations; indeed, the impasse reached by Quattrocento Florentine art is well illustrated by these vastly enlarged easel-paintings, conceived independently of the space destined to house them, their cartoons prepared with reference to a workshop's visual angles and transferred to the wall surface without any modification. With one's first steps into the Stanza della Segnatura, on the other hand, the mind, guided by the eye, is immediately transported into a lucid world where there reigns a harmony derived from moderation. The compensated gestures of Plato and Aristotle in the *School of Athens* (*pl. 75*), answered by those of the two saints standing on either side of the altar in the fresco wrongly called the *Disputa* or 'Disputation concerning the Blessed Sacrament' (*pl. 77*), express that law of equilibrium through which the human being achieves total self-accomplishment. Leonardo, deeply troubled by the problem of gestural expression, had already employed this compensated gesture in his *Virgin of the rocks* (*pl. 76*), in which the angel's dynamic gesture is balanced by the Virgin's static gesture. Raphael gives these two movements to the two philosophers who dominate classical culture, but the compensation here is stricter, since the movements interpret the oscillation of the pans of a pair of scales seeking a just weight: each movement expresses the essential doctrine of the two masters of Greek thought. We are concerned here, then, with a key gesture.

The lunette of the *Virtues* yields us another key, that to Raphaelesque art: a melodic liaison between

73 Leonardo da Vinci (1452–1519). Detail of *Mona Lisa* (*La Gioconda*). Paris, Louvre.

74 Alesso Baldovinetti. Detail of *Virgin and Child*. Paris, Louvre.

The profoundly humanist ideal for which the painters of the Quattrocento sought expressive form in the type figure of the Madonna was restated by Leonardo in terms of the profane world, by incarnating that ideal in a living model.

figures whose gestures, attitudes and inflexions, although gratuitous in appearance (at least as regards their expressive value) are in fact motivated by the desire to achieve a perfect continuity between the counterbalanced forms. The homogeneity of the forms throughout the room produces a consonant space in which the rhythms spread from one wall to the other. At a moment when the art of painting showed signs of becoming moribund, Raphael rejuvenated it through means similar to those of Giorgione, by enriching it with musical principles. What the latter found in chromaticism, the former obtained through harmony. Raphael went further, by creating a 'scenic' spatial vision long before the invention of opera and the rise of stage design. Rejecting the yoke of linear perspective within which Quattrocento man had dreamed of imprisoning things, Raphael expanded space by means of curvature. In the *School of Athens*, as in the *Triumph of the Church*, he created for the spectator a scenic space so new that it remained for long undeveloped by others, and it was not until the eighteenth century that the theatre itself rediscovered it.

We know that in 1518 Raphael organized the performance in Rome of Ariosto's *I Suppositi*, building a theatre and designing the setting. We do not know what this setting was like, though it probably conformed to the elementary scenographic principles of the time; in fact, a letter from a contemporary, describing the spectacle, says of the stage setting that 'it was a fine vision of entrances and perspectives that were highly praised'. At the end of the sixteenth century, the permanent setting of the Teatro Olimpico at Vicenza, designed by Palladio and Scamozzi, still brought the spectator's vision up sharply against the wall of the setting, the *frons scenae* in which a few perspective vistas provided the sole visual relief. It was essentially as a working painter that Raphael conceived this flight into space which was to constitute the future for both painting and the theatre.

His boldness may be appreciated by a comparison of the *Disputa* (*pl. 80*) with the *Paradise* painted by Orcagna at Santa Maria Novella a century and a half previously (*pl. 78*). The vision of the Trecento artist is theologically more correct, since the concept of paradise is that of a world no longer governed by the distance and hierarchy appropriate to our own. But Raphael conjures forth a possible paradise as seen by a spectator sitting in the 'royal box' of an ideal theatre, substituting a human point of view for the divine concept. Fra Angelico had first pointed the way when he arranged the ring of angels and the elect around Jesus and Mary in the

perspective of a diagonal movement (*pl. 79*), a fact which is in itself sufficient to refute those who would deny Fra Angelico his place in the Renaissance and make of him a mere mendicant wandering in the fusty aftermath of the Middle Ages.

In the *Foligno Madonna*, and, even more, in the *Sistine Madonna* now in Dresden, Raphael created the theatrical typology of appearance which for the next three centuries was to provide the model for the representation of the supernatural. The *Sistine Madonna*, which Augustus the Strong, while Elector of Saxony, bought for an enormous sum, had such intense transcendental significance for post-Renaissance man that its form was passed on intact as far as Ingres. Although the painting may have lost some of its powers of fascination for us today, it has throughout its history inspired an ever-renewed chorus of admiration (to which Goethe contributed some verses). Even in our own days, the view of this image aroused such mystical emotions in the breast of the Marxist Sergei Bulgakov that he was converted to Christianity; later, after he had been ordained and become a distinguished exponent of Orthodox theology, a newly acquired passion for Russian icons turned his love of the picture into hatred!

One non-conformist school of thought holds that the decadent phase of Raphael's art commences with the paintings executed in the other Vatican Stanze, after the completion of the Stanza della Segnatura, but it would seem unfair to reproach the artist for failing to reproduce the harmony of the Segnatura frescoes in themes which were not in themselves harmonious. Having descended from the lofty regions of the ideal, Raphael entered into contact with the human drama. Although his temperament found the clash of battle uncongenial, he succeeded in adapting his melodic system to the expression of tumult in the *Fire in the Borgo*, as he did in the *Liberation of St Peter*, where the angel of light (*pl. 72*), a sun of justice, stands out against a night scene worthy of Tintoretto. In these paintings he achieved a loftiness of spirit that only Rembrandt was to rediscover. Whereas in the Stanza della Segnatura he had delighted in giving classic expression to all ages of humanity, from the ideal beauty of adolescence to the majesty of old age, he now became attracted by the realism of individuated expression, as in the *Miracle of Bolsena* with its memorable portrait of the indomitable Julius II (*pl. 82*) and its depiction of the rugged soldiers of the Swiss Guard. It is true that the prejudice of the anti-Raphaelites has declared Sebastiano del Piombo to be the creator of these figures, but then this same faction has even gone so far as to attribute the

75 Raphael. Plato and Aristotle, detail of *The School of Athens*. Vatican, Stanza della Segnatura.

76 Leonardo da Vinci. Detail of *The Virgin of the rocks*. Paris, Louvre.

77 Raphael. Detail of the *Disputa* (*pl. 80*). Vatican, Stanza della Segnatura.

Both Leonardo and Raphael sometimes convey the classical ideal of equilibrium through a subtle balancing of gestures. A particular significance attaches to the gestures with which Plato and Aristotle express their essential philosophy: Plato, the idealist, points at the sky, whereas Aristotle, the explorer of nature, seems to wish to embrace the earth.

78 Andrea Orcagna (active 1343; d. 1368). Detail of *Paradise*. Florence, Santa Maria Novella.

79 Fra Angelico. *The Crowning of the Virgin*. Florence, Uffizi.

extraordinary Giorgionesque landscape of the *Foligno Madonna (pl. 83)* to Dosso Dossi!

Overwhelmed by commissions and entrusted with various architectural and archaeological projects, Raphael became in his last years a sort of painting contractor, designing cartoons which were converted into frescoes by a whole team of apprentices led by Giulio Romano as foreman. Although this procedure led to some diminution in the composition's formal strictness, its quality remained intact: in any case, the new manner provided fresh sources of inspiration for the future. The *History of Psyche* (Farnesina) opened the way to the Olympian cadences of the baroque world, while the cartoons of the *Acts of the Apostles* and the biblical frescoes of the Stanze later inspired Poussin. Moreover, Raphael's love of antiquity provided the positive stimulus for the humanist adoption of the ornamental devices known as *grottesche* (grotesques), inspired by the Roman paintings found in places such as the Golden House of Nero. The superb decorations that he himself executed in the *stufetta* of Cardinal Bibiena and in the recently rediscovered Vatican *loggetta*, and those created by Giovanni da Udine under his supervision in the Vatican *loggie* and the Loggia della Farnesina, all incorporate the elements of modern still-life and realistic depiction of animals, based on the principles of this ancient form of decoration. Raphael demonstrates such incessant powers of renewal and so animated a creative faculty that all attempts to represent him as being the prisoner of academic formulas must inevitably fail.

80 Raphael. The *Disputa*. Vatican, Stanza della Segnatura.

The conquest of space achieved by Raphael in the *Disputa* contrasts with Orcagna's *Paradise* which belongs to the heavenly world where the notion of distance is unknown. Fra Angelico's *Crowning of the Virgin* marks a step forward in a definition of curved space which was to present an entirely new solution in relation to the perspective-oriented ideas of the Quattrocento.

In fact, in the domain of painting at least, the scope of Michelangelo's art is by no means as great as that of Raphael. He is supposed to have been more conscious than Raphael of his creative urge, and yet he, too, was indebted to Rome for the revelation of his genius. The sculptures he executed prior to his arrival in Rome were essentially Donatellesque variations: even in the case of certain Madonnas, that of Bruges, for instance, or the *Pitti Madonna* (a *tondo* or large medallion), he may be said to follow Raphael. And what a peculiar hybrid is his *David*, with Michelangelo's artificial muscles grafted on to a Donatellesque anatomy. The strange crucifix of painted wood, recently discovered and now in Santo Spirito, Florence, confirms (if it is indeed by Michelangelo's hand) that the artist's direction during his Florentine youth gave no hint of the powerful nature of the work that he was to accomplish in Rome. This epicene *Christ* has a distinctly mannerist quality about it, and one's natural inclination would be to date it at around 1550 rather than the years preceding 1500. The *Holy Family* (or *Doni tondo*) – the one easel-painting which art historians credit unanimously to Michelangelo – would make one suspect that it was the art of painting which rescued this sculptor from his complexes. What would he have been had not the ceiling of the Sistine Chapel offered to his imagination an inexhaustible field of forms to create, liberating him from the craft limitations of statuary? Since Michelangelo never completed any work of art except his paintings, it is permissible to suggest that he was essentially a painter, possessed of an urge to create sculptures which he never had the heart to finish.

Simultaneously, Raphael at the Segnatura and Michelangelo at the Sistine Chapel were rediscovering classical antiquity's profound vision of the human body as the very substance of art, thus bringing to fruition a concept that the Quattrocento had sought hesitantly to express. But Michelangelo went much further than Raphael in this direction, for he dreamed of an impossible world populated solely by human beings: the self liberated from the non-self, but subject to the will of God.

In the Sistine Chapel, Michelangelo created the first true painted ceiling, covering the vault with painted architectural settings upon which he posed his personages. Rather than visualizing these figures in foreshortening, as seen from below, he applied them in apparent bas-relief or in the round to the vault's concave surface, treating it as though it were a partition-wall (*pl. 84*). He was not bold enough to suspend them above the head of the spectator, as Correggio was shortly to do. For Michelangelo, as for Raphael also, form was an *image* giving expression to an idea; it is an extraordinary chance that brought these two together, to work a few paces apart in an atmosphere of mutual jealousy, the one painting a world in revolt, and the other an idea of concord.

Two instincts vied for supremacy in Michelangelo's soul, the cult of beauty and the passion for drama. Some of his figures are constructed according to the strictest principles of classicism, while others, on the contrary, evoke the exuberance of the Hellenistic period of antiquity and foreshadow the baroque forms of the seventeenth century; this dualism was almost certainly intentional, since the artist sometimes combined the opposing principles in his *ignudi*, nude adolescent figures (*pl. 85*). Michelangelo bequeathed to his age a power of corporeal expression which enraptured a very great number of artists, though none of them ever came near to achieving the same effects. But despite his immediate influence, he must be considered to have diverted painting from its true course by running counter to the impetus bestowed upon it by Raphael. The future of painting lay in spatial expression, in the exploitation of its resources for the purposes of discovering nature and exploring the soul's feelings. Michelangelo checked this advance by re-emphasizing mural painting and by limiting it to the one theme, that of the human body, which was to obsess the mannerists to the point of frenzy.

Michelangelo and Raphael alone bear the responsibility for Roman classicism, although Michelangelo himself fostered the anti-classicism which sprang up after Raphael's death. The future of classicism lay elsewhere, in Venice, a city preserved from both spiritual and political adventures, where a natural sensuality tended to soften the rigours of Florentine-style neoplatonism by discerning greater reality in the world of appearances than in the world of ideals. Titian exemplifies this attitude. When he paints a nude (*pl. 91*), he reduces Giorgione's Venus to the status of a simple courtesan; his art as a whole seems to lack the element of discovery. Having inherited Giorgione's means, he used them to increase the register of human and natural expressions available to painting, aided in his ambition by his extraordinary longevity. But if he attempted with doubtful success to transcend the technique handed on to him by Giorgione, it is certain that he did not invent that technique any more than he invented Giorgione's poetics. However, before his death he experienced a sudden rejuvenation and with it a belated access of boldness.

81 Raphael. Detail of *The School of Athens*. Vatican, Stanza
della Segnatura.

Only the conformist prejudice of anticonformism could
blind anyone to the rhythmic elegance of Raphael's
brushwork, even in figures, such as this, in which he is most
closely inspired by antiquity.

82 Raphael. Head of Julius II, detail of the *Miracle of Bolsena*. Vatican, Stanza d'Eliodoro.

83 Raphael. Landscape, detail of the *Madonna of Foligno*. Vatican, Pinacoteca Vaticana.

The evolution in Raphael's painting towards an increasingly free treatment can be clearly traced in the transition from the *School of Athens* to the *Miracle of Bolsena*, the *Liberation of St Peter* and the *Madonna of Foligno*.

84 Michelangelo (1475–1564). *The Delphic Sibyl*. Vatican, ceiling of the Sistine Chapel.

Michelangelo endows with expressions of passion these faces whose beauty is inspired by classical antiquity. In terms of historical precedent, Michelangelo's outlook resembles that of Scopas, while Raphael recalls Phidias.

85 Michelangelo. *Ignudi*. Vatican, ceiling of the Sistine Chapel.

In the *ignudi*, Michelangelo was able to experiment with all the attitudes of the human body, and it is from these that classic and baroque form descended.

7 Elusive Giorgione

86 Giorgione (1476/8–1510). *Tempesta*. Venice, Accademia.

We know too little about Giorgione to trace a biography, but can glean enough to visualize a passionate life with a tragic destiny, of a kind which is popular today with those who are no longer capable of perceiving human interest except in a dramatic context. This young patrician endowed with genius, 'drawn towards romance and delighting in the lute, sang and played this instrument so divinely that he was often called upon to exercise these talents at the concerts and social gatherings arranged by the Venetian nobility'. One can picture the carefree life of this child of pleasure, a golden existence cut short brutally by an atrocious death. At the age of thirty-four, Giorgione was carried off by the plague after, it is said, having witnessed the death at his side of a woman with whom he was at that moment engaged 'in the delights of love'.

From all this, however, the exacting historian can retain only the single fact that Giorgione died a victim of a plague epidemic; the proof for this is provided by a letter dated 7 November 1510 and addressed to Isabella d'Este who was seeking to acquire a painting by the late master. We are not even certain that Giorgione was a member of the noble family of the Barbarelli, since Vasari describes him as being of humble origin. The nickname Giorgione appears to be a distortion of the Venetian-style appellation by which he is referred to in contemporary documents: *mistro* Zorzo, Zorzou or Zorzi da Castelfranco. His birthplace, Castelfranco, is a pretty town lying at the foot of the fore-Alps, surrounded by what is perhaps Europe's best-balanced countryside, where all the elements – water, mountain, sky, tree and human habitation – combine in easy harmony. The only surviving documentary evidence relating to his works concerns sordid negotiations with the Fondaco dei Tedeschi (the German Exchange) in Venice over payment for the frescoes which he had painted there. Unfortunately, nothing remains of these frescoes but faded fragments. A few references to works of his in Venetian collections, including lists drawn up fifteen years after his death, attest to his posthumous fame. And that is all.

The mystery of Giorgione has been further obscured by the very efforts which have been made to clarify it. The uncertainties surrounding the man and his work offer a fertile field for art critics to indulge in their favourite exercises, and they have seized the opportunity to the full: the study of Giorgione has almost succumbed beneath the weight of *giorgionismo*.

Of the few works recorded by Marcantonio Michiel as being in Venetian collections shortly after Giorgione's death, it has been possible to identify three: the *Tempesta* (Venice), the *Sleeping Venus* (Dresden) and the *Three philosophers* (Vienna). The *Concert champêtre* (*Rustic Concert*) in the Louvre, which has frequently been attributed to Titian, is not mentioned until the seventeenth century, but it fits in well with the *Judith* in the Hermitage, and also with the *pala* or altarpiece known as the *Castelfranco Madonna*, which, although not mentioned in any document, is, by some miracle, accepted unanimously as being by Giorgione's hand. To these we may add the Vienna *Laura*, authenticated by an inscription which does not appear open to doubt, the *Man with the arrow*, also in Vienna, and the *Christ carrying the Cross* in the Scuola San Rocco (Venice), although this last work is now no more than a ruined remnant. It is reasonable to think that the two pictures in the Uffizi attributed to Giorgione, the *Judgment of Solomon* and the *Ordeal by fire*, are in fact early works. Finally, we may possess an indirect reflection of Giorgione's own face in the Brunswick *Portrait of a man*, which may be a partial copy of a *David* mentioned by Vasari, the composition of which is known to us through an engraving.

There is no doubt that there emerges from this small group of paintings a personality that is well defined psychologically, artistically and technically. During 1955–6, I was able to see almost all the pictures attributed to Giorgione, even those not included in the exhibition at the doge's palace in Venice, notably the Hermitage *Judith*, that essential painting which provides the central link between the Castelfranco *pala* and the Louvre *Concert champêtre*. I have acquired one conviction as a result: Giorgione is not susceptible to proof, only to feeling, and must be approached with the heart rather than the mind. A certain poetic charm which is quite unique emerges from his works.

Giorgione's almost undefinable poetry is slightly

87 Giorgione. Detail of the *Tempesta*. Venice, Accademia.

different from the dark, 'saturnine' romanticism upon which so many authors have expatiated since the thesis set out by G. F. Hartlaub in *Giorgiones Geheimnis* (Munich 1925). The subject of two of Giorgione's pictures, the *Tempesta (pls 86–7)* and the *Three philosophers*, whose meaning has been lost to us, has been interpreted by this historian as signifying the existence in Venice of an occultist secret society, of which Giorgione is presumed to have been a member. According to this theory, the *Three philosophers* symbolized the three masonic orders and the picture was made to be hung in the society's meeting-room. There is no bridling the imagination once it is freed from the constraints of history; however, the truth here is doubtless simpler. The *Three philosophers* probably symbolize the three forms of wisdom. As for the *Tempesta* (which is not, in fact, stormy at all), X-ray examination has revealed a female nude beneath the young man at the left: there seems no reason to disagree with Eugenio Battisti's opinion (in *Rinascimento e Barocco*, Milan 1960, p. 151) that the picture represents the nymph Io, impregnated by Jupiter manifesting himself as a streak of lightning, and protected by Mercury in the form of a shepherd. This explanation tallies with a particular passage in Ovid's *Metamorphoses*.

I would add that the Castelfranco *pala*, too (*pls 88–9*), may well contain a hidden meaning. The reduction to two attendant personages – a warrior and a monk – of the usual *sacra conversazione* which in the work of followers of Bellini is usually more heavily peopled, may indicate the artist's intention to symbolize the two choices open to man at the moment of embarking on life: action and contemplation. But this is unimportant. The true mystery of Giorgione lies elsewhere than in a question of the more or less hermetic meaning of his paintings or the frenzied romanticism of his imitators. It is possible, even probable, that artists such as Savoldo, Dosso Dossi and Pordenone profited from his inspired example, but the element of emotionalism in their treatments is contrary to Giorgione's outlook, profoundly foreign to that chaste reticence of the soul which can be apprehended only by allowing oneself to become slowly steeped in it in complete inner silence. This salutary process was rendered more difficult at the great 1955 exhibition at the doge's palace by the necessity of making oneself deaf to the false notes struck by so many attributed pictures, all clashing with the divine violins of the master.

It is at this point that Titian appears in his true light: he uses feelings to flaunt them and catch beautiful reflections from them. Titian is not only

an artist but a man of the world as well, and occasionally even something of an orator. His virtuosity contrasts with Giorgione's spontaneity, which is compounded of hesitation, irresolution, modesty and even timidity; these feelings imbue the face of the woman giving suck in the *Tempesta*, of the *Laura*, of the *Man with the arrow*, of the two saints and the Madonna of the Castelfranco *pala*, of the *Christ carrying the Cross*. A certain gentle melancholy contributes a hint of bitterness to the *Portrait of a man*. But this is as far as one may go: any hint of emotionalism can only derive from Titian, not Giorgione, and this is why I hesitate to ascribe to the latter the *Concert of chamber music* in the Pitti (Florence). The old man and the youth would marry well into the Giorgionesque family, but at the centre there is an adult who possesses feelings, who is well aware of the fact and shows it too openly; his sidelong glance and rolling eyes have found part of the traditional repertory of emotional expression in art since the sculptures of Scopas, and already foreshadow Rubens.

It has been claimed that a comparison of Titian's *Sacred and profane love* and Giorgione's *Concert champêtre* (*pl. 90*) would reveal their respective authors simply through the joyous atmosphere radiating from the first painting, in contrast with the sadness impregnating the second. Giorgione's sadness, however, is never a lamentation. It is, rather, a profound gravity that emanates from his works, and this gravity is specifically Venetian, a heritage from Byzantium. The same nuance is apparent in Giovanni Bellini's grieving figures, mostly saints, in whom one senses the melancholy of the divine being transported to earth but still dreaming of heaven; immured in his own self, he is unable to become part of the world whose beauties the artist has spread around him. But Giorgione succeeded in secularizing painting, and his sublunary beings, no longer remembering heaven, live upon earth. A wall is suddenly broken down, that wall of contour within which Bellini enclosed his human figures. The soul pours forth through this breach, and, for the first time in painting, contact is established between the soul and the world: the universe ceases to be a spectacle whose marvels the painter enumerates and contemplates without being able to participate except intellectually. Now the soul, burdened with the weight of the world that has invaded it, tends to withdraw into itself, and this withdrawal expresses itself through a perfectly controlled silence. Herein lies the quality that may truly be called Giorgionesque. It is this quality, too, that binds Giorgione to Vermeer, to whom he is akin as a painter through his intimist feeling for light,

especially the way he spreads pearls and diamond-bright needles along the edges of shadows.

The *Castelfranco Madonna* (*pl. 89*), more than any other painting by Giorgione, gives an insight into this immersion in nature of figures enveloped rather than delimited by their contour. Because, in this

88 Giorgione. St Francis, detail of the *Castelfranco Madonna*. Castelfranco, San Liberale.

The melancholy look of Giorgione's personages provides painting with a new direction, that of the expression of sentiment.

sacra conversazione, the personages have their backs turned to the landscape, it is easier to appreciate what they owe to it. Every aspect of them reflects their surroundings: their deeply reflective faces whose features are blurred by a soft shadow, St Liberale's armour which is a mirror of light, the moist drapery of the Madonna's robe. Enamoured of music – which in his time was essentially polyphonic – Giorgione invented symphonic painting. An identical fluid circulates throughout the picture: each colour contains some echo of the nearest and most distant colour; the light does more than envelop things, it seems to give them life, assuming an infinity of subtle variations in response to the tonalities of the colours and substances which absorb it, diffuse it gently and reflect it in bright flashes.

Bellini, Giorgione's master, spreads his colours evenly over the whole surface of his paintings,

making each of its tones homogeneous. Giorgione, on the other hand, employs a richer pigment which he wields freely according to the requirements of the object to be painted and the intensity of the light. He inaugurated the modern handling in which paint thickness varies in direct proportion to light intensity, and the layers of paint are progressively thinned, to a point of transparency, in order to represent the shadow whose mystery shows hollow on the surface of the canvas, while the light accents are thrust towards the eye by thick impasto. Titian was the first artist capable of making full use of the new processes created by Giorgione. The difference between them is that Titian practised the technique as a virtuoso, whereas for Giorgione it was a means rather than an end.

Prior to Giorgione, a picture was thought out before being painted. Giorgione's method of pro-

◀ 89 Giorgione. The *Castelfranco Madonna*. Castelfranco, San Liberale.

90 Giorgione. *Concert champêtre*. Paris, Louvre.

Giorgione plunges man into the heart of nature; it is present everywhere in the form of light and atmosphere enveloping beings and things, even when, as in the *Castelfranco Madonna*, it is still only a backcloth.

cedure was absolutely revolutionary. Vasari's comment on his supposed predilection for drawing is the sort of conventional formula which this Florentine artist, for whom painting was *l'arte del disegno*, applied to all the great masters; if Giorgione had really completed so many drawings, it is surprising that none of the great private collections, which vied so eagerly for drawings by the masters, contained any

at all by him. On the contrary, Giorgione gives the impression of having attacked his canvas directly, placing his faith in pure improvisation. Indeed, composition is by no means the strongest element in his painting: the *Tempesta*, a work of his youth, is very badly planned, with its complicated system of *coulisse* foreshortening; the dissection of the landscape in the *Three philosophers* is eccentric, with

unity to a picture by Giorgione is the immersion of all the forms in a single fluid, a single atmosphere. Painting, as he did, according to spontaneous impulse, Giorgione sometimes hesitated, and recent X-rays of three of his paintings have revealed to us the ghosts of these uncertainties. It even seems that he sometimes abandoned a canvas because of his feelings of dissatisfaction or despair: two of his paintings were completed by others, the *Three philosophers* by Sebastiano Veneziano and the *Sleeping Venus* by Titian.

Several factors combine to suggest that Giorgione may well have been the first artist to paint for his own pleasure. The silence of the archives proves that he received few commissions (one only is recorded, that of the decoration of the Fondaco dei Tedeschi). In addition, he is known to have painted only one religious picture, the *Castelfranco Madonna*. F. Saxl has argued (*Lectures*, London 1957) that the *Sleeping Venus* seems to have been inspired by the description of the sleep of a nymph in the *Hypnerotomachia Poliphili* of Francesco Colonna, a book which reflected the literary imagination in Venice in Giorgione's day. But this description is itself certainly based on some antique statue of Ariadne. And in any case, Giorgione cannot have been illustrating the *Hypnerotomachia*, since he turned the nymph into a Venus, a fact proved finally by the presence of Cupid, overpainted subsequently but recently revealed by X-ray examination. The artist's imagination, aroused by his reading, drew an ideal image from the subject in the process of transposing it. The theme of closed eyes also constituted an innovation in painting; the pure face expresses latent being, closed shut upon its mystery.

It is curious that most of the pictures by Giorgione of which record has survived, whether landscapes or figures, represent unexplained subjects. But this fact does not necessarily make Giorgione a hermetic painter, creating enigmatic variations on obscure themes. It would seem, rather, that (as Venturi has claimed in his rebuttal of Hartlaub's thesis) he was the first painter to dispense with a subject, that is to say the first of all modern painters. It is easy to imagine the contrast between Giovanni Bellini, who had never in his life created a work which had not been commissioned in advance, and his independent-minded young pupil disinclined to paint for churches or monasteries, or to amuse his colleagues in the *scuole* with the kind of picture-books that Carpaccio was turning out at the time. Here was an artist impatient to express his feelings, thinking of painting in terms of a passionate quest for a new universe, the universe of the soul. He was fortunate to have the encouragement of a circle of aristocratic art

The *Venus of Urbino* is the first naturalistic nude in the history of painting. Giorgione, who inspired Titian's theme, had painted a goddess; Titian, on the other hand, posed a living woman in the pose of Giorgione's Dresden *Venus*.

a third of the canvas swallowed by shadow; as for the *Castelfranco Madonna*, in which he had to conform to current conventions, he adopted a pyramidal arrangement which was totally commonplace. The *Concert champêtre*, which is certainly his last work, is better balanced, but still forms juxtaposed compartments. Titian was to show a far greater facility in the distribution of planes and figures. What brings

lovers who bought his work, and when the connoisseur Marcantonio Michiel prepared his notes on Venetian collections in 1525 it was in the *palazzi* of the Vendramins, the Grimanis, the Veniers, the Loredans, the Corners and the Rams that he discovered Giorgione's paintings.

Here was a veritable revolution, a major turning-point in the history of painting: a picture ceased being merely an appendage to a monument, dependent upon a social structure for its existence; it became an autonomous object, a *work of art*.

This new concept of a picture as a glorious message springing straight from the depths of the soul also gave it scarcity value, and soon wealthy art lovers were vying with each other to acquire these unique objects at any price. On 25 October 1510, Isabella d'Este, Marchioness of Mantua, who was always on the lookout for precious objects to add to her collection, wrote to Taddeo Albano of Venice asking him to try to obtain for her a *Notte* (nocturnal scene) which she described as *molto bella e singolare*, and thought must be among the effects of 'Zorzo da Castelfranco'; as far as the price was concerned, she authorized him to pay any sum necessary, 'for fear that the work should be bought by someone else'. This proves that Giorgione did not work to order, and that there were pictures in his studio for sale. Isabella, who had been frustrated in her repeated efforts to obtain a picture from Leonardo da Vinci, had no better luck with this *Notte*; we know from Taddeo Albano's reply that there were two pictures, but that neither of these was available. However, he may possibly have negotiated successfully for the *Concert champêtre* on her behalf, since that painting was later in the collection of the Gonzagas of Mantua.

The vague nature of the landscapes in Giorgione's paintings adds weight to the argument that he is a 'pure' painter, that is to say, one who seeks to fulfil his inner yearnings by composing pictures in which he is not obliged to interpret a given theme. Only the *Tempesta* lends itself to description, and even here the enumeration of its constituent details is soon exhausted (supporters of the thesis of hermetic intention have tried to see in it the four elements), whereas the elements that make up the topographical universe of a picture of Bellini's such as the *St Francis* (New York, Frick collection) are endless. The landscapes of the *Three philosophers*, the *Concert champêtre* and the *Castelfranco Madonna* are so featureless that they cannot be related to any actual site, and the fairly precise landscape of the *Sleeping Venus* is by Titian. For Giorgione, nature is not a spectacle unfurled for the eye's contemplation, and he avoids depicting panoramic landscapes; from his vantage-point in a single meadow, whose small space surrounds him, he creates the 'motif', the unified subject, as painted by the modern landscape painter. Since for him nature is one and indivisible, it can be perfectly expressed in any single one of its aspects, in a small corner of the Venetian countryside where he was born, for instance.

At one time, Giorgione was hailed as the first artist to paint the *tramonto*, the hour tinged with the sadness of the setting sun, described by Aretino and so dear to Venetians, especially Titian. This opinion was based upon the *Concert champêtre*, but its twilight shadows were in fact the product of the progressive discoloration of the glazes, and the cleaned surface eventually revealed full daylight. The landscape of the *Castelfranco Madonna* is imbued with the clear light of morning. And in the *Three philosophers*, the sun is rising, not setting.

Until Bellini's time, painting had been a search for harmony between God, man and the world, but for post-Bellini Venetians the dialogue was reduced to the last two terms. Giorgione transformed painting into the expression of an emotion, the confidential message of a soul. The beauty of the *Concert champêtre* has tended to draw attention away from the essential peculiarity of this themeless picture. It would be difficult to attribute any symbolic meaning to this gathering of nudes and young musicians disporting themselves freely in natural surroundings. Yet this is a unique instance in Venetian painting. Although attempts have been made in the past to attribute the *Concert champêtre* to him, Titian never painted so *gratuitous* a picture: the Bridgewater House *Diana and Callisto*, which might be considered similar, symbolizes the three ages of man, while the three Ferrara *Bacchanals* are evocations of the golden age. Titian is in fact a true theme painter, an 'illustrator' seeking motivation for his inspiration in a literary subject. Palma Vecchio was the only Venetian to imitate Giorgione, and the clumsiness of his efforts are only too apparent in his *Concert champêtre* (Uffizi). Giorgione's whole concept was so modern that it inspired Manet three centuries later. The enigma of the *Concert champêtre* is the enigma of Giorgione himself: in its magnificent isolation, this work, certainly the last that the artist completed, is his supreme message.

During the sixteenth century, painting in the north of Italy was fed by the two contrary streams of Giorgionism and classicism, but all these currents can be traced back eventually to Giorgione. If he had never lived, it would have fallen to Titian to lead the rebellion against the heritage of Bellini, and himself invent the free handling which abandoned the definition of forms in favour of a subtle moulding

of shades of expression. In the event, it sufficed for him to borrow this handling from Giorgione and develop its possibilities, although along the lines of a different creative method. As with Giorgione, his primary concern was painterly quality, but he differed in that he first carefully led up to the work itself through a whole series of drawings; in this way, while using a visibly improvised handling, Titian in fact progressed unerringly towards a meticulously calculated composition. Throughout his long life he never ceased to multiply the resources of this free handling, incorporating extensively into his pictures blends of colours which have, unfortunately, lost their true values over the years. Titian also owed to Giorgione the sense of intimate harmony between man and nature which favoured the expression of his sensuality and which allowed him, for example, to evoke the twilight in the *Entombment* (Louvre) simply through its reflection on the faces of the participants. Furnished with all these techniques, he became the poet of Venetian painting, creating forms derived from the contemplation of pagan or Christian literary sources. Up to the moment when, in extreme old age, a new fire began to course in his veins, he always remained centred on this art of averages that depended upon a harmonious relationship between the artist and his social surroundings.

Without going as far as Berenson, who called Titian the Augustus John of his time, one can say that he preceded van Dyck (who was greatly influenced by him) in the role of the aristocracy's favourite portraitist, eager to furnish a flattering image of his sitter; no one excelled him in expressing the soul of Venice with its voluptuous inclinations. The three Bacchanal paintings, commissioned by Alfonso d'Este, Duke of Ferrara, for his alabaster chamber, contain a sensuality which bursts out like a fanfare at the beginning of Titian's career; but this freedom in fact justified itself as an evocation of antiquity. Similarly, the *Feast of the gods* which Bellini painted for the same room, and the landscape of which was later repainted by Titian, derived the inspiration for its scenes from Ovid, Lucian and Philostratus respectively. This expansiveness of a life without restraints was the prerogative of the gods, not mankind, and was situated in a world of myth rather than reality. Titian showed far greater boldness when he painted the picture, incorrectly called the *Venus of Urbino* (*pl. 91*), which in 1538 in a letter from Guidobaldo II of Urbino is designated simply as a 'nude woman'. This was the first time that a woman had displayed her naked charms to a painter without the pretext that she was simply there to conjure up the beauty of some immortal in the artist's mind. Here we are entering the world of

93 Giovanni Girolamo Savoldo
(c. 1480–after 1548). *Man at arms*.
Paris, Louvre.

The bold composition of Savoldo's
Man at arms is doubtless inspired by
a lost picture by Giorgione,
mentioned by Vasari.

modern painting; this nude study, which does not represent Leonora, Duchess of Urbino, as was once thought, but, as the duke's correspondence establishes, a studio model, initiates a long line of descent that passes through Velázquez, Boucher, Fragonard and Manet, to end with Renoir.

Classicism had hardly begun to establish itself at Rome, in the pontificates of Julius II and Leo X, when a reaction against it began to set in. The most astonishing aspect of this reaction is that Raphael himself anticipated it in the last Stanze of the Vatican. In Florence, this ferment was already brewing in 1520. In northern Italy, though, the

situation was more complex. There, anticlassicism did not have the character of a reaction, since its first vigorous impulse was synchronous with the classicism whose principles were established by Titian in Venice itself; it was, rather, a spontaneous movement which sprang up in the provincial schools of Brescia, Cremona and Ferrara, and which in many ways foreshadows romanticism. The precocity of this form of romanticism is all the more remarkable if one thinks that already in 1521 Moretto and Il Romanino were commissioned to paint the chapel of the Blessed Sacrament in San Giovanni Evangelista at Brescia, and that in 1520

the administrators of the cathedral of Cremona cancelled their contract with Il Romanino, so that the decorations for the dome should be completed by the extravagant Pordenone, whom they considered more 'avant-garde'.

This romantically oriented movement has been called 'Giorgionesque', although attempts have also been made to discover local roots for it, especially in Brescia, and so to identify a 'pre-Giorgionism'. The idea of a link with Giorgione rests mainly on a certain form of portrait, with a melancholy expression, which was supposedly inspired by a few figures formerly attributed to Giorgione but now generally considered to be copies of lost originals. But even if one were to make an exception in the case of the Brunswick portrait, and treat it as a faithful image of a lost portrait of Giorgione, it would still remain a very fragile base upon which to erect this whole edifice. What is more probable is the Giorgionesque derivation of the romantic interpretation of landscape indulged in by Savoldo and Dosso Dossi, for all the painters in and around Venice must have been struck by the novelty of Giorgione's particular feeling for nature.

As regards the question of whether Giorgione may be considered the inventor of chiaroscuro,

94 Giovanni Girolamo Savoldo. *Flute-player*. Florence, collection Contini-Bonacossi.

To plunge the face in a portrait in semi-darkness, as a way of expressing the mystery of the soul, was a singularly audacious notion at that time.

nothing in his extant paintings lends weight to such a supposition. We have, it is true, documentary evidence that he painted two *Notti*, one of which was so fine that, after his death, Isabella d'Este made every effort to obtain it. On the other hand, it has been pointed out that in the sixteenth century the term '*Notte*' applied to this kind of picture always designates a Nativity, whether it is a night-piece or not. It has even been suggested that Giorgione's *Notte* might be the Allendale *Nativity* now in the National Gallery, Washington, in which the lighting effect is of broad daylight. As far as present historical knowledge is able to determine, the two earliest *tenebrosi* pictures in Italy are by Savoldo and Il Romanino; their great originality lies in the fact that, whereas in Correggio's *Notte* (about 1530) and two other night-pieces by Savoldo the illumination is a supernatural light emanating from the Infant Jesus, in these two pictures the lighting is produced by an artificial source. They both represent the apostle St Matthew visited by the angel and writing under his inspiration, either by the light of an oil-lamp (Savoldo's version, in the Metropolitan Museum) or a candle (Romanino's version, in San Giovanni Evangelista). Raphael had used chiaroscuro in his composition at the Vatican depicting St Peter delivered from prison (*pl. 72*), where a supernatural light emanating from the angel floods the whole prison, while outside the soldiers are lit by their own torches in a moonlit landscape. But the chiaroscuro of Il Romanino's *St Matthew* (*pl. 92*), as also that of Savoldo's picture, is of a quite different nature: the feeble glimmer of the lamp or the candle produces a complex play of violently contrasted lights and shadows which expresses the pathos of the inner life, as in the nocturnal scenes of the followers of Caravaggio. Indeed, there is such a family likeness between Il Romanino's *St Matthew* and the first St Matthew painted by Caravaggio for San Luigi dei Francesci, Rome, that it seems hardly possible that the latter should not have seen the earlier composition. The theme of the apostles, ordinary humans trans-figured by the Holy Spirit, was to become one of the favourite motifs for seventeenth-century artists concerned to evoke the depths of the human soul. The paintings created by Il Romanino on the four pendentives of the cupola of the chapel of the Blessed Sacrament at San Giovanni Evangelista constitute the work of a genuine precursor.

The situation in the provinces was particularly favourable for avant-garde painting. The history of painting abounds in examples of provincial artists inhibited neither by the dogmas nor the traditions laid down in the great art centres. These blind creators often showed greater foresight than the masters who lent their lustre to the schools. An imagination unbridled by conformist patterns, a hand never subject to automatism, a blissful ignorance of technical rules, sometimes combined to produce artists of genius who instinctively anti-cipated future developments despite the apparent disadvantage of isolation.

In antiquity, classical aesthetics, although reign-ing supreme in the large cities, gave way, in the outer limits of the Roman world, to a feeling for forms which constituted a profound influence in the formation of the sculptors, and anticipated that of the Middle Ages. In a later age, while the learned speculations of official theological art held sway in Byzantium, monks in the rock-monasteries of Cappadocia, caring little about dogma and follow-ing their inclinations in their paintings, evolved an emotionally charged religious idiom which became known to the West through intermediaries and pro-vided inspiration for the artists of the Dugento and Trecento. In the extraordinary creative ferment of the Renaissance, Italy, the country most subject to the orthodox rule of the established schools, nevertheless offers us examples of provincial painters whose work was created without reference to tradition despite the fact that they sometimes lived in the immediate vicinity of a great centre. Within more or less easy reach of Florence or Venice there were 'provincial' centres in which painters gave free expression to their temperament.

The Lombard Duchy of Brescia, conquered early in the fifteenth century by Venice, had been a war-like city famous for its arsenals, and still knew how to bear arms when occasion warranted. By the sixteenth century, it was no longer one of those places in which history is made, but it continued to dream of past glories, and Il Romanino painted on its walls plumed warriors who, with all their swashbuckling airs, betrayed some sense of un-easiness. To have one's portrait painted in Venice by Titian was a guarantee that it would radiate health and serenity, whereas a Brescia painter would bring some inner torment to the surface. The painter most faithful to the spirit of Giorgione was the Brescian Savoldo. In his *Man at arms* (*pl. 93*), reflected in a play of mirrors, he was certainly imitating a picture by Giorgione described by Vasari and now lost. The people Savoldo shows us seem lost in thought, plunged in an anxious and heartfelt self-questioning. The *Flute-player* (*pl. 94*) may be listening to the last echo of his instrument or else dreaming of as yet unplayed melodies; his face is half in a shadow, a boldness which Titian, whose models expected their likenesses to be well

lit, would never have got away with. The figure is swathed in a soft, fine, ash-grey shadow which colours the face, explores the greys of the fur and caresses the delicate hands.

It is difficult to tell whether a picture such as the *Flute-player* was done as a portrait or simply for the artist's own pleasure, as must have been the case with the *Peasant*, who had obviously not commissioned it. In any case, it seems extremely probable that, apart from the works he completed for the great and for churches, Savoldo painted for the sake of painting, in the spirit of Giorgione; Titian, pre-eminently the 'painter of his age', never permitted himself this luxury. Savoldo was far more interested than Titian in experimenting with colours. The intensity of Titian's colours is flattened by their fusion in a tonal unity; the true colourists, Lotto and Savoldo, were outside Venice, outside Titian's orbit, at least, and it would seem to be from these that Veronese was to derive the brilliance of his colour. Savoldo's work shows his fondness for unusual colours: blue-greys, silvery greys, garnet-reds, pinks, pure whites, deep blacks, greenish blues, purplish violets, oranges, bright yellows. On one occasion, in the *Mary Magdalen approaching the Sepulchre* (*pl. 96*), he produces a great burst of violent yellow which drenches the whole picture: such a bold stroke was not to be repeated again until the advent of Tiepolo. Usually, though, what unifies all his colours and prevents them from being discordant is a chiaroscuro which envelops them in a soft shadow, or sometimes adulterates all the tones by converting them into the hues of a night-piece, thus anticipating El Greco's effects. Savoldo was, indeed, an extraordinary precursor, anticipating not only El Greco, but also Veronese, Caravaggio, Tiepolo. To this list one might add Bassano, whose landscapes he foreshadows in his liking for rustic settings; he must have been the first to include the portrait of a farmhand in a picture; and in his *Nativity* he gives St Joseph the furrowed features of a man of the people.

Although Savoldo knew what was going on in Venice, having worked there on several occasions, he did not allow himself to be diverted from his purpose. Moretto, on the other hand, wavered between a belated Bellinism and the seductions of Titian, although these proved rather too sophisticated for his provincial timidity. But he loved the subtle hues of Brescia, especially the greys. The soul of Brescia came alive in his portraits, in which, as in certain portraits by Savoldo, the hands are open and stretched out towards the spectator, as in expressionistic portraits of the baroque era.

Il Romanino, who worked at Brescia, Cremona

95 Pordenone (*c.* 1484–1539). *The Conversion of St Paul.* Spilimbergo, Cathedral.

Breaking away from classicism, Pordenone was the first artist bold enough to 'break' the surface of his painting by making the figures seem to be moving towards the spectator.

and Trent, was avowedly provincial and brashly self-confident. Whether fresco or oil, each painting was for him a bravura piece in which he sought to astonish, by any one of a number of means: indifference to the subject, off-handedness, not to say impudence, the use of airless compositions packed with human figures, squat bodies surmounted by bullet heads, slipshod treatment, exaggerated foreshortening, caricatured expressions. His *Last Supper* (church of Montichiari) accumulates two clusters of unprepossessing characters. And yet, to show off his knowledge, he painted one of the most beautiful still-lifes that Italy has produced, a composition that can stand comparison with the best seventeenth-century Dutch work in that idiom.

The proud city of Cremona, prosperous thanks to the fertility of the surrounding countryside, was too far from Venice to arouse her cupidity, and tended

96 Giovanni Girolamo Savoldo. *Mary Magdalen approaching the Sepulchre*. London, National Gallery.

In this picture Savoldo has painted a Venetian woman dressed up as Mary Magdalen, and invented a bold use of colours that was later imitated by Veronese and Tiepolo.

ing eight frescoes, he was replaced in 1517 by Altobello Melone, another Cremonese painter who 'thawed out' the Bellinesque immobility and brought to graphic language a new freedom which Il Romanino was to draw upon when he took over the project in 1519. This was Il Romanino's first important commission, and in the four frescoes of the Passion which he painted in the nave he indulged in every whim that his imagination could conjure up, filling the compositions with the extravagant costumes of which he was so fond. But this did not seem audacious enough to the people of Cremona, and in August 1520 the cathedral's newly appointed administration grievously wronged Romanino by cancelling the contract that their predecessors had made with him. They replaced him with Pordenone, whom they qualified as a *magister summus et pictor excellentissimus* (supreme master and most excellent painter), and from whom they expected miracles just because he had been to Rome.

Emboldened by this expression of confidence, Pordenone took every conceivable artistic liberty, and turned the cathedral into a veritable experimental laboratory for his spatial and expressionist researches, filling the dome with frenzied crowds and convulsive figures. These innovations must have proved perfectly acceptable to his patrons, since a bill of payment to him qualifies him as a *magister modernus*. Without a question, the avantgarde was in favour in Cremona!

Pordenone anticipated Caravaggio by sixty years, resembling him in his life as well as in his art. He appears to have been a violent man, and ready to cross swords at the slightest provocation. While at Venice, he is supposed to have incurred the enmity of the all-powerful Titian, for daring to enter into competition with him to win a commission from the doge, and actually winning the commission; after that, while painting at Santo Stefano there, he always kept a sword and buckler within reach. Although this story may be apocryphal, it fits in with what we know of his character from legal documents of the time. When his father died in 1533, he sued his brother Baldassare over the division of the inheritance. He was denounced by his brother for having abstracted some of the unapportioned goods, and after the ensuing brawl Baldassare lodged a complaint against Giovanni Antonio, with the Podestà, for having tried to lure him into an ambush. Pordenone's name, like that of Caravaggio, must have featured frequently in police reports. He came to a miserable end, under circumstances similar to those that attended, later, the death of Caravaggio, dying alone of a mysterious illness, in

to gravitate in the orbit of Milan, where an insipid Leonardesque manner still prevailed. Cremona's success in resisting this tendency was doubtless due to the fact that she had been exposed to the eccentric influence of Ferrara. At the beginning of the sixteenth century, her school of painting had provided the meeting-point for various different tendencies which the cathedral's decoration emphasizes. Boccaccio Boccaccini, born in Ferrara of Cremonese parents, started work on it in 1514, in a spirit inspired by Peruginesque and Raphaelesque classicism, though not without bringing to these influences a personal accent that presaged the Emilian charm of his later work (*Nativity of the Virgin*). After paint-

97 Il Romanino. Landscape, detail of *The Visitation*. Brescia, Cathedral.

a Ferrara inn. He was probably poisoned; at least, that was the opinion of the dismayed duke who had invited him to Ferrara.

Pordenone was among the first painters to break down the barrier separating the spectator from the actors. Well before Caravaggio – in 1520 in Cremona, in fact – he directed the movements of his figures backwards, and in the *Christ nailed to the Cross* not only pointed the foot of the Cross towards the faithful but made it protrude beyond the cornice which edges the picture, while one of the thieves, his hair gripped by a soldier, is teetering in space, one arm hanging down over the same cornice. In the *Crowning with thorns*, a horseman is depicted as

though in the process of springing into the nave; and the artist repeats this leap into space in an even more audacious manner in the *Conversion of St Paul* in Spilimbergo Cathedral (*pl. 95*). In the Scuola San Rocco, Venice, he hurls down on us the infirm who are supposed to jump into the *Pool of Bethesda*; the pool itself, rather than being painted, is suggested in the space between the spectator and the picture.

Even Caravaggio never went so far as Pordenone in producing effects of foreshortening seen from close up. There is, too, an aggressive quality in Pordenone which forces the spectator to take part in the confused mêlées he sets in action on the inner

In painting this fragment of nature, Il Romanino seeks to communicate an impression rather than to describe.

98 Dosso Dossi (*c.* 1479–1543). Detail of *Apollo and Daphne*. Rome, Galleria Borghese.

Dosso Dossi paints wild visionaries, such as this Apollo, which is as different as it could be from the serene figure of another violin-playing Apollo, that depicted by Raphael in the *Parnassus*.

99 Dosso Dossi. Landscape, detail of *Circe*. Florence, Uffizi. ▶

Dosso Dossi's views of nature, outlined boldly in a splash of touches of colour, are mirages rather than landscapes; they foreshadow Rembrandt's dream landscapes.

100 Dosso Dossi. *St John the Baptist*.
Florence, Pitti.

This spectral image of *St John the Baptist* is doubtless a self-portrait of the artist.

walls of churches. The spectator ceases being a witness and becomes an actor in these battles of vagabonds; they are compulsively lifelike, because Pordenone went down to the slums to find his models, and re-created their violence in his hasty treatment, his slapdash drawing and his sketchy Daumier-like relief. On the wall of the façade of Cremona Cathedral, a colossal fresco showing a yelling mob in an apocalyptic storm turns out to be a *Crucifixion* acted out by footpads. All the participants in this drama, from the Christ to the thieves, from the holy women to the soldiers, are persons possessed. This vision of horror is all the more extraordinary if one bears in mind that by this date Michelangelo had not yet painted the *Last Judgment*. At Rome, Pordenone could only have seen the calm visions of Raphael or the intensely moving monumental frescoes of the Sistine ceiling.

Although the sheer power of biblical fervour emanating from the Sistine Chapel must have had an enormous effect in liberating this simple provincial from the constrictions of the style of Bellini, the sight of German engravings must have played some part too. These engravings had had such a success in northern Italy that Dürer journeyed to Venice specially to prevent his own from being counterfeited.

On the dome of the Malchiostro Chapel in the cathedral of Treviso, Pordenone imitated Michelangelo by painting the Creator of the world. But, with a boldness that was to remain unparalleled until the advent of the eighteenth-century Italian and German ceiling painters, he suggested movement by shifting the composition off-balance, propelling the cherubs towards one side of the concave surface. He repeated this composition, later, in the Franciscan church at Cortemaggiore, and here the group of cherubs comes tumbling down over the edge of the cornice in the direction of the altar picture which depicts the Immaculate Conception. In both these domes, the sky seems literally to be tipping over on to the earth. Pordenone is the first painter to have filled the enclosed space between a church's outer walls by projecting images beyond the partition-walls on which they are painted, thus creating that life of forms in space which the baroque art of the seventeenth and eighteenth centuries was to rediscover. This animation of the interior through mural decoration was later to be controlled by the baroque painters as though they were harmonizing a ballet or concerto; but Pordenone achieved the effect in terms of confusion and anarchy. One cannot but admire the sheer power of imagination that drove this passionate artist to launch himself upon his frescoes at Cremona Cathedral at the moment

in time when Raphael was breathing his last, and when, in neighbouring Ferrara, Titian was just completing, in the *camerini d'oro*, his voluptuous visions of the golden age.

Dosso Dossi had also had a part in decorating these *camerini d'oro*, having collaborated with Titian in painting the *Feast of Cybele* there. This is one of Dossi's only two classical works, the other being *Circe* (a theme he treated twice: Uffizi, Florence, *pl. 99*, and National Gallery of Art, Washington). The unfounded suggestion that Ferrara's spirit of rebellious independence had died with Cosimo Tura and Ercole Roberti was disproved, not only by Lodovico Mazzolini (died before 1530) with his *Massacre of the Innocents* (Uffizi), but by Dossi himself. Perhaps it was his love of parallels that inspired Vasari to provide Dossi with the same year of birth as Ariosto: there is no doubt that the two were twin geniuses, in any case. The epic of *Orlando furioso*, which has continued to fire the imagination of painters including Delacroix, was born in the court of Ferrara, with its poetic, dream-like atmosphere. It would be fascinating to know how it came about that the ancient magical world dear to the Celts achieved expression in this city of the Renaissance: there is no more astonishing literary creation than this poem in which farce alternates with tragedy; in which the heroes fight and struggle surrounded by the powers released by wizards, or in thrall to enchantments woven by the sorceresses who are their lovers; in which the living and the inanimate constantly exchange their forms; in which Roland, the wisest of knights-errant, pursues love fruitlessly while sowing it along his path, and finally loses his reason. A topsy-turvy world, where mirage succeeds mirage in an endless chain, where the very concept of man breaks down in the seething swirl of a nature in perpetual creative gestation.

It is the reflections of this poetic world which illuminate with their lightning flashes Dosso Dossi's strange pictures. We know little about the man himself, except that his sense of the bizarre was not always appreciated, if we are to believe the story of his setback at the Este palace, where Girolamo Genga is supposed to have gone so far as to have Dossi's frescoes obliterated. Apparently he was on bad terms with his brother, Battista, although the latter collaborated with him on most of his pictures. Even in his run-of-the-mill religious pictures, he made every effort to adapt the required details to his whims; but without any doubt he preferred court-commissioned secular pictures, in which his imagination had freer rein. Some of these themes were clearly inspired by a poet: *Jupiter, Mercury and Virtue* (Vienna), for example, the *Nymph Calypso*

(Galleria Borghese), the *Departure of the Argonauts* (Washington), and the doubtful mythological subject known as *Antiope* (Marquess of Northampton). Dossi painted the magician Circe twice, the first time sweet and simple as a Giorgione nymph, the second time, ten years later, a figure fully conscious of her power. His most expressive painting is undoubtedly the *Apollo and Daphne* (*pl. 98*); its divine violinist could not be more distant in spirit from the peaceable musician who conducts the singing and dancing of the Muses in Raphael's *Parnassus*. Brandishing his bow, the delirious Apollo conjures up on the horizon impetuous storm winds from which a puny figure of a woman, usually considered to represent Daphne, is fleeing in terror. Set off by brilliant splashes of colour, Dossi's landscapes reveal to our eyes a russet ground burnt by the passage of some meteor, or hovering in the mists of a dream, like the landscapes of Rembrandt. In the midst of these enchanted castles and blazing forests, lit by the blood-red rays of the setting sun, live a hazily defined race of people born of water, fire, tree or wind, ready at a single wave of the magician's wand to revert to the elements. With his portraits, Dossi occasionally makes a real effort to follow the model, but at other times he seems to have re-created one of those dream beings who inhabit his distant provinces. It is perhaps not unduly fanciful to imagine that his own face may be reflected in that of the *St John the Baptist* whom he painted twice, a spectral countenance with melting features which seem ready to fade away altogether, so faintly are they delineated on the canvas (*pl. 100*).

Among all the painters of this period, Dosso Dossi is, with Savoldo, the one whose affiliation to Giorgione is the most evident. Savoldo's figures are clearly members of the same family as the saints of the *Castelfranco Madonna*. For his part, Dosso Dossi derived his feeling for landscape from the *Concert champêtre* and, even more, from the *Tempesta*. He sensed the impulse, common to man and nature, that quickens Giorgione's paintings, but he went even further: in his landscapes (*pl. 99*), man abandons his soul to nature. Lost in an evolving cosmos, man is reduced to the status of a furtive apparition, condemned at the very moment of his birth.

Thus, *giorgionismo* dissipates the mystery around Giorgione at the same time that it proves his worth. During his short life, the master of Castelfranco fashioned the most profound of all truths, that of the soul as prime mover. All the painting accomplished in Venice and within Venice's field of influence radiated this truth for a long time to come.

101 Albrecht Dürer (1471–1528). Arco, detail of *Mountain landscape*. Paris, Louvre (Cabinet des Dessins).

8 Northern humanism

The German Renaissance was anticlassical. Politically and spiritually, it expressed itself through the Reformation which divided the Church with its proclamation of the rights of God as against those proclaimed by humanism. The first quarter of the sixteenth century, which saw Luther's revolt, was also the period during which German painting sparked into a brilliance which very soon burnt itself out and was not to be revived until our own century.

In his eagerness to assimilate the Renaissance, Albrecht Dürer attempted vainly to squeeze through the strait gate of forms and principles the immensity of the German soul with all its repressed desires, for which the only outlet hitherto had been an often confused mysticism. The Germanic need to embrace the world in its multiple aspects was stimulated by the phenomenological spirit of the Reformation, which brought back to earth human curiosity about the Beyond.

In order to remain master of the hunger for knowledge that devoured him, Dürer tried to make himself as objective as Leonardo, whom indeed he resembled in many ways; but, unable to assuage this fever, he ended up as a Faust, filled with a deep yearning for the infinite. Like Leonardo, he perfected a marvellous analytical instrument with which to carry out his experiments: drawing. Drawing had been an indispensable auxiliary for the painter's researches since the end of the fifteenth century, but its significance as a method for Dürer was the opposite of what it had been for Leonardo or Raphael. In his preliminary sketches, Leonardo stylizes the impression of the real or the flow of thought, while Raphael is able, with a few strokes of the pen, to project on to paper the rhythm of the form his mind has envisaged: this manner of drawing, intended to express a form in its unity by means of a single flowing line, postulates a pre-existing idea. Dürer's procedure, on the other hand, is one of pure analysis (*pl. 102*). Confining himself to the object, he first reproduces the appearance of one of its terminal points, then proceeds by degrees until each segment has been brought forward to constitute a whole; the form which presents itself to his eyes is broken down into its articulations,

explored in its various facets, reduced to the state of a skeleton, and endowed with an astonishing but essentially soulless verisimilitude. During the nineteenth century, van Gogh was to practise the same style of drawing. It is only the watercolours, in which Dürer notes down travel impressions (*pl. 101*), or sketches features of some animal or plant, that retain a spiritual quality not yet sterilized by analysis.

Drawing, which for the Italians had remained a means, was transformed by Dürer into an end in itself. By transferring the image to wood or copper

With lines as violent as strokes of a whip, Urs Graf flagellates the pitiful victim who may perhaps be Christ.

104 Nikolaus Manuel Deutsch (1484–1530). *Death disguised as a soldier embraces a young woman*. Basle, Kunstmuseum.

This soldier-painter had no compunction in deriding the idea of death by depicting it in terms of violently erotic gestures.

by engraving, he assured it a distribution as extensive as that which printing was simultaneously providing for human thought. The engraving process liberated Dürer from all the petty restrictions that working to order imposed upon him in his painting; in this new medium he was free to express his aspirations in objects possessing an excellent commercial value. Engraving was so much an autonomous art for him that, to celebrate the glory of the Emperor Maximilian, he raised a triumphal arch which consisted of ninety-two printed woodcuts and was over eleven feet high.

Dürer's virtuosity in handling a gouge or a burin has never been equalled. Although in the woodcut his line is synthetic, in copper engraving it lends itself ideally to the exploration in depth and the enumeration of the infinite which haunted him so. It was this latter medium that he chose for expressing his philosophical thought (*Nemesis, The Knight, Death and the Devil, St Jerome, The Sea Monster and the Prodigal Son, Melencolia, Adam and Eve*), while the woodcut served him for the speedier production of the religious series which sold so well.

Dürer proved that black and white had just as many resources at its command as colour. His engravings earned him world-wide fame during his lifetime, and remained models for the future, especially the copper engravings in which the line is more modern, less Gothic, than in the woodcuts. Rembrandt was greatly in his debt.

The marvellous tool created by Dürer to allow him to carry out his methodical investigations served others to explore the realm of the imaginary. Albrecht Altdorfer and Wolf Huber produced convulsive landscapes which spring up in a sort of pyrotechnic display of lines. The boldness of the linear composition in the engravings of Urs Graf and Nikolaus Manuel Deutsch redeems the otherwise intolerable realism of their licentious images. These two Swiss painters took part, as mercenaries,

in the Italian wars, Deutsch as a field clerk, Graf as a soldier, and seem to have retained from their soldiering the feeling that the whole world is depraved. Their drawings describe the life of the foot-soldier, his bragging and indiscipline, his coarse manners, his cruelty (*pl. 103*), his encounters with love and death (*pl. 104*). The work of these two represents the first echo in art, since Hieronymus Bosch, of a feeling of revolt against human idiocy.

However, when Dürer took up a paintbrush it would seem almost as though his inspiration froze. Avant-garde in drawing, he remains archaic in his painting, in which the predominant influence remains Bellini, through whom, in fact, he first discovered the Renaissance. His paintings are the exact opposite of his engravings: the teeming world of his woodcuts and engravings suddenly congeals when interpreted in colour. This man, capable of including the infinite in the few square inches of a plate, in his paintings succeeds only in producing juxtaposed images painted in strident colours which make them clash violently rather than blend together. Even the prodigious visions of the universal contained in the *Nemesis* (*pl. 105*) or the *Small Passion* are transformed into a somewhat inert landscape background. This failure is nowhere more apparent than in the *Martyrdom of the Ten Thousand*, a seething composition coiled in upon itself like a form which has failed to erect itself in space. His finest picture is the 1511 *Adoration of the Trinity* (*pl. 106*). At the same moment as Raphael, he conceived the idea of a composition in space being arranged like a floating ring seen in perspective in depth. But whereas in Raphael's fresco, the figures are actors playing to the spectator, in Dürer's picture their thoughts and their faces are turned towards God; there is even a promise, in this painting, of the soaring grace of the baroque and rococo ceilings of eighteenth-century Germany.

Painting is fluid, and made to unify matter. Drawing separates matter. Dürer's obsessive anguish, resulting from an inhibition of the faculty of attraction, found in drawing an outlet which painting refused. In his immediate circle, the gift for painting flourished among masters of more modest ambitions. Even if Lucas Cranach, with his belated style, was basically an image-maker, the profound romanticism of the German nature inspired certain other artists, especially Albrecht Altdorfer, Wolf Huber and Grünewald, with a creative power that allowed them to break through the constraints which paralysed Dürer. A new feeling for nature flourished among the painters of the Danube school, Altdorfer and Huber, a vision of subjective nature which was able to express the soul's impulses

105 Albrecht Dürer. *Nemesis*.
Engraving on copper. Paris,
Bibliothèque Nationale.

By means of line alone, Dürer
creates an imposing universe which
seems somehow to be dominated by
the absurd.

106 Albrecht Dürer. *The Adoration of the Holy Trinity*. Vienna, Kunsthistorisches Museum.

With its hovering figures making a semicircle facing the front of the picture, this composition constitutes a bold spatial vision.

107 Wolf Huber (*c.* 1490–1553).
View of Feldkirch. Pen-and-ink
drawing. Munich, Alte Pinakothek.

(Stimmung) in terms of paint, and thus bring it closer to the spiritual essence of things. This fusion was achieved through light, an iridescent light in permanent process of transformation, passing ceaselessly from shadow to brightness and from brightness to shadow, moulding beings and things alike, enclosing them in the same living tissue, making them participants in the same drama. Although Altdorfer's artistic output consisted mainly of altarpieces, together with a few more personal pictures, including pure landscapes (the first in the West), a chance commission resulted in his producing a painting which ranks with the Isenheim Altarpiece as the greatest masterpiece of German painting.

In 1529, Altdorfer executed for William IV of Bavaria *Alexander's Victory (pl. 109)*, which is now in the Munich Pinakothek. In contemplating this marvellous picture one calls to mind the words of Heraclitus: 'War has begotten the world, war reigns over the world.' The universe is a conflict of forces which create and re-create worlds, and man himself finds himself implicated in the perpetual flux of phenomena; the cosmos is a vast theatre in which man, activated by his own conflicts, makes history.

108 Albrecht Altdorfer (c. 1480–1538). *River landscape.* Pen-and-ink drawing. Budapest, Museum of Fine Arts.

Abandoning Dürer's strict objectivism, the graphic artists of the Danube school created visionary landscapes which expressed their pantheist feelings.

123

109 Albrecht Altdorfer. Detail of
Alexander's Victory (*The Battle of Issus*).
Munich, Alte Pinakothek.

No painting has ever contained a
greater expressive power than this
pictorial microcosm in which the
human drama takes place in the
context of a cosmic vision.

A vast plain, seen from a high mountain and bordered by the estuary of a great river, is filled to its edges by the massed forces of two rival armies. Nature seems to be associating itself with the human drama by staging a drama of its own, that of the sun setting behind thick clouds, while at the opposite side of the picture, the moon rises in the sky; the movements of the two heavenly bodies, representing the alternation between day and night, symbolize the unfolding of time, the cosmic time in terms of which the time of history is recorded. Even Bruegel never carried painting further in its creative capacity than does this universe-picture.

The Italians had created a rectilinear space – the world seen through the window of the human intellect – but the Germans preferred this hovering vision, which was already tempting a few Florentines at the end of the fifteenth century and had been adopted by Leonardo. One can almost see the globe, covered by its horde of murderous ants, rotating in front of one's eyes. Oil-painting, this mirror which van Eyck had invented, no longer reflects the calm, paradisaical visions so dear to the men of the Middle Ages, for whom the whole of nature was a garden; now, images of murder and glory are reflected in its limpid water, as though they had been conjured up by some sorcerer. Nature is no longer a thought emanating from God; being thought out by man, it has become the cosmos.

This vision should be correlated to the great geographical and cartographical movement which was just then refashioning the appearance of the earth. *Perspectiva artificialis*, rectilinear perspective, had been invented by city men used to the plunging vistas of streets. An alternative vision, as expressed in the work of certain Florentine artists such as Baldovinetti and Pollaiuolo in the second half of the Quattrocento, derives from a cartographical conception. The first maps showing the world in two hemispheres date from the end of the fifteenth century. The battle in *Alexander's Victory* is being fought over ground that represents a spherical projection, a portion of a planisphere, and when Altdorfer painted this picture in 1529 his was an absolutely original perception.

Twenty-five years later, this bird's-eye view, contemplating a projection of the earth's orography and planimetry, had become unexceptional. Bruegel spent part of his life in Antwerp, the most cosmopolitan city of the sixteenth century and at that time the great centre of mapmaking under the leadership of Mercator and Abraham Ortelius. The latter, the author of a *Theatrum orbis terrarum*, wrote proudly of his friendship for the man he called 'the greatest artist of his century', and it is not surprising, perhaps,

that in his paintings Bruegel drew inspiration from the art of cartography.

At the moment when Bruegel appeared on the scene, the Flemish school was mired in the endless complications of a crisis produced by the inability of painters to assimilate the new relations between space and figure that had been imposed upon them by the Renaissance. With the coming of Bruegel, all these problems were resolved as though by magic. He borrowed from Hieronymus Bosch a few elements of his symbolic system. But, more important, he revived Bosch's handling of paint, freeing colour from the obligation, imposed upon it by the Flemings, of serving strictly to complement form, and transforming it into a light fluid, circulating through all the parts of the picture like blood in an organism. Despite the frequently repeated claim that his short stay in Italy between 1552 and 1553 left absolutely no mark on him, the fact is that he gained from this visit something far more profound than the imitation of a style: he gained a principle. For there seems no doubt that it was the contact with Italian art that gave him the organizing genius to resolve multiplicity into unity. He achieved, in fact, what was later to be Cézanne's ambition: to be classic in terms of nature. In his majestic composition, *Winter (pl. 110)*, the line of four trees, following the same direction as the hunters, guides the onward movement of the space which the flight of a bird of prey is pursuing through the air as far as the distant mountains. This bird in space is sufficient on its own to defy the eye's attempt to calculate the immensity in which it is gliding. The gyratory composition of the *Land of Cockaigne*, inspired perhaps by the idea of the wheel of fortune, makes the men so real that we can almost touch them. The diagonal direction of the *Blind leading the blind* drags us down with them in their headlong fall, while in the background the tiered roofs of the calm village church teach us that the wisdom of the species withstands the folly of individuals. And then we are made dizzy, in looking at the *Magpie on the Gibbet (pl. 112)*, by the way the space swirls around the gibbet upon which is perched that legendary bird whose pranks are recorded in so many popular tales, transformed here into the point around which the universe revolves. In *The Bearing of the Cross (pl. 111)*, the event is dispersed over a vast plain until the details become blurred where the plain's distant reaches drop behind the horizon.

No painter ever explored space as thoroughly as Bruegel. In comparison, Rubens merely passed through space. Bruegel achieved a synthesis between the Italian vision of perspective and the innate Flemish predilection for large dimensions,

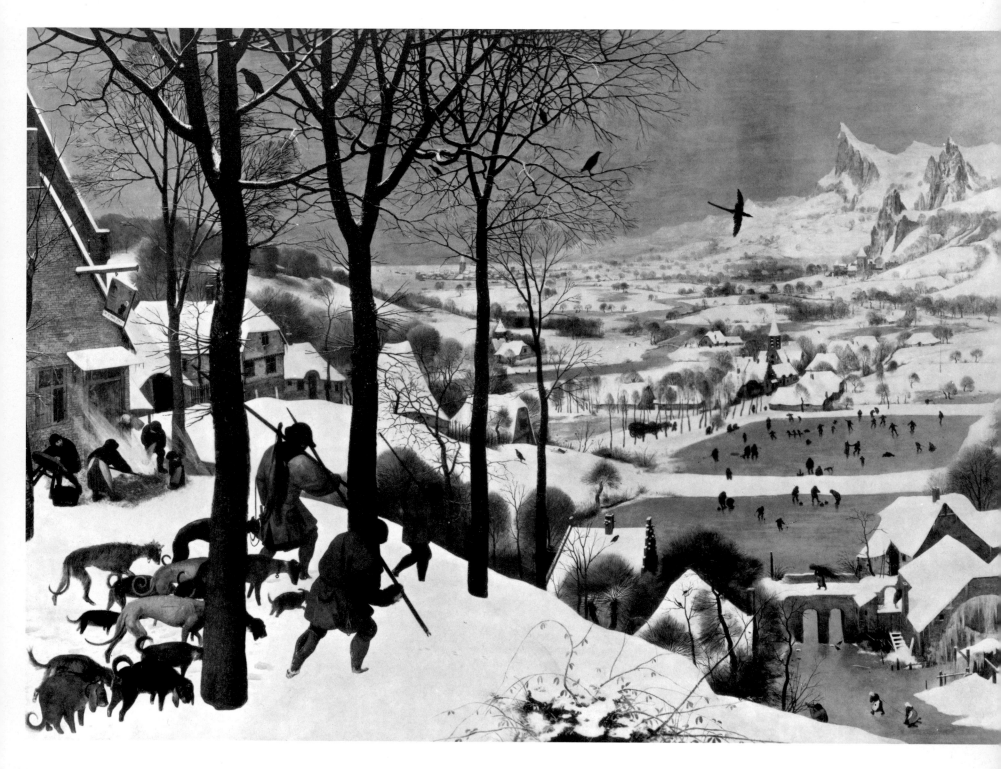

by blending broadness and depth in the vastness of a world of infinite perspectives. If one were to seek an appropriate emblem for Bruegel, it would surely be the eagle: alternately soaring through the air while the universe races away like a film beneath his wings, and swooping vertiginously down to earth to seize his prey. Perhaps no other artist has ever delved so deeply into the predicament of man, forced to witness the unfolding of his destiny on the surface of this earth while longing for deliverance from his terrestrial yoke. Even though confining himself within the borders of his provincial scene,

Bruegel retained the memory of the mountains and seas he had seen during his Italian voyage, and lived in his imagination through the great adventure which, during his lifetime, impelled men to cross oceans in search of new territories to conquer. He was neither a historian nor a moralist, but an anthropologist; he took as his subject for analysis the human phenomenon at its most elementary, at the point where it lies outside the scope of history, hoping that a study of the instinctual life of the common people would reveal something of the mechanism of human existence. Following a theory current

110 Pieter Bruegel (*c.* 1525–69). *Winter.* Vienna, Kunsthistorisches Museum.

Bruegel resolved the crisis of the mannerism which had enmeshed the Flemish school, by creating a universe the natural appearance of which conceals a profound strictness; he re-established the living relationship between figures and space which had been neglected by the previous generation of painters.

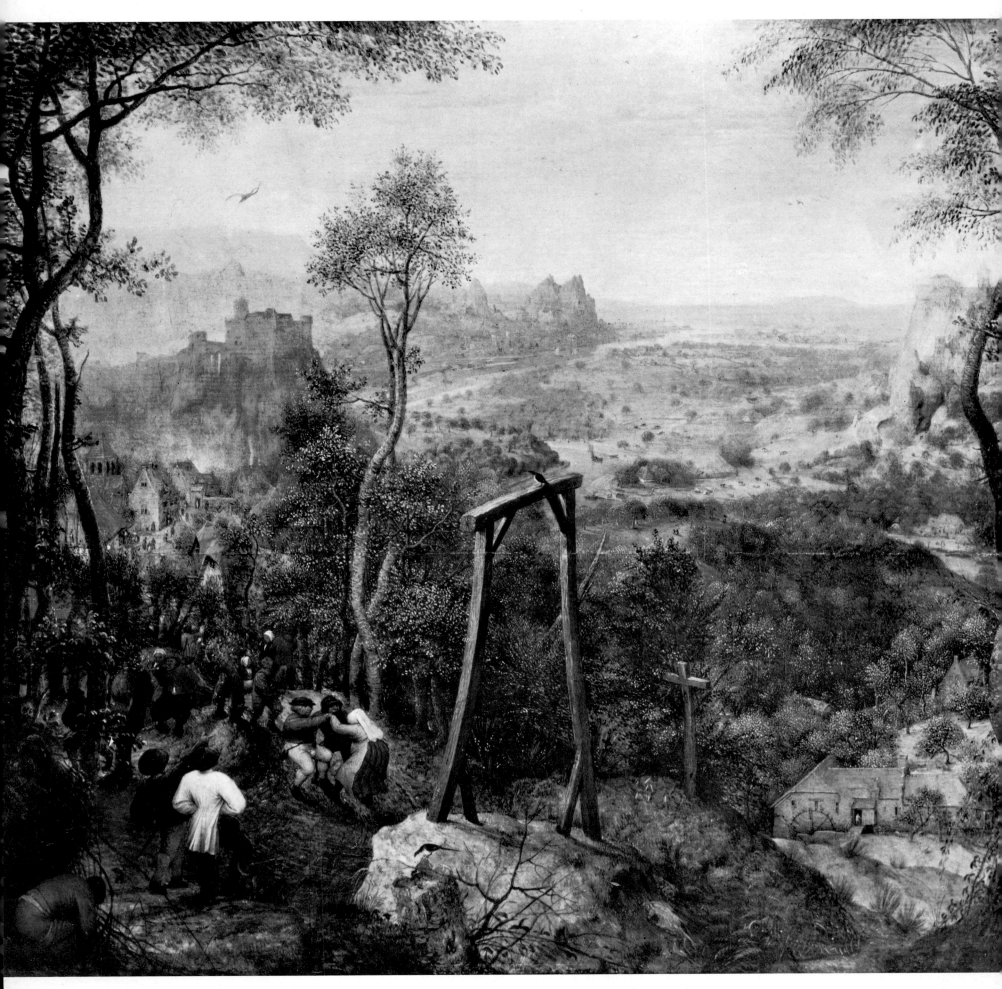

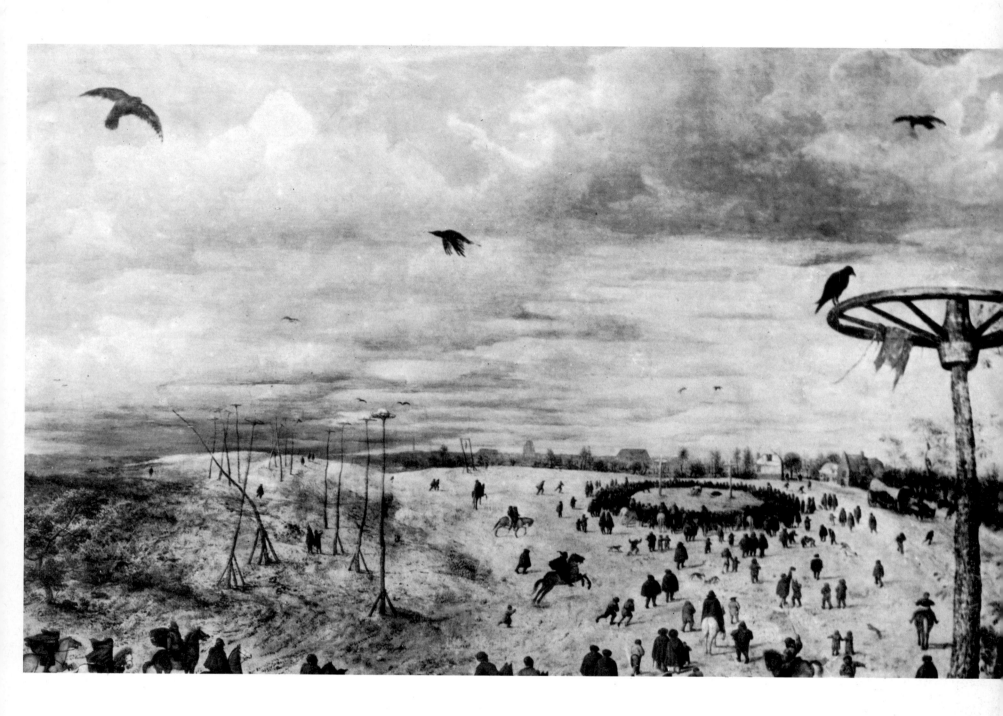

in his time, he saw in human folly a sort of negative image which would reveal the truth of the soul. Bruegel's 'drollery' may appear to be nothing more than picturesque amusement, but in reality it is a manifestation of humanism.

All Bruegel's compositions are based upon principles which are so simple that they appear perfectly natural; yet the sheer genius required to extract this 'natural' element from nature's multifarious spectacle can best be appreciated by comparing it with the works of an artist such as Patinir, which are no more than puzzle pictures. By regulating the universe, Bruegel achieved the dream of sovereignty that had tormented the painters of the Quattrocento, especially Leonardo. Bruegel is one of those poet-painters in whose art

form flows fully moulded from the idea that engenders it. And yet there are still some who see in him nothing more than a jester, wily peasant, great drinker and womanizer. Others, again, suppose his painting to be charged with hidden significance deriving from symbolic initiations and humanist inspirations. Bruegel is certainly a philosopher, but one who thinks in forms; nothing could be further from the spirit of the *rhétoriqueurs* than his highly allusive art. His work might be summed up by this phrase from Cicero which his friend, Abraham Ortelius, chose as the epigraph of his *Theatrum orbis terrarum*: 'The horse is created to carry and to draw, the ox to plough . . . but man to consider and contemplate with the eyes of understanding the disposition of the universal world.'

III Pieter Bruegel. Detail of *The Bearing of the Cross*. Vienna, Kunsthistorisches Museum.

◀ 112 Pieter Bruegel. *The Magpie on the Gibbet*. Darmstadt, Landesmuseum.

Certain paintings by Bruegel suggest a view from a height; during the sixteenth century, this bird's-eye view was enjoyed, in their imagination, by the geographers and scholars who, in the wake of the navigators, were drawing up maps of the earth.

113 Giuseppe Arcimboldo (1527–93). *Head composed of the faces of animals*. Graz, Joanneum.

9 The labyrinth

In 1895, in a Latin thesis presented at the Sorbonne, Romain Rolland argued that Italian painting after Raphael had been in a state of decadence, produced by the estrangement from nature and the substitution of the principle of the authority of antiquity, by admiration for Michelangelo and by the scholastic system imposed by the Carracci brothers. Opinions have changed considerably since that date. The classicism elaborated at Rome during the pontificate of Julius II was of short duration, as are all classic forms, resting as they do on a delicately balanced structure. But what followed it was something more complex than a mere 'decadence': it was a crisis in the art of painting, a new style. This style has been called 'mannerism', a name derived from the term *maniera*, used by Vasari in his *Lives of the Artists* to designate the style of a particular master.

The first attempt to rehabilitate mannerism, which was long regarded (and Rolland's attitude was entirely typical) as the decay of the Renaissance, came in 1920 with the appearance of Hermann Voss's study of sixteenth-century Roman and Florentine painting (*Die Malerei der Spätrenaissance in Rom und Florenz*). And between the two wars the surrealists added their voices in favour of this world which seemed to have emerged from the twilight zone of the human conscience. The path followed by the painters of that era has been compared to the one traced by strollers lost in a maze, that favourite adornment of gardens since the Middle Ages when it was known as the 'house of Daedalus'. If one were to equate inventive power with nonconformism, the mannerist painters could all be labelled avant-garde; but our own era has taught us that nonconformism nurtures its own conformism, and audacity its own academicism. Thus the Italian courts of the second half of the sixteenth century, deprived of the distractions of war, were constantly seeking relief from boredom, and the court painters had no option but to provide such relief; there was therefore no particular merit in being audacious, since it was taken for granted that the artist would be a constant source of original, and preferably wildly eccentric, ideas.

With this in mind, I would prefer to apply the term 'anticlassicism' rather than 'mannerism' to the initial avant-garde stage of the revolt against classicism; this has the advantage of pinpointing the originality of the early work of Pontormo and Rosso, and of including painters, such as Correggio, whom historians of mannerism have tended to regard as isolated figures, but who, unlike so many mannerists, were genuine creative innovators.

Anticlassicism was born in Florence, the city abandoned by Leonardo, Raphael and Michelangelo. Its first ferments may be discerned in the struggle which pitted Leonardo against Michelangelo in the competition for the decoration of the Sala del Gran Consiglio of the Palazzo Vecchio in 1503 and 1504. Since the idea of competition and the desire to outbid the opposition inevitably go hand in hand – Leonardo was over sixty and his rival only twenty-eight – each did his utmost to demonstrate his virtuosity. The wriggling masses of bodies in Michelangelo's cartoon of the *Battle of Cascina*, far from prefacing the noble cadences of the Sistine ceiling, heralded the fall of the damned in the *Last Judgment*.

The workshop of Andrea del Sarto, a painter whose disturbing *morbidezza* was already challenging the serenity of classicism, may be said to have provided the basis for the reaction against it, since his pupils included Pontormo and Rosso. They both made their first appearances as artists by his side, working in the precincts of the Annunziata between 1513 and 1517. Pontormo's *Visitation* and Rosso's *Assumption*, while showing the care exercised by pupils to follow their master's rules, give a hint of some indefinable sense of uneasiness. Rosso really hit home in 1521 with the famous *Deposition* (*pl. 114*), a veritable manifesto of anticlassicism, in which the tragic is expressed plastically by the aggressiveness of the volumes, stylized into a kind of cubism, and of the strident colours. This picture may almost be considered the *Demoiselles d'Avignon* of mannerism. We do not know how this strange work was received, although such eccentricity cannot have passed unnoticed in the traditional atmosphere of early sixteenth-century Florence. Vasari relates that a *Sacra Conversazione* (*pl. 115*) painted by Rosso in 1518 provoked lively criticism; no sooner had Monsignor Buonafede, administrator

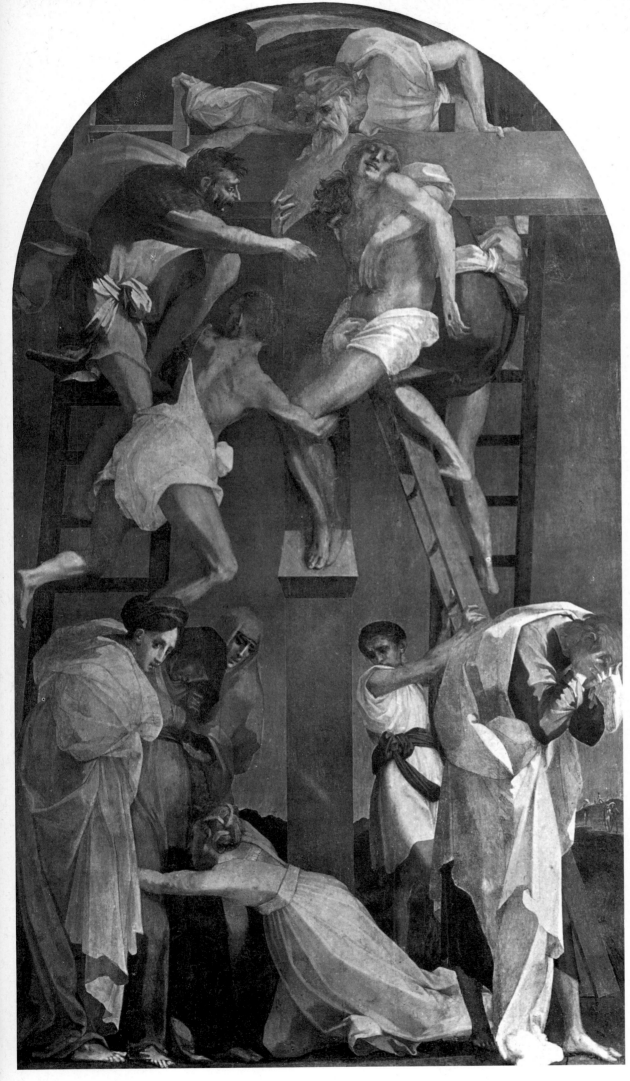

114 Giovanni Battista Rosso (1494–1540).
Deposition. Volterra, Pinacoteca.

The reaction against classicism originated in Florence
just at the time when Raphael had established its
principles in Rome. Certain pictures were judged so
scandalous that they were refused by those who had
commissioned them; this was the case with Rosso's
Sacra Conversazione (*pl. 115*) painted in 1518 for Santa
Maria Novella.

115 Giovanni Battista Rosso. *Virgin and Child enthroned with four saints*. Florence, Uffizi.

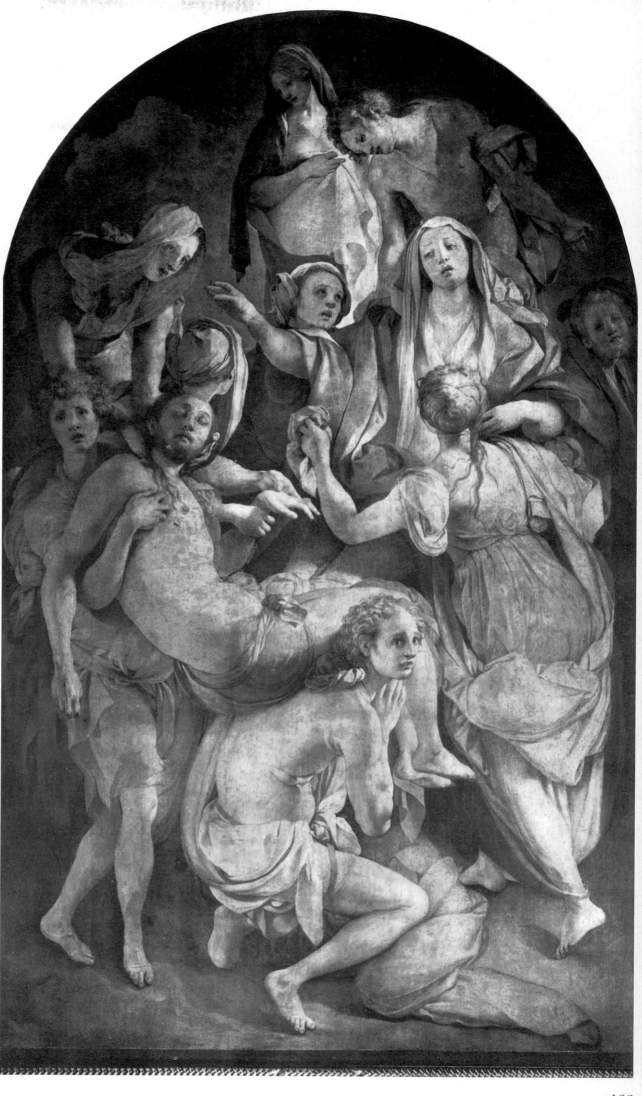

116 Jacopo Pontormo (1494–1557).
Deposition. Florence, Santa Felicità.

of the church of Santa Maria Novella, who had commissioned the painting, seen 'all these diabolical saints, Rosso being accustomed to depict certain cruel and desperate expressions in his oil sketches, . . . than he fled from the house and refused to accept the panel, declaring that he had been cheated.' This, then, was the first picture in the history of painting to create a scandal. The idea of outdoing others in extravagance was born, and five years later Pontormo painted his own *Deposition (pl. 116)*, a blasphemous work which, in a tottering composition, piles up tiers of androgynous wild-eyed creatures, one of whom, in the foreground, has adopted an indecent stance. A strange feeling of vengeful zeal seems to suffuse this work by a hypochondriac whose diary reveals him as being obsessed by his digestive processes and haunted by a terror of death, a man who ended by barricading himself in his house, drawing up the ladder which gave access to his studio like a drawbridge.

During this time, at Parma, a painter was producing work which showed that it was possible to reject classicism without necessarily adopting a revolutionary attitude. The anticlassicism of Rosso and Pontormo was based upon a negation, while that of Correggio was purely creative.

Risking the disapproval of a certain school of modern critical thought, I have no hesitation in saying that Correggio was one of the great creators of modern painting. Even his earliest works show how his use of movement disturbs the precepts of classic composition; in the *Rest on the Flight into Egypt* (Uffizi), painted around 1516, the composition has a diagonal flow, in the manner of Rubens. Then in 1518 he paused, and seems to have surrendered himself to the delights of humanism in the Camera di San Paolo of the Parma convent; here, for the abbess, who would appear to have led a far from monastic life, he painted a mythological cycle which is among the most pleasing of those created during the Renaissance.

In 1520, however, he was awarded the commission for the decoration of San Giovanni Evangelista. The only surviving painting is the *Ascension (pl. 118)* on the cupola, a work of astonishing boldness. Only a visit to Rome on his part can explain his successful assimilation of the morphology of Michelangelo and Raphael. But although he may have borrowed his *ignudi* from the Sistine Chapel, here he launches them into mid-air, and this *Vision of St John at Patmos* really is suspended above our heads. This was the first use in history of a *trompe-l'œil* effect to produce the illusion, exploited so brilliantly later by baroque artists, of nude figures floating in space.

Five years later, Correggio repeated this *tour de force* with his *Assumption of the Virgin (pl. 119)* for the octagonal dome of the cathedral, but with this painting he went even further, and his hordes of interlaced bodies whirling round in space almost obscure the Virgin in their midst. The pictures of the last period of his brief life are increasingly regulated by the rhythm of movements. The confused grouping of the *Madonna with St Sebastian*, with its mannerist overtones, is an exception. The *Martyrdom of St Placid and St Flavia (pl. 117)*, the *Deposition*, the *Madonna with St Jerome*, the *Madonna with St George* are all composed according to a system of counterpoint, with alternately advancing and retreating movements travelling diagonally, so that the painted surface becomes a centre of intense activity, suggesting to the beholder a snapshot of a moment in time. In addition, to emphasize his great spiritual tenderness, Correggio creates a sort of mime in which facial expression plays an important role, suggesting a unity of feeling among the characters; St Placid and St Flavia, for example, awaiting their martyrdom, gaze passionately towards heaven. All the elements of the baroque were invented by Correggio: spatial vision projected on to the curvature of cupolas, composition in terms of movement, the rhetoric of expression. But these qualities were not to be appreciated until half a century later, when Barocci and the Carracci had succeeded in taming the exuberance of mannerism.

During the seventeenth century, Correggio was one of the most widely imitated artists of the Renaissance, and Pietro da Cortona, Guido Reni, Eustache Le Sueur and Rubens were all in his debt. His influence continued to be felt in the eighteenth century, by Pellegrini and Boucher, for example, and was of the utmost importance for Prud'hon in the dawn of our own era. Indeed, no other artist, with the possible exception of Raphael, has exercised such a lasting influence. Yet during his lifetime he received the treatment which has been meted out to so many innovators. In an age of arrogant self-advertisement, he appears to have been timid by nature and to have led a discreet existence wholly devoid of the glamour that attached itself so easily to the lives of celebrated artists. His decoration of the dome of Parma Cathedral provoked violent criticism: labelled a 'hash of frogs' legs', it so upset the cathedral authorities that they broke their contract with the artist, thus preventing him from painting the apse. Yet Titian, when contemplating the dome, declared that even if it were to be turned upside down and filled with gold the value of its paintings would still not have been approached.

The calm of the Venetian school was broken by the appearance of a painter who was even more precocious than Correggio, and who shared his anti-classical instincts. But Lorenzo Lotto never knew Correggio's posthumous fame, until he was finally dragged from obscurity by Bernard Berenson, who in 1895 devoted an enthusiastic book to him. Although a Venetian, and one of the rare artists to be born on the lagoon, Lotto worked mostly outside his native city, in the surrounding area and as far afield as the Marches, Treviso, Bergamo, Jesi, Recanati, Ancona and Loreto. There is a mystery here which can only be explained by some incompatibility of humour between Lotto and Venice; no doubt its artistic circles, attuned to the classicism of Bellini and Titian, were little inclined to appreciate his odd temperament, his inventive curiosity, the small attention he payed in his painting to polite custom. Lotto was one of those 'provincials' who, like Pordenone, Romanino and Savoldo, found that remote towns gave them a greater freedom to develop their critical approach to art. He seems to have enjoyed working in Bergamo, where he spent the most fruitful years of his life. Berenson remarks that there would appear to have been a close bond between the artist and the people of this town who, according to contemporary accounts, themselves tended to be of a capricious and moody disposition.

His background as an artist remains obscure. The three giants of Venetian classicism, Bellini, Giorgione and Titian, made only a superficial impression on him in his early years; on the other hand, he seems to have been marked by a mysterious northern influence, illustrated by indubitable affinities with Jacopo dei Barbari, Albrecht Dürer and even Holbein, to whom the *Youth before a white damask curtain* (Vienna) was once attributed. Apart from the impact of Il Perugino, with whose work he may have become acquainted while working in the Marches, the paramount influence on him was Raphael, an influence established during the stay he made between 1508 and 1512 in Rome, where he had been summoned to execute paintings in the Vatican. The works of the Bergamo period, the frescoes of Trescore (1524) and San Michele al Pozzo Bianco (1525), the cartoons for the stalls of Santa Maria Maggiore (1523–32), are all full of reminiscences of the Stanze and even of the Sistine Chapel.

During this same period, Lotto produced his three finest altarpieces, which are also the most personal and the freest from outside influence, those of San Bartolomeo (1516), San Bernardino (1521, *pl.120*) and Santo Spirito (1521). In these, he reveals the full power of his compassion, vivacity

and unforced tenderness, to which is added an entirely new sense of composition in space and a taste for saturated colour differing radically from Titian's symphonic variations. (The latter, incidentally, have been affected by the passage of time, whereas Lotto's colours have remained intact.) Between 1530 and 1540, on the other hand, he seems to have come entirely under Titian's sway. These deviations from his natural path probably explain the element of slackness which can be detected in his last paintings, apart from the portraits. But, in fact, nothing could have been further from Titian's calm sensitivity than Lotto's temperament, tormented by a curiosity and impatience which impelled him to refashion his approach ceaselessly, like Picasso in our own century. Titian's society portraits, in which the individual reveals himself beneath the mask of convention, are serene effigies. Lotto's portraits, on the contrary, relate him to the northern painters; each figure posing before him becomes the subject of a character study, and these psychological portraits retain a truly modern accent (*pl. 121*). The remarkable aspect of his religious pictures is that the male and female saints, and even the roguish choirboy angels, are individuals, and if the Virgin is a beauty, hers is a living beauty (*pl. 122*).

Lotto is an independent, the indocile scion of a school which insisted that all progressive tendencies should be founded upon a respect for tradition. There has been some attempt to represent him as a precocious mannerist, but the few points he has in common with them are largely superficial. His unstrained sincerity and spontaneous genius set him apart from the anxieties and sophistications of mannerism. He stood equally distant from the Venetian classicism which unfolded with the majesty of a dogma; as a painter of temperament, Lotto constituted a scandalous exception to the Venetian rule.

It will be seen that the anticlassical reaction commenced as early as 1520–5, and so may be considered to have preceded mannerism properly so called rather than to have emanated from it: the expressive force of Pontormo's and Rosso's first works goes beyond mere *maniera*. Mannerism spread throughout Italy between 1525 and 1530 as a result of the scattering of the Roman artists, and continued into the rest of Europe; Rosso and Primaticcio, for example, went to Fontainebleau to create the basis for a new court art.

Rather than a style, mannerism is a pattern of imagery, as is surrealism today; and all the freer because there was no longer a *regola d'arte* to exercise a restraining influence on those painters who seemed

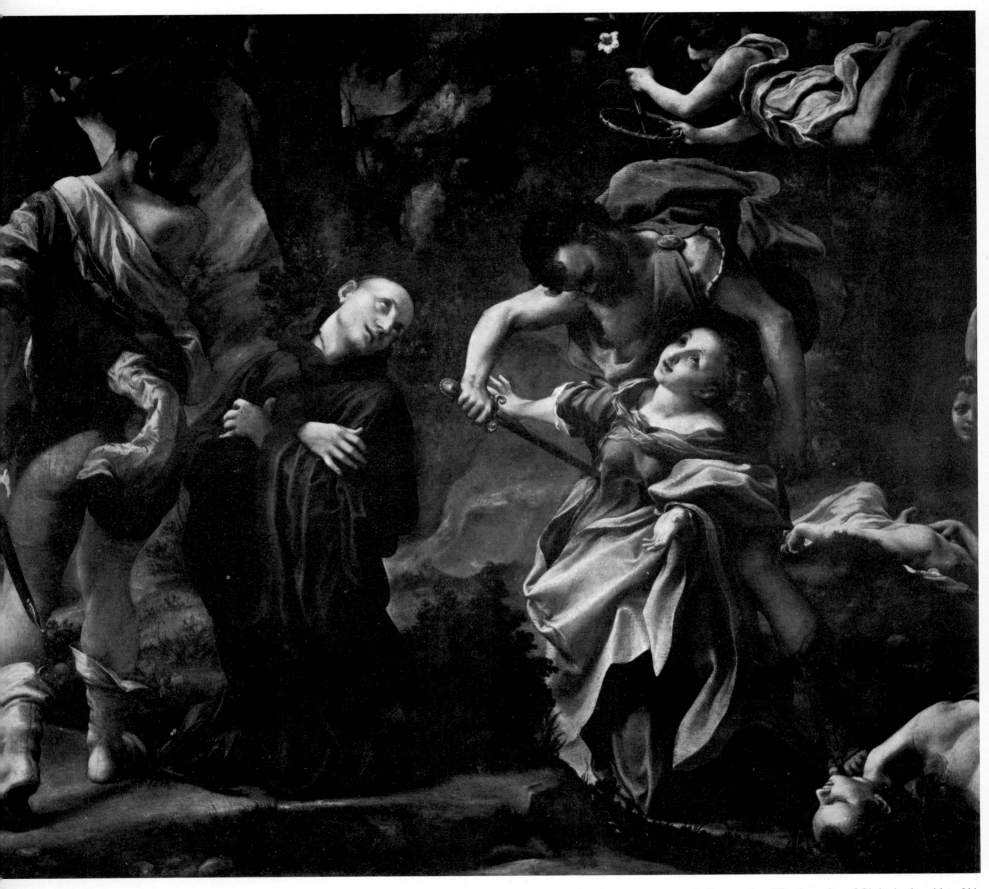

117 Correggio (*c.* 1489–1534). *The Martyrdom of St Placid and St Flavia*. Parma, Pinacoteca.

118 Correggio. *The Ascension of Christ in the midst of his apostles*. Parma, San Giovanni Evangelista.

Correggio detaches Michelangelo's *ignudi* from their supporting walls and suspends them in mid-air. These spatial researches dominate the contrasting movements of the figures in his easel-paintings.

The calm of the Venetian school was broken by the appearance of a painter who was even more precocious than Correggio, and who shared his anticlassical instincts. But Lorenzo Lotto never knew Correggio's posthumous fame, until he was finally dragged from obscurity by Bernard Berenson, who in 1895 devoted an enthusiastic book to him. Although a Venetian, and one of the rare artists to be born on the lagoon, Lotto worked mostly outside his native city, in the surrounding area and as far afield as the Marches, Treviso, Bergamo, Jesi, Recanati, Ancona and Loreto. There is a mystery here which can only be explained by some incompatibility of humour between Lotto and Venice; no doubt its artistic circles, attuned to the classicism of Bellini and Titian, were little inclined to appreciate his odd temperament, his inventive curiosity, the small attention he payed in his painting to polite custom. Lotto was one of those 'provincials' who, like Pordenone, Romanino and Savoldo, found that remote towns gave them a greater freedom to develop their critical approach to art. He seems to have enjoyed working in Bergamo, where he spent the most fruitful years of his life. Berenson remarks that there would appear to have been a close bond between the artist and the people of this town who, according to contemporary accounts, themselves tended to be of a capricious and moody disposition.

His background as an artist remains obscure. The three giants of Venetian classicism, Bellini, Giorgione and Titian, made only a superficial impression on him in his early years; on the other hand, he seems to have been marked by a mysterious northern influence, illustrated by indubitable affinities with Jacopo dei Barbari, Albrecht Dürer and even Holbein, to whom the *Youth before a white damask curtain* (Vienna) was once attributed. Apart from the impact of Il Perugino, with whose work he may have become acquainted while working in the Marches, the paramount influence on him was Raphael, an influence established during the stay he made between 1508 and 1512 in Rome, where he had been summoned to execute paintings in the Vatican. The works of the Bergamo period, the frescoes of Trescore (1524) and San Michele al Pozzo Bianco (1525), the cartoons for the stalls of Santa Maria Maggiore (1523–32), are all full of reminiscences of the Stanze and even of the Sistine Chapel.

During this same period, Lotto produced his three finest altarpieces, which are also the most personal and the freest from outside influence, those of San Bartolomeo (1516), San Bernardino (1521, *pl. 120*) and Santo Spirito (1521). In these, he reveals the full power of his compassion, vivacity

and unforced tenderness, to which is added an entirely new sense of composition in space and a taste for saturated colour differing radically from Titian's symphonic variations. (The latter, incidentally, have been affected by the passage of time, whereas Lotto's colours have remained intact.) Between 1530 and 1540, on the other hand, he seems to have come entirely under Titian's sway. These deviations from his natural path probably explain the element of slackness which can be detected in his last paintings, apart from the portraits. But, in fact, nothing could have been further from Titian's calm sensitivity than Lotto's temperament, tormented by a curiosity and impatience which impelled him to refashion his approach ceaselessly, like Picasso in our own century. Titian's society portraits, in which the individual reveals himself beneath the mask of convention, are serene effigies. Lotto's portraits, on the contrary, relate him to the northern painters; each figure posing before him becomes the subject of a character study, and these psychological portraits retain a truly modern accent (*pl. 121*). The remarkable aspect of his religious pictures is that the male and female saints, and even the roguish choirboy angels, are individuals, and if the Virgin is a beauty, hers is a living beauty (*pl. 122*).

Lotto is an independent, the indocile scion of a school which insisted that all progressive tendencies should be founded upon a respect for tradition. There has been some attempt to represent him as a precocious mannerist, but the few points he has in common with them are largely superficial. His unstrained sincerity and spontaneous genius set him apart from the anxieties and sophistications of mannerism. He stood equally distant from the Venetian classicism which unfolded with the majesty of a dogma; as a painter of temperament, Lotto constituted a scandalous exception to the Venetian rule.

It will be seen that the anticlassical reaction commenced as early as 1520–5, and so may be considered to have preceded mannerism properly so called rather than to have emanated from it: the expressive force of Pontormo's and Rosso's first works goes beyond mere *maniera*. Mannerism spread throughout Italy between 1525 and 1530 as a result of the scattering of the Roman artists, and continued into the rest of Europe; Rosso and Primaticcio, for example, went to Fontainebleau to create the basis for a new court art.

Rather than a style, mannerism is a pattern of imagery, as is surrealism today; and all the freer because there was no longer a *regola d'arte* to exercise a restraining influence on those painters who seemed

117 Correggio (*c.* 1489–1534). *The Martyrdom of St Placid and St Flavia*. Parma, Pinacoteca.

118 Correggio. *The Ascension of Christ in the midst of his apostles*. Parma, San Giovanni Evangelista.

Correggio detaches Michelangelo's *ignudi* from their supporting walls and suspends them in mid-air. These spatial researches dominate the contrasting movements of the figures in his easel-paintings.

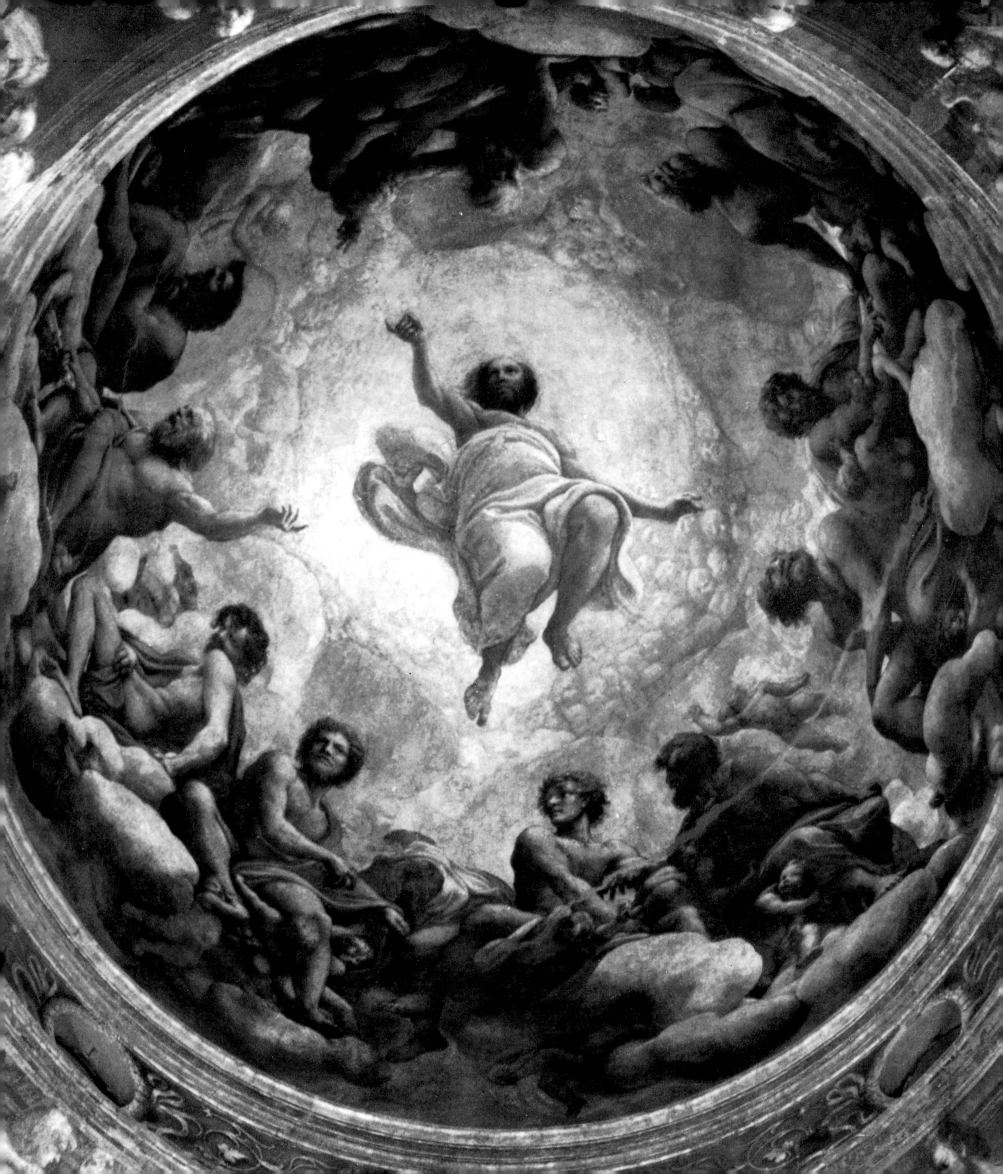

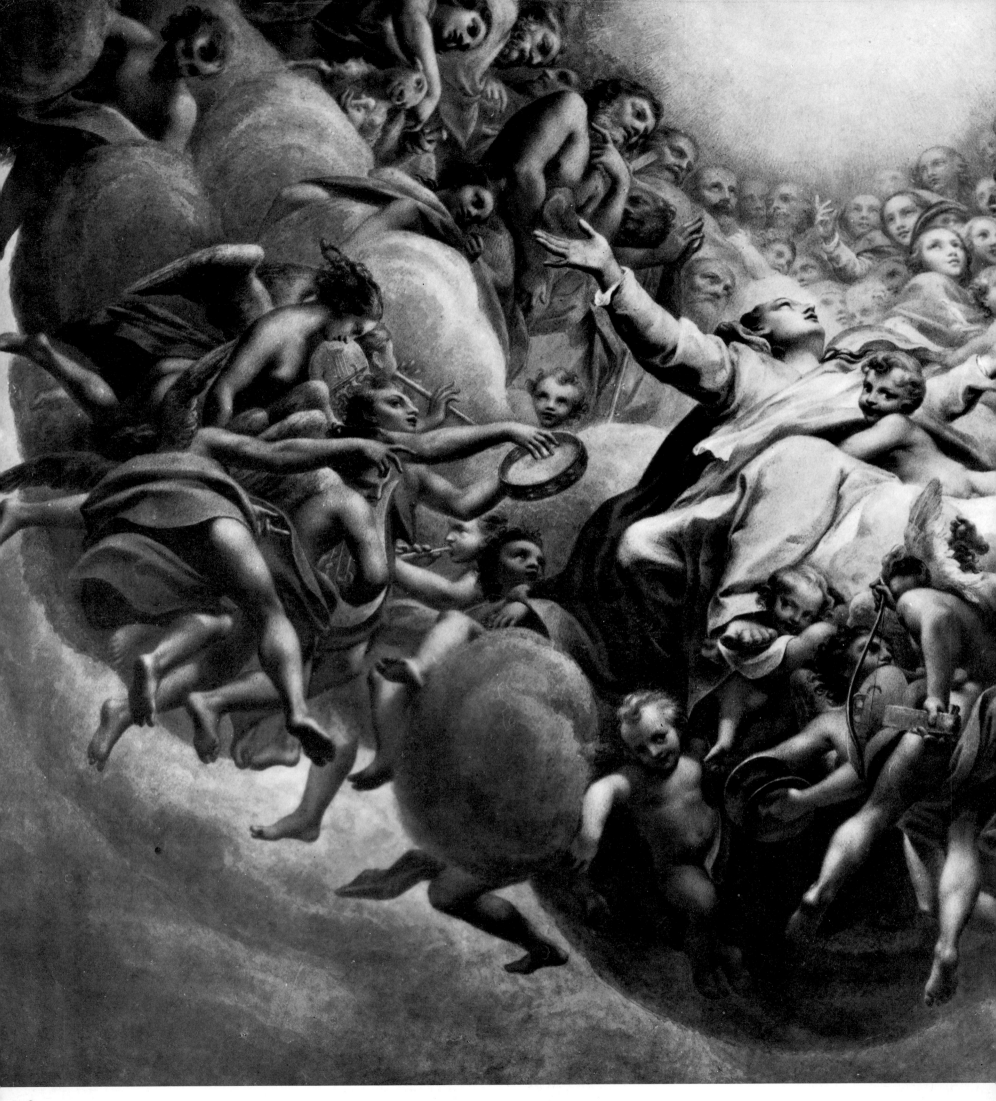

119 Correggio. Detail of *The Assumption of the Virgin*. Parma, cupola of the Cathedral.

This ceiling composition seemed so audacious to Correggio's contemporaries that the commission for the decoration of the choir, which was to have followed the decoration of the cupola, was withdrawn from the artist.

139

LOTVS
M D XII

120 Lorenzo Lotto (*c.* 1480–1556). *Virgin and Child enthroned with four saints*. Bergamo, San Bernardino.

Lotto instils a lively quality into the old pictorial theme of the *Sacra Conversazione* which Titian is treating with such solemnity at the same time, turning it into a joyous occasion in which even the angels are taking part.

121 Lorenzo Lotto. *Portrait of a man*. Rome, Galleria Borghese.

In contrast to Titian's conventional portraits, Lotto painted character studies which often contained more or less hidden allusions, as in this picture where the rose petals and the skull symbolize the briefness of life.

122 Lorenzo Lotto. *The Annunciation*. Recanati, Santa Maria Sopra Mercanti.

In this extraordinary composition, Lotto sweeps aside all the conventional ideas surrounding such a traditional subject, turning a religious scene into a theatrical drama.

to have been suddenly 'abandoned by the gods', by those gods who had watched over Italian art for three centuries. Very few of them possessed the genius to transcend their self-imposed limitations. Among these few was Parmigianino, whose manneristic variations on Correggio contain refinements that are absolutely foreign to his model, being the product of artifice. This excessively self-conscious art produced painting such as the *Madonna with the long neck* (*pl. 123*), in which elongation and an exaggerated foreshortening that projects the bust towards the background turns her into some kind of precious object of a hard, gem-like perfection. It is understandable that this undisciplined manner of painting, its peculiarities given sanction by the occultism that was all the rage at the time, should have spread freely throughout Europe. Prague, under the reign of Rudolf II, was one of its most active centres; there, the Milanese Arcimboldo amused the court with portraits in which the faces are composed of flowers, fruits, objects, even animals (*pl. 113*) or flames.

An opposite effect of anticlassicism was seen in a devoted application to reproducing nature with a mimetic exactitude, renouncing all aesthetic considerations and directing skill solely towards the scrupulous re-creation of the object, plant or animal. This taste for painting flora and fauna originally found expression within grotesque ornaments, as though this irruption of gratuitous matter could not be tolerated by the classical spirit unless caught up in some decorative rhythm. Flowers, plants and animals were detached from nature and reproduced on their own. The insatiable curiosity about nature which filled seekers such as Aldrovandi prompted them to make 'copies' of natural objects and creatures and build up collections of them. Dürer had provided an example of this mimetism, and at the beginning of the sixteenth century, Joris Hoefnagel had practised it for the courts of Munich and Vienna. Italy, versatile as ever, did not lag behind in this field. The finest of all naturalist painters is a Veronese, Jacopo Ligozzi, who painted for the Grand Duke Francesco I de' Medici some admirable plates of plants and animals which are now in the Uffizi collection.

On 31 October 1541, Michelangelo finally revealed to the eyes of his disconcerted admirers the fresco of the *Last Judgment* in the Sistine Chapel, above the altar where, the following day, Paul III was due to celebrate high mass for the eve of All Saints' Day. The artist had been working there since the spring of 1536, preparing to deliver in this form his personal Christian message. No doubt Michelangelo's concept was influenced by an

123 Parmigianino (1503–40). *The Madonna with the long neck.* Florence, Pitti.

Parmigianino's researches are the affectations of an aesthete unconcerned with the moral content of a picture and interested only in making it a vehicle for intellectual speculation.

original project, which had been to paint a Resurrection above the altar and a Fall of the Angels above the entrance. The intention of this scene would have been to show above the altar, where the sacrament effecting salvation is administered, the terrible face of supreme Justice which would appear at the end of time.

According to Charles de Tolnay (*Michelangelo*, Princeton, 1947 etc.), several myths can be detected at work in this colossal image, for which Michelangelo found inspiration not only in a careful reading of the Bible but also in a profound knowledge of antiquity: the myths of the revolt of the Titans and of the wheel of fortune, the heliocentric cosmology which the artist may have drawn directly from the sources of antiquity, and which may have had a symbolic value for him, the Pythagorean myth of celestial attraction projecting the souls of the chosen towards the stars, while the damned are committed to the souls of animals. The Sun-Christ, centre of an orbital gravitation, is both Zeus and Apollo, and in fact borrows certain traits from the Apollo Belvedere. The most surprising aspect of this syncretism is the indisputable fact that the pose of the Virgin (*pl. 125*) has been borrowed from a rather lascivious antique statue, the squatting Venus (*pl. 126*); there seems no reason to doubt that Michelangelo, remaining faithful to Florentine neoplatonism, intended to suggest a fusion between the Virgin and the platonists' Venus, who represented the guardian principle of Humanity saved by Love. This conception of a mystagogy uniting Christianity and paganism is entirely appropriate to the world of the Renaissance. But the religious significance of the fresco is impregnated with the spirit of the Reformation: at the time that he painted it, Michelangelo, together with his close friend Vittoria Colonna, was frequenting a religious circle in which Juan Valdés played the role of spiritual adviser, and which, like the Protestants, professed a belief in salvation through faith alone. This circle was broken up by the Inquisition, and if Michelangelo escaped the attentions of the authorities it was doubtless because of the almost princely status he enjoyed in Rome.

However, it was not this heretical atmosphere that shocked his contemporaries but, rather, the indecency of this display of colossal nude figures in a church, for Michelangelo had not veiled any of the anatomical characteristics of his personages. Even before the work was finished, the pope's master of ceremonies, Biagio de Cesena, had condemned it as being a fit decoration for a bath-house or a tavern, and Michelangelo had revenged himself for this remark by giving this official's features to Minos, king of the underworld. Michelangelo's most

124 Michelangelo. Damned soul, detail of the *Last Judgment*. Vatican, Sistine Chapel.

violent critic was Aretino, who resented the former's avowed lack of respect for him, and in a letter which he made public, as a 'baptized Christian', this blackmailer and apologist for vice set himself up as the defender of morality.

Paul III, who was still activated by the spirit of the Renaissance, came to Michelangelo's defence. Paul IV was on the point of ordering the fresco destroyed, but contented himself in the end with having the genitals veiled (*pl. 124*) by Daniele da Volterra, who thus gained the nickname 'Il Braghettone'. Pius IV had yet more draperies added. The question of the work's continued existence was

125 Michelangelo. The Virgin (inspired by the statue of *Venus and Cupid*), detail of the *Last Judgment*. Vatican, Sistine Chapel.

126 *Venus and Cupid*. Hellenistic period. Roman copy. Naples, Museo Nazionale.

Despite the veneration in which Michelangelo has always been held, the innovations of the *Last Judgment* have continued to provoke bitter criticism from the moment of completion of the composition until the present day.

again raised under Pius V: El Greco, who was in Rome, urged its destruction, proposing to replace it by a fresco that would be 'modest and decent and no less well painted than the other', but the saint did not dare efface the sacrilegious decoration and limited himself to having certain bodies repainted. Clement VIII, finally, decreed its suppression, but had to retreat in face of the protests of the Accademia di San Luca. In 1762, Clement XIII ordered more veils still to be added, and in 1936 rumours circulated that Pius XI had expressed a desire to see this covering-up process continued.

Until the end of the sixteenth century, writers on art, even those most favourably disposed towards Michelangelo, such as Vasari, all criticized the *Last Judgment*, at least in the name of decorum or the appropriateness of the image to its subject. As we have seen, the scandal of the *Last Judgment* has not yet died down. Many Catholics continue to veil their faces in front of it, and many lovers of art continue to find it 'in bad taste'. Aesthetically, Michelangelo was ahead of his time and can be considered an immediate forerunner of the baroque: and the audacities of baroque art are today still an object of scandal for lovers of classicism as much as for lovers of modernism.

127 Antonio Campi (*c.* 1514–87 or after 1591). *The Empress Faustina visiting St Catherine in prison.* Milan, Sant'Angelo.

10 Difficult victories

Some time around 1580, the Italian painters finally came down from the clouds and regained contact with concrete reality. Rather than involving a return to classicism, this reaction against mannerism engendered the baroque. In 1585, the Carracci founded in Bologna the teaching academy known as the Accademia degli Incamminati. Although aiming at renovation, their approach was essentially scholastic and was based, additionally, on a careful study of nature, as is shown by the huge number of drawings they made and by Annibale's few realist paintings. Other artists, however, who did not belong to this Bolognese circle with its traditional faith in the idea that anything could be learnt, overcame mannerism through more genuinely progressive personal efforts. Antonio Campi of Cremona, for example, anticipated Caravaggio's night-pieces by twenty-five years in his 1580 painting *The Empress Faustina visiting St Catherine in prison* (*pl. 127*). And he was not the only one, at that time, to seek from the night those deep sources of inspiration which would make the artist aware once more of the human drama. The few night-pieces painted by Luca Cambiaso in Genoa approach far closer to the feeling of the seventeenth century. Georges Isarlo was the first to point out how closely Cambiaso's *Madonna with a candle* (Palazzo Bianco, Genoa) foreshadows Georges de la Tour; as for the *Workshop of St Joseph* (*pl. 130*) Cambiaso preludes not only La Tour but the Rembrandt of the *Holy Family* (the *Carpenter's family*).

Isolated in the distant school of Genoa, which lacked any indigenous tradition, Cambiaso sought to create the basis for a new art. His originality is less evident in his paintings, where the treatment is slack and conventional, than in his admirable drawings, which often possess Rembrandt's visionary spontaneity. Each time Cambiaso set his marvellously agile pen to paper he embarked on a voyage of discovery; in front of his easel his enthusiasm seemed to cool. Clearly, the process of painting bored this impatient artist, and it was no doubt this, rather than a desire to show off, that prompted him to paint with both hands at the same time, as though he were a pianist. His researches

led him in two opposite directions: realism and abstraction. He attempted to prise religious subjects loose from the iconological shell within which they were trapped, and to breathe into them a new vitality, that of the human drama. Thus, the *Visitation* (*pl. 128*) takes place on a flight of stairs, its landing crowded with children and with seated women, one of whom is working her spinning-wheel; at the curve of the steps, the bemused Virgin observes the approach of St Elizabeth, exhausted by her exertions in climbing the stairs. It was Cambiaso who initiated the popular, evangelical approach which guided religious painting until Rembrandt's time, and for which Caravaggio is generally given credit.

Cambiaso's cubist drawings (*pl. 129*) have received great attention in modern times, but far from being the 'bizarre' product of a mannerist imagination, a suggestion recently revived by Jacques Bousquet (*Mannerism: the Painting and Style of the late Renaissance*, translated by Simon Watson Taylor, New York 1964), they reveal an attitude which is the exact opposite. The artist was seeking to rediscover the principles of the construction of the human body, principles that had become lost in the platitudes of mannerism. He was not the inventor of the process known in Italy as *quadratura*; Dürer, for one, had employed it occasionally for the same reasons. Lomazzo, writing in 1584, traced this system of schematizing the human body to a Lombard tradition, claiming that Vincenzo Foppa had already used it, and that Bramante had made a book of models which was known to Raphael and which had passed into Cambiaso's possession. But Soprani, writing a biography of Cambiaso in 1674, protested violently against this assertion, which he considered a plot to tarnish the glory of his hero. Whatever the facts may be, Cambiaso's cubism is based upon absolutely opposite motives from those of twentieth-century cubism, since his whole aim was to discover the visual reality of the body, while the cubists set out to destroy it.

The study of another artist, Federico Barocci, will allow us to perceive the passage from mannerism to baroque, a passage which in his case resulted from an internal effort showing proof of great creative

128 Luca Cambiaso (1527–85). Detail of *The Visitation*. New York, collection Bertina Suida Manning.

129 Luca Cambiaso. *The Resurrection of Christ*. Frankfurt-on-Main, Städelsches Kunstinstitut.

Although as a painter Luca Cambiaso often shows himself to be still influenced by the conventions of his time, his drawings express an untrammelled creative imagination. He sometimes makes use of a cubist procedure to define his forms more effectively.

130 Luca Cambiaso. *The Workshop of St Joseph*. Wilton House, collection Earl of Pembroke.

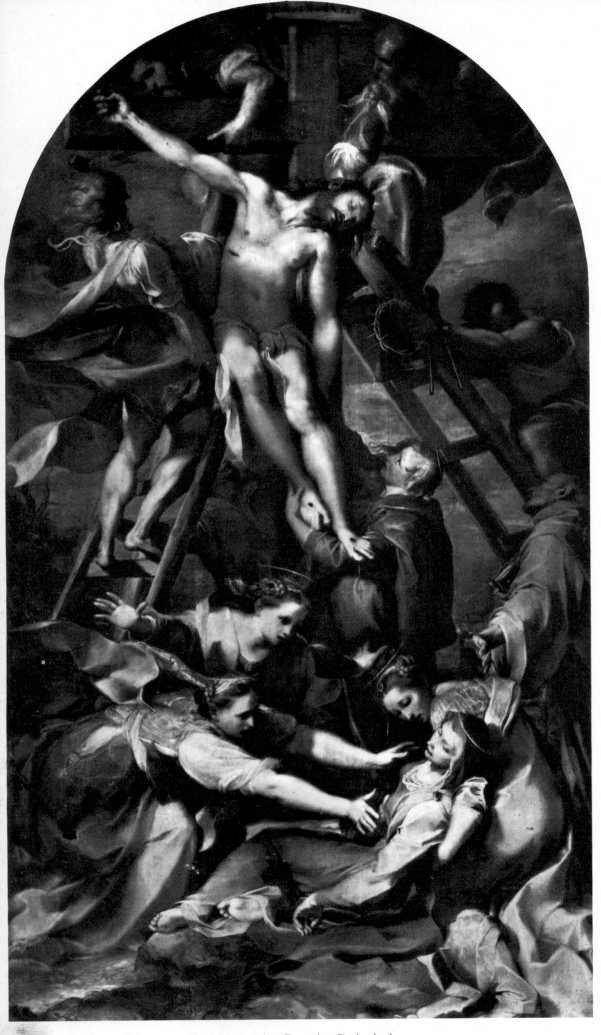

power. His *Deposition* of 1567 (*pl. 131*) is a typically mannerist composition, comparable to the celebrated 1521 *Deposition* by Rosso (*pl. 114*). Yet some ten years later, in 1579, his *Madonna of the People* (*Madonna del Popolo*) (*pl. 132*) demonstrated that he had succeeded in eliminating mannerist complications and creating a composition in which spatial balance is achieved by subtle modulations of form, thus anticipating the baroque. In this respect, he went beyond the Carracci, whose forms always remained heavy and even awkward; he achieved that definition of human figures in space which was to be a characteristic accomplishment of the baroque painters of the following century. The sources from which he drew his principles were Raphael and Correggio; fortunately he had remained uninfluenced by Michelangelo's *terribilità*.

Barocci derived his style directly from Correggio who, from his position astride mannerism, was the true initiator of the baroque. Bellori, in his *Lives*, tells us that Barocci was much impressed by a few pastels by Correggio which a painter returning from Parma showed him. But it seems clear that the influence must have been far deeper; indeed, to understand Barocci's art at all one must suppose that he had been to Parma himself and seen Correggio's masterpieces there, so close a knowledge of them is revealed by his own pictures. Among those artists who were seeking to detach themselves from mannerism, drawing was practised as a discipline, and Barocci was as assiduous in this respect as the Carracci and Cambiaso. We know from Bellori that Barocci's beautiful paintings were the fruit of methodical preparatory work, and hundreds of surviving drawings bear witness to this fact. The recent biographer of Barocci, Harald Olsen, in a painstaking inventory of these, lists no less than eighty-seven preliminary studies for his masterpiece, the *Madonna of the People*.

So great an effort on the part of an artist who was partially disabled must arouse one's admiration. Bellori's account of Barocci's life paints a grim but not untypical picture of those times, when it was perfectly normal to make use of the sword or poison to rid oneself of a rival. In this case, it seems that a group of painters who were jealous of Barocci's precocious talent invited him to a banquet at which they contrived to have him eat a poisoned salad. Although he survived, he contracted a disorder of the digestive tract which could not be cured even by the physicians called to his bedside by Cardinal della Rovere. For four years he was unable to paint, and then was able to paint only two hours a day, remaining in constant suffering night and day. It was in order to recover his health in his native

131 Federico Barocci (*c.* 1535–1612). *Deposition.* Perugia, Cathedral.

132 Federico Barocci. *Madonna of the People (Madonna del Popolo).* Florence, Uffizi. ▶

climate that he is supposed to have left Rome and returned to Urbino. In any case, this provincial environment favoured the development of an art whose apparent ease is in reality a conquest, based upon profound meditation. By renouncing the lax Roman atmosphere in this way, Barocci was able to find his affinity with the aesthetic of religious intuition recently developed in Emilia on Correggio's initiative, which had allowed this region to avoid the mannerist confusion then reigning at Rome and which Bologna escaped only through the academicism of the Carracci.

Preserved by its very backwardness from the crisis in the arts that, originating in Florence, had spread its mischief throughout Italy, sheltered by its geographical situation and political position from the disquiet that filled men's minds elsewhere, Venice found itself spared for a long time from mannerism and its anguished obsessions. While Florence exerted its saturnine influence over the rest of Italy, Venice produced Veronese, one of the greatest but one of the least inventive of painters, who depicted life in the hedonistic style favoured by Venetian artists from Bellini to Titian. Capitalist stability allowed Venice to outlive its era of political glory and maintain the illusion of a power which now derived solely from its revenues.

The torment which afflicted the other artists of Italy did touch one Venetian, a painter enamoured of grandeur but sapped by a congenital weakness: Jacopo Robusti, called Tintoretto. This strange genius has provoked the interest of Jean-Paul Sartre, who has endowed him with the romantic stature of a *peintre maudit*, 'the prisoner of Venice'; and before that, Jules Villemin attempted to apply to him the methods of psychoanalysis. Sartre's study of Tintoretto does throw some light on his subject, but the personality that emerges from his investigations is more credible as a literary creation than as an historical figure. As for Villemin's thesis, it results in some extremely bold extrapolations, such as the suggestion that the artist's cycle of the Scuola di San Rocco was inspired by St Ignatius of Loyola's *Spiritual Exercises*; a prudent historian can only accord limited interest to such exercises in a still inarticulate field of experimental psychology.

It will doubtless be more fruitful to look at the pictures themselves rather than their subjects, which in that era were still not a matter of free choice for the artist, and to examine those subjects only in relation to the manner in which the artist has interpreted them. It will be worth while to recapitulate briefly the few anecdotes which provide the basis for the fictionalized view of Tintoretto. To begin with, he is supposed to have been so precocious

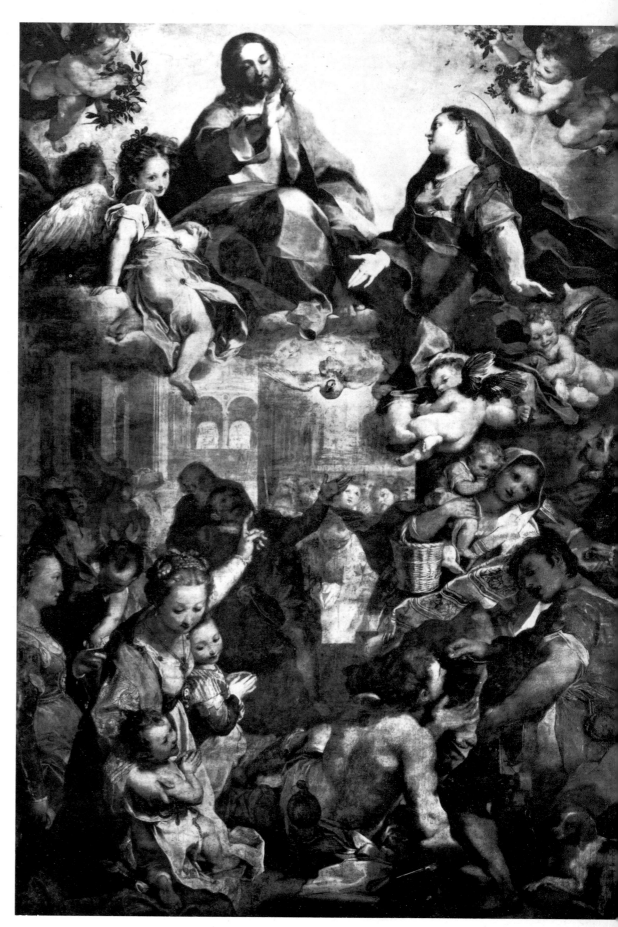

A comparison between the *Deposition* of 1567 and the *Madonna of the People* of 1579 shows how Barocci was the first to be able to put an end to the confusion of mannerism and create a new order, that of baroque composition.

that Titian grew jealous of him when he was still only twelve, and expelled his new pupil from his workshop; this early experience of Tintoretto's has allowed certain interpreters to discover in him neurotic tendencies typical of 'the child abandoned by his father'. However extraordinary young Jacopo's gifts may have been, it is unlikely that they could have aroused Titian's hostility at that early stage; it seems far more likely that the expulsion – if it occurred at all and is not simply a myth – resulted from youthful misbehaviour. In any case, we have no idea who taught the rudiments of painting to this young prodigy who in 1539, at the age of twenty-one, was already in possession of his full artistic powers. It is certain that he was energetic in securing commissions for himself, using such business methods as making gifts of his pictures, or selling them for nothing but the cost of the materials, or securing advantage for himself in competitions by producing a finished work where his colleagues had only sketches to show. This pushfulness may well have been interpreted as impatience to impose his own style of painting, an idea well calculated to shock right-thinking people in a Venice reigned over by the all-powerful Titian who, in the words of Sartre, 'was a whole academy in himself'. In any case, it is difficult to visualize this painter, the recipient of so many official and private commissions, as a recluse and misanthrope. He undoubtedly forced the hand of the Scuola di San Rocco when, at the 1564 competition, he unveiled before the astonished members of the confraternity his own completed painting, already in the place designated for the winning picture. This ruse succeeded admirably, since during the next thirty years, until 1594, the Scuola offered him its walls as a vast field for the exercise of his imagination. No doubt the confraternity was initially tempted by the favourable prices that the artist must have quoted them, since the sample he gave them of his talent in the 1564 picture was mediocre. But the fact that he worked for so many years on this one commission must mean that some genuine attachment existed, based on mutual sympathy.

Although Tintoretto may occasionally have imitated Titian, or assimilated the style of Veronese (who repaid the compliment by borrowing from Tintoretto), his whole art was nothing less than a manifesto directed against the classicism which Titian had elevated into a dogma in Venice. The confusion in his compositions, his love of river imagery, the feverish nature of his eternal quest, all bring him close to mannerism. But the rapid, spontaneous touch which is his most original characteristic contrasts strongly with the elegant, even affected treatment typical of the Florentine, Emilian and Roman mannerists. He transcends mannerism, too, in his consciousness of the drama that motivates him.

It is a matter of controversy as to whether Tintoretto ever saw Michelangelo's frescoes in the Sistine Chapel, particularly the *Last Judgment*. We are too ill-informed about his life to know if he travelled, or if he really was the 'prisoner of Venice'. Personally, I can detect no direct influence of Michelangelo in Tintoretto's art, and if he has anything in common with Michelangelo it is his constant preoccupation with the idea of the end of the world. But whereas for Michelangelo the end of the world is a matter affecting mankind alone, it assumed with Tintoretto the nature of a cosmic upheaval. It is perfectly natural that an inhabitant of Venice, that floating city eternally menaced by some fresh invasion by the sea, should imagine the last day as a diluvial cataclysm. Tintoretto's *Last Judgment* in Santa Maria dell'Orto is a flood in which the bodies of the damned are swept away by cataracts. The artist constantly showed his predilection for themes in which water forms an integral part of the drama; indeed his whole artistic output resembles some kind of river of flowing shapes. It is relevant that the mainlanders Titian and Veronese were classicists; with the Venetian Tintoretto, mobility is the principle of his composition, just as fluidity is the essence of his treatment. Once the earth has been swallowed up by the waters, the universe reverts to the primordial space from which the earth originally sprang. Many of Tintoretto's bodies (*Origin of the Milky Way*, *The Three Graces*, *Bacchus and Ariadne*) float in the ether, weightless, just as the bodies carried away by the flood float on the waters. Tintoretto, who painted a Paradise of elliptic orbs suggesting the idea of heliocentric gravitation, was the first artist to feel that lure of infinite space which in those days affected only a few scholars and which, a century later, made Pascal tremble at the brink of the abyss of heresy. This premonition probably resulted from instinct rather than any conscious reflection of Copernicus's recently formulated theories, although it is normal that at any given moment of time a particular vision of the world should motivate the creative expression of artists as well as thinkers.

Tintoretto employed a further method of breaking down forms: the explosion of light and shadow. His famous *St Mark rescuing a slave* (1548) inaugurated this kind of explosive composition, in which all the elements are dispersed along the many axes of a space that is literally split open, and the process is used in conjunction with an aquatic

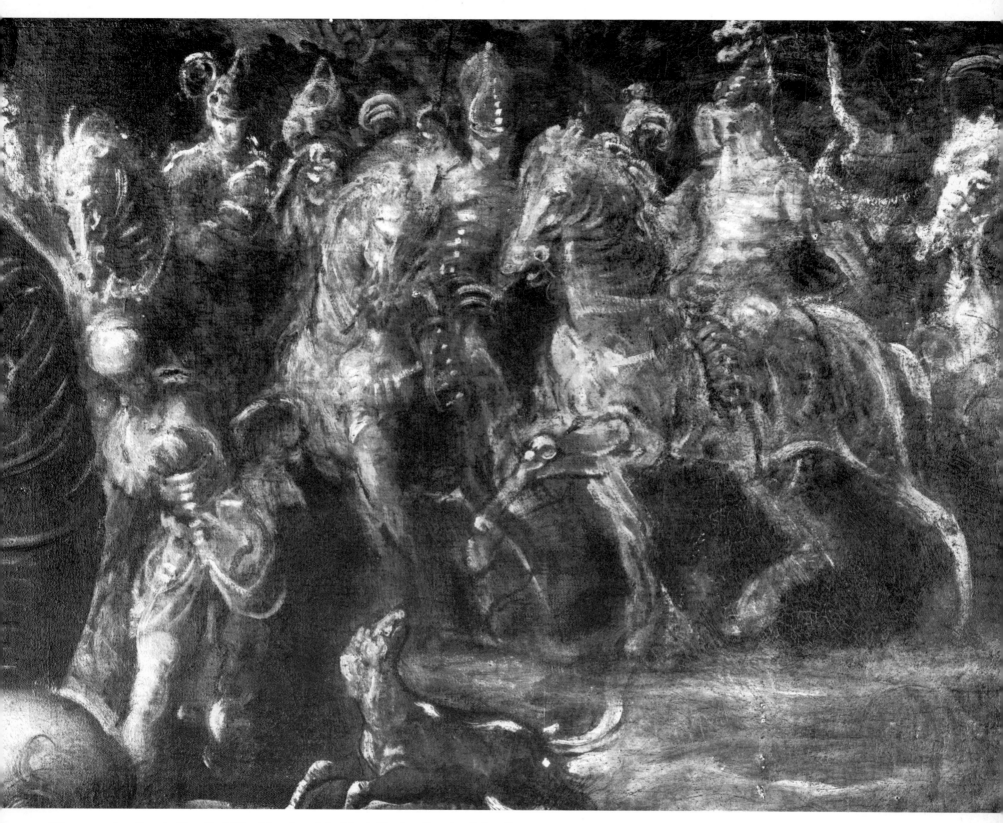

133 Tintoretto (1518–94). Detail of *The Adoration of the Magi*. Venice, Scuola di San Rocco.

Contrary to the principles of classical execution, Tintoretto inaugurated an abbreviated, rapid, allusive treatment which suggested rather than described forms.

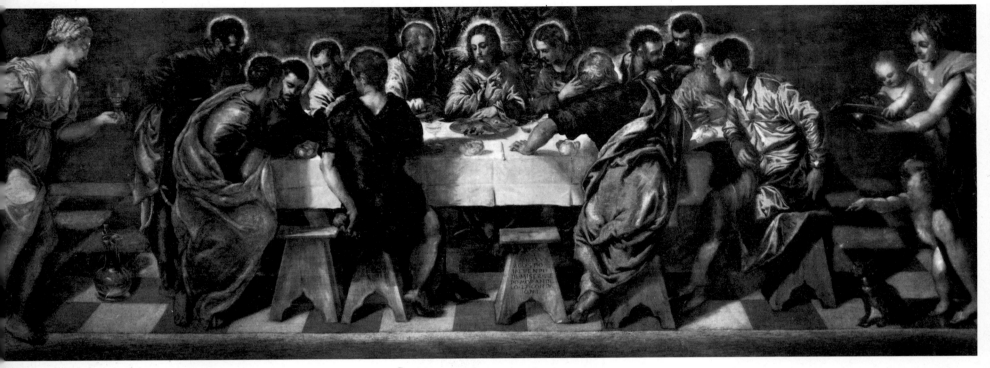

134 Tintoretto. *The Last Supper* (1547). Venice, San Marcuola.

135 Tintoretto. *The Last Supper* (c. 1560). Venice, San Trovaso.

136 Tintoretto. *The Last Supper* (c. 1580). Venice, Scuola di San Rocco.

The numerous *Last Suppers* which Tintoretto painted show a gradual development in the direction of drama and spatial exploration, but also increasing mastery of technique.

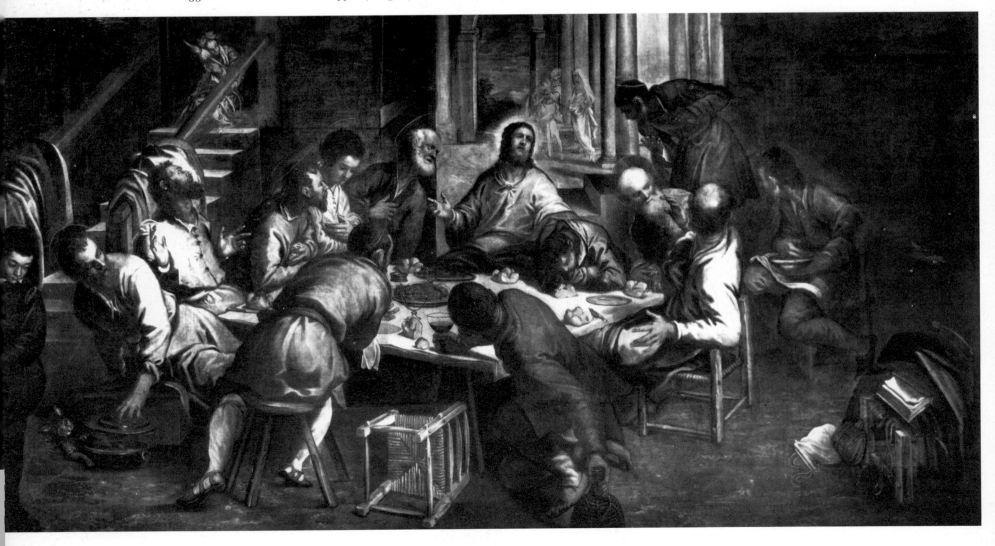

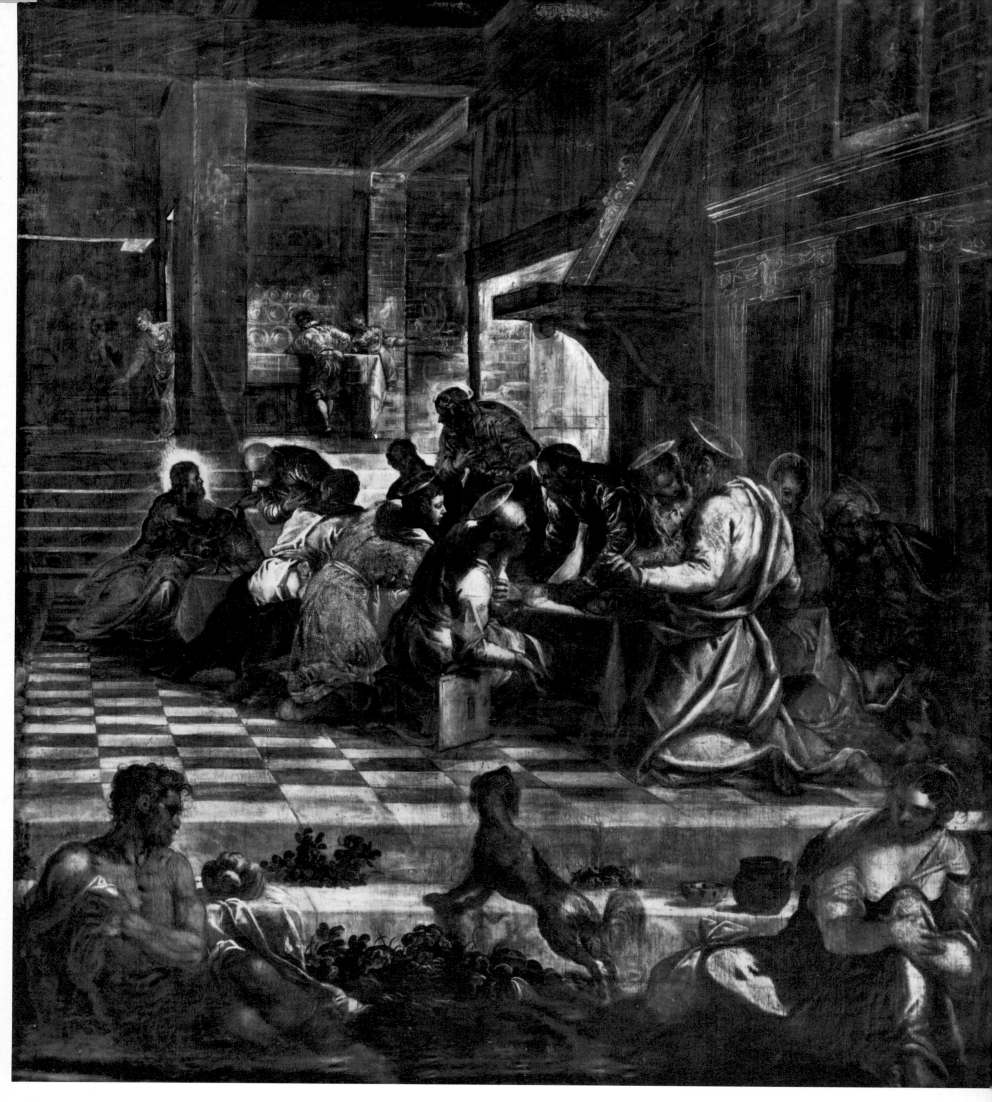

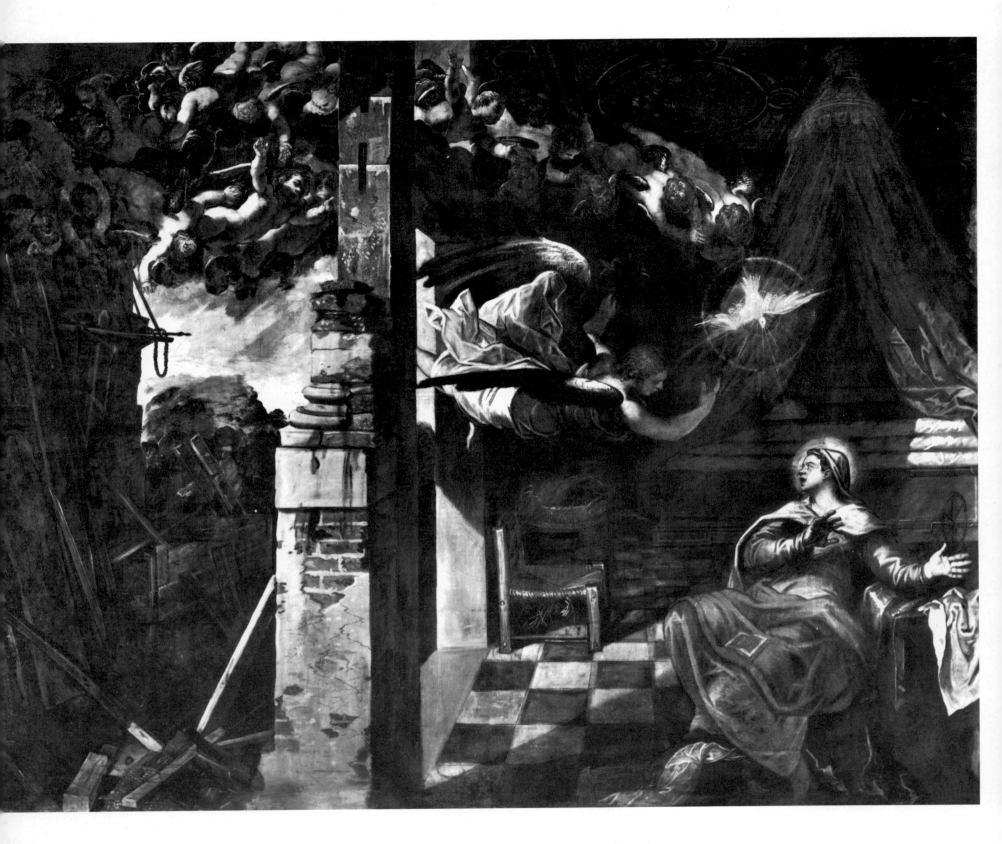

137 Tintoretto. *The Annunciation.*
Venice, Scuola di San Rocco.

In a sort of cosmic drama,
Tintoretto confronts the natural
world with the supernatural world.

fluidity which makes the forms stream uncontrollably from the brush. Becoming aware of this anarchic exuberance, he strove to bring it under control; the study of one particular subject, which he painted ten times during his life, the *Last Supper*, will serve to illustrate this progression in his art.

He first tackled the theme of the *Last Supper* in 1547 at San Marcuola (*pl. 134*), with a soberly classic composition arranged broadways, following the larger dimension of the working surface, and given solid equilibrium at both sides by two figures. By 1560, in the San Trovaso version (*pl. 135*), this liturgical celebration had been turned into a drama which projects the distracted actors in all directions. This drama reaches a peak of frenzy in the San Polo version composed between 1565 and 1570,

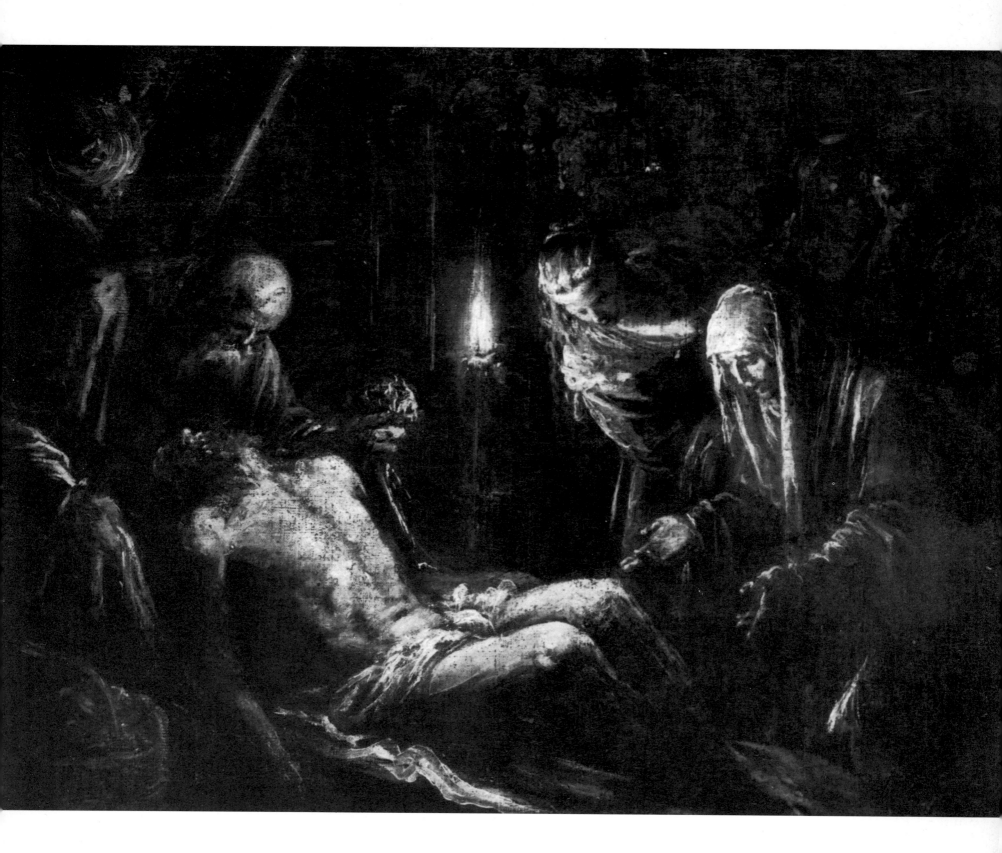

where the composition totters despite the efforts made to hold it in balance. Towards the end of his life, however, around 1580, in paintings of the same theme at the Scuola di San Rocco (*pl. 136*) and at Santo Stefano, Tintoretto succeeded in canalizing this movement within the diagonals of space, inventing a method of composition which was to be used very frequently during the baroque era. At the same time, so as to counter this tendency of the composition to spill over towards the viewer, he wedged it securely along a step, thus showing unmistakably his desire to rediscover the solidity of the earth's contour. At Santo Stefano, figures seem to have positioned themselves at the four corners of the picture as though to enclose the painting surface more effectively, while at San Rocco the vast hall

138 Bassano (1510/18–92). *Deposition.* Lisbon, Museu Nacional de Arte Antiga.

Bassano is the true initiator of a handling which was to be that of Rembrandt, and which involved working the pigment in depth.

139 Titian. *Christ crowned with thorns*. Munich, Alte Pinakothek.

Towards the end of his life, Titian abandoned the Venetian technique of transparent painting, and, like Bassano, adopted the method of working pigment in depth which Rembrandt was later to revive.

which houses the composition imprisons the restless space within its quadrature. The artist had no need of this stratagem in the *Last Supper* at San Giorgio Maggiore, painted in 1592–4, shortly before his death; here, he achieves unity between the natural and supernatural worlds through the simple interplay of gestures in the context of a structural space, making the symbolic event a drama of universal significance.

This brief survey of Tintoretto's career gives some indication of his complex nature. Once he had realized that Titian's painting could not be developed except by the artist himself (and, in fact, Titian's longevity allowed him to achieve that development), he was seized by a creative fever. Enjoying a facility that led him astray as often as it served him well, his breathless approach produced a world of forms constantly in the process of being swept away by a hurricane. Perceiving intuitively that beyond this universe lay another that would open itself up to mankind's imagination, he nevertheless struggled to stem this process of disintegration by inventing new structures. He finally achieved this ambition in the Scuola di San Rocco, which remained for so long a laboratory for his artistic experiments. Here, during a great part of his life, he conferred with his own soul, and the hospice became for him a retreat for meditation, where he painted from a sense of inner necessity rather than pride. The real Tintoretto, the Tintoretto true to himself rather than to others, is to be found in this great cycle of images. The huge *Crucifixion* of 1566 is still chaotic, but the *Christ before Pilate*, the *Carrying of the Cross* and the two versions of the *Life of St Roch*, belonging to the same sequence of paintings, are organically controlled. The later compositions such as the *Adoration of the Magi (pl. 133)* and the *Temptation of Christ* (1576–81) and, above all, the last ones, the *Annunciation (pl. 137)*, the *Flight into Egypt* and the *Holy Family* (1583–7), are 'accomplished' works in which the majestic rhythms of the baroque find orderly expression. Mellowed by age, the artist at last discovered the path of nature that had remained hidden from him previously, but which now provided a revelation that allowed him to transform cosmic drama into landscape, as in *St Mary the Egyptian* and *St Mary Magdalen*.

Despite Tintoretto's reputation as a 'wild' painter, he should rather be considered as one of the most marvellous examples of creative energy, a man who tamed a turbulent temperament and guided his tremendous energies throughout his life towards a final and complete triumph. In this way he avoided the sense of failure that cast a shadow over Michelangelo's last years and made it impossible for that

artist to complete many of his projects.

One painter who was briefly influenced by Tintoretto, despite the provincial isolation in which he lived at Bassano, was Jacopo da Ponte, known as Bassano. The reputation he enjoys today is somewhat disproportionate to his talent, and doubtless results from the great honour that befell him of having inspired the youthful El Greco. The 1957 exhibition of his work at the doge's palace in Venice allowed us to judge him as a painter of rather poor imagination, sticking to traditional compositions to which he gave a fresh and mannerist flavour through his liking for popular scenes and animal life. His novelty lies in a happy way of wielding a brush that is very different from Tintoretto's passionate approach, a sketched style that allowed him to work rapidly and also provided a means of avoiding structural problems. In this, he resembles Luca Giordano, and might equally well have merited the seventeenth-century painter's appellation 'Fa Presto'. Giordano, though, entirely lacked the kind of caprice which, in Bassano's work, was to open up new perspectives for painting in the seventeenth century. Bassano's paintings are full of such felicities of expression, and in this respect he must be considered further ahead of his time than Tintoretto and closer to the Titian of the last period (*pl. 138*).

Titian was constantly tormented by technical problems; and, unfortunately, his experiments to increase the seductive power of the sensual colour-values he had inherited from Giorgione had a deleterious effect on the lasting quality of his paintings. No doubt the reservations expressed by certain critics (Berenson, Isarlo, Sartre) about his genius result from the fact that many of his pictures really have lost their original flavour, and, strictly speaking, if an artist's work should always be considered as a whole, it follows that any failure is no less unfortunate for being a technical one.

Towards the end of his life, however, tired of these fruitless researches and of the classic formalism which he had maintained for nearly half a century, Titian allowed his brush to move with greater freedom over his canvas. Attaching less importance to keeping form subservient to reality, he listened to inner voices; in a few paintings, such as the *Descent from the Cross* (1559, Prado) or the *Christ crowned with thorns* (1560, *pl. 139*), he gave a foretaste of Rembrandt's sublime handling, with a sort of thick, viscous pigment in which the forms have become nothing more than manifestations of an inner life. This transformation can be seen in the *Marsyas* (Prague), the *Tarquin and Lucretia* (Vienna), the *Virgin and Child with SS. John and Catherine*

(National Gallery), the *Nymph and Shepherds* (Vienna), the famous *Pietà* which was finished after his death by Palma Giovane, and the admirable *St Sebastian* (Hermitage).

It is not impossible that Titian, at a certain point, may have cast an interested glance in the direction of Bassano and Tintoretto. He was certainly acquainted with the latter's work, as can be seen from 1550 onwards in paintings such as the *Diana and Callisto* (Bridgewater House) which seethes with life as vigorously as does Tintoretto's *Nine Muses* (Hampton Court), where the nine seem numberless. Thus the two enemies, taking entirely opposite paths, ended up by meeting each other.

The figures at the base of El Greco's *Christ driving the traders from the temple* (Minneapolis version), painted during his stay in Rome, include portraits of Titian, Michelangelo, Raphael and a further unidentified person. The reason for this remains obscure, although the insertions may well have been made at the request of whoever commissioned the work; in any case, we have no reason to interpret it as a gesture of respect by the artist to his masters. Certainly he owed something to Titian, but Raphael contributed nothing to his development, and his attitude towards Michelangelo was, as is well known, extremely disrespectful. During his Italian period, El Greco was a close follower of Tintoretto and Bassano, and would doubtless have remained so had he not for some unknown reason decided to move on to Spain. The case of El Greco highlights one of the sources of creative inspiration: the 'dialogue' between an artist and his environment, the decision to accept or reject that environment. El Greco discovered his true artistic nature in Spain, although the kind of painting that he formulated there went completely against the grain of the Spanish school's evolution.

Uprooted from his Venetian surroundings, El Greco's thought turned inwards. The intense mystical speculation sweeping Spain at that time oriented him towards a religious exaltation which nothing in his Italian period would have allowed one to foresee. Establishing himself in Toledo, he completed for the cathedral the painting *El Espolio* (*Disrobing of Christ*) which provoked such lively controversy at the time. After this, he offered Philip II a picture made especially for him, the *Adoration of the Name of Jesus* (*Dream of Philip*). The king, who was well aware of the futility of the Spanish school of painting of his time, would seem to have wished to put this unknown artist to the test; in any case, he commissioned El Greco to paint a large picture, the *Martyrdom of St Maurice and the Theban Legion*, for a chapel in the Escorial. The artist worked on the

painting for two years and in 1582 delivered it to the king, who was not pleased by what he saw and did not hand it over to the prior of the monastery until 1584. The prior, in his turn, hesitated to install the painting in its allotted position in the chapel; finally, the king commissioned a substitute from an obscure Italian, Romulo Cincinnati. Nevertheless, the difficulties must have arisen from some question of iconographic orthodoxy rather than aesthetic considerations; the superiority of El Greco as a painter was sufficiently acknowledged by the fact that the king awarded him 800 ducats for a work judged unsuitable, while Romulo received only 500 ducats. The *St Maurice* was, in fact, deprived of its sacred function rather than refused; it was given a home in the rooms of the Escorial set aside for a museum.

The peculiarities of the *St Maurice* are, to some extent, the gratuitous revelations of an artist in search of himself. His self-discovery came a few years later, with the *Burial of Count Orgaz*. El Greco ultimately benefited from his rejection by the court and his consequent withdrawal from the Madrid scene, for it was in the overheated atmosphere of Toledo that the forty-five-year-old artist was able gradually to give full expression to his genius. Isolated as he was in a foreign country (he never learnt to speak Spanish well), his thoughts naturally went back to his Cretan heritage, and the ancient Byzantine tradition rose to the threshold of his conscious mind. The change he was about to impose upon the art of the Renaissance was comparable to that which the Byzantine art of the fifth and sixth centuries had imposed upon the art of classical antiquity. El Greco had no love for the human body celebrated so untiringly by the Renaissance and glorified by Michelangelo: his whole aim was to torture the body as though plunging it into an inferno, forcing it to expiate some gross excess of pride. This elongation of proportions, with the consequent dematerialization of human forms, is typical of the aesthetic expression of every civilization which recognizes the primacy of the spirit over the senses: the Christian East, Chinese Buddhist art, the Gothic, and even mannerism in so far as it calls into question the positivism of the Renaissance. El Greco exaggerates this tendency to the point where his human figures are transformed into long flames writhing in that lacerated space which Tintoretto had taught him to create (*pl. 140*).

Some years ago, at a time when it was fashionable to explain genius by physical blemishes, an attempt was made to show that this elongation resulted from the artist's defective vision, based on the assumption that he had suffered from astigma-

141 El Greco. Head of the Virgin, detail of *The Holy Family*. Toledo, Hospital Tavera.

142 El Greco. Head of the Virgin, detail of *The Holy Family*. X-ray photograph. Toledo, Hospital Tavera.

El Greco's distortions are deliberate, as this X-ray photograph shows. Using a model, the artist first painted in the Virgin's face with realistic accents; when completing the composition, he incorporated the distortion which was an integral aspect of the style he was aiming at.

tism. But laboratory tests soon put paid to this tendentious nonsense: X-ray photographs reveal that certain faces in El Greco's paintings conceal other far more realistic faces. It was no doubt his mistress Doña Jerónima who posed for the *Holy Family* of the Hospital Tavera, in which the model's face is hidden beneath that of the Virgin, as though behind a mask *(pls 141–2)*. El Greco's instinct was served, in fact, by a consciously directed will.

Although the many examples of pious imagery supplied by El Greco and his studio prove that this aspect of his painting had a certain success, it was not really Spanish in spirit, and remained very distant in feeling from the mystical flights of his contemporaries, St Teresa and St John of the Cross, despite the affinities which have been alleged. The visions of these saints embraced a world of light in which they imagined themselves living in happy familiarity with the beyond, an attitude which, during the following century, helped to spread religious realism. El Greco's human beings, however, do not live in paradise: they aspire to it. They are not the elect of heaven but souls in purgatory consumed by a burning desire for God and bitterly aware of all that still separates them from him.

On more than one occasion El Greco found himself at loggerheads with the ecclesiastical authorities who commissioned pictures from him, although this fact does not imply that his talent was not appreciated. He found himself in a similar position to Caravaggio, his audacities being as highly appreciated by enlightened art lovers and fellow artists as they were frowned at by the clergy. He was proud by nature, too, and conscious of his dignity as an artist. The lawsuit he engaged in against the confraternity of the Hospital de la Caridad, Illescas, when it contested the price of the altar he had painted and sculpted for the hospital, demonstrated his indomitable nature. The confraternity fought him tooth and nail, but throughout the years that the case dragged on, from one appeal to another, the successive experts that were summoned all came down on his side in the dispute. Only after the Council of the Archbishopric of Toledo had seized all their church's precious objects, including the Virgin's mantles and jewellery, did the Caridad brothers finally admit defeat and decide to make their peace with the artist. The outcome of this case had considerable repercussions throughout Spain. At the beginning of the eighteenth century, the biographer of the Spanish painters, Palomino, who was no admirer of El Greco's, said that 'all artists are indebted to him for having defended their rights so honourably, in that he was the first one ever to put up a good fight'. In fact, the final resolution of the lawsuit, in May 1607, remains a landmark in the history of the social emancipation of artists.

◀ 140 El Greco (1541–1614). *Assumption of the Virgin*. Toledo, Museo de San Vicente.

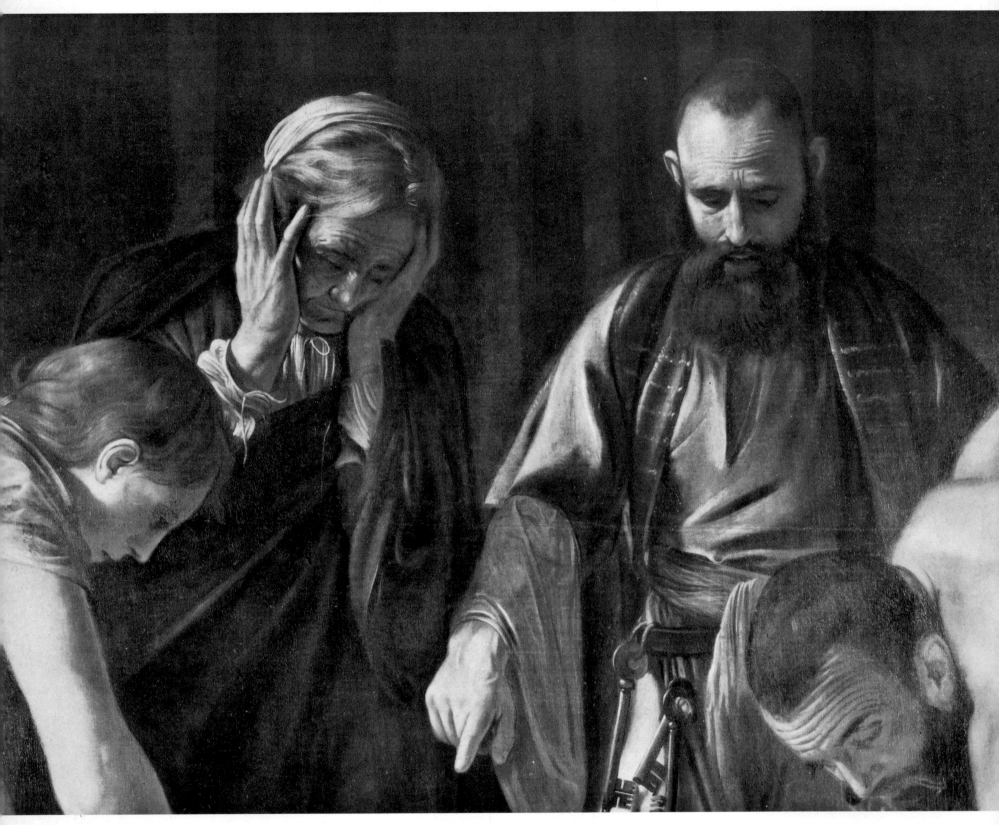

143 Caravaggio (1573–1610). Detail of *Beheading of St John the Baptist*. Valletta, Cathedral.

11 The weight of the soul

Caravaggio is a painter after the heart of our own epoch. His frantic existence provides all the excitement demanded by those who prefer to reduce artists to the level of their own human foibles. He must seem a hero to all those for whom creation is synonymous with disruption.

In fact, the story of Caravaggio's life is so utterly at variance with his art that it is of little use to us in approaching the paintings except in terms of analysing his unconscious psychological motivation. Caravaggio was a man who could not even eat artichokes in an inn without picking a quarrel with the server. He was a heartless wretch who refused to recognize his brother. He was a troublemaker who spent his nights in low haunts and was constantly arrested for brawling. One such quarrel, over a game of cards, ended fatally, with his adversary dead and Caravaggio himself wounded: on this occasion, he succeeded in escaping after hiding in the Sabine hills. Reaching Naples, he later embarked for Malta, where the Order of St John was in search of artists. Here, after assaulting a knight justiciary, he was thrown into prison, but managed to escape to Sicily where he went from one town to another seeking refuge. Returning to Naples, he tried to reingratiate himself with the Grand Master of the Order by making him the gift of a painting; but once again he got involved in a brawl, and this time suffered a severe head wound. According to Bellori, he then left Naples for Rome, having learnt that Cardinal Gonzaga's intercession with the pope on his behalf had secured him a pardon. But the strange direction he took makes it seem more likely that he was heading for Tuscany and avoiding the papal states. He disembarked at Porto Ercole in the Maremma, which was at that time a Spanish possession; here he was arrested by the Spanish guard in mistake for someone else, and imprisoned. Released after two days, he found that the felucca which had brought him had sailed away, taking all his baggage and, no doubt, his pictures too. In despair he wandered about the swamps of Porto Ercole under the terrible July sun, *il sol leone* as Baglione calls it, searching for his lost possessions. He caught malaria and died miserably in a hospital, at the age of thirty-seven, perhaps without even knowing that a pardon was awaiting him in Rome.

This is one side of his biography, but there is another. At an age when others are just starting out, Caravaggio was already acknowledged in Roman circles as a great artist, and receiving important commissions that made him the envy of the other young artists. Although the Church authorities were shocked by his new kind of realism and turned down some of his altarpieces, he invariably found a wealthy patron to buy them at huge prices. When the *Death of the Virgin* was rejected by the church of Santa Maria del Popolo, the rumour soon went round that a masterpiece was on the market. Rubens, who was then court painter to Vincenzo Gonzaga, Duke of Mantua, urged him to acquire it, advice backed up by the duke's representative at Rome who wrote that its author was 'among the most famous modern painters of Rome, and this picture is considered one of his best works'. The duke promptly bought the painting; the Romans were dismayed at losing this unique work, and the duke's representative wrote to him that to satisfy the unanimously expressed wish of the city's painters he had been obliged to delay its despatch by one week so that it could be viewed by the public. And the whole of Rome filed past the admirable and scandalous picture.

When Caravaggio fled from Rome after slaying the young Ranuccio Tommasini, it was Duke Martio Colonna who afforded him protection in his palace. Going on to Naples, Caravaggio found that his fame had preceded him, and here, as elsewhere in his constant search for refuge, he was given painting commissions. In Malta he was treated with great honour; the grand master, Alof de Wignacourt, was so pleased with his portrait that he gave him a gold chain, and two slaves to look after him; the Order created him a knight. These favours indicate that Caravaggio was not basically antisocial and that his rages probably came over him in sudden fits. It seems safe to assume, too, that he was by no means irreligious. There could have been no greater triumph for him than this elevation to the same rank as his rival, the Cavaliere d'Arpino, in whose studio he had worked during his early years, and whom he had supplanted at San Luigi de' Francesi; protected by the Order, he was now in a position to obtain a pardon and return to Rome.

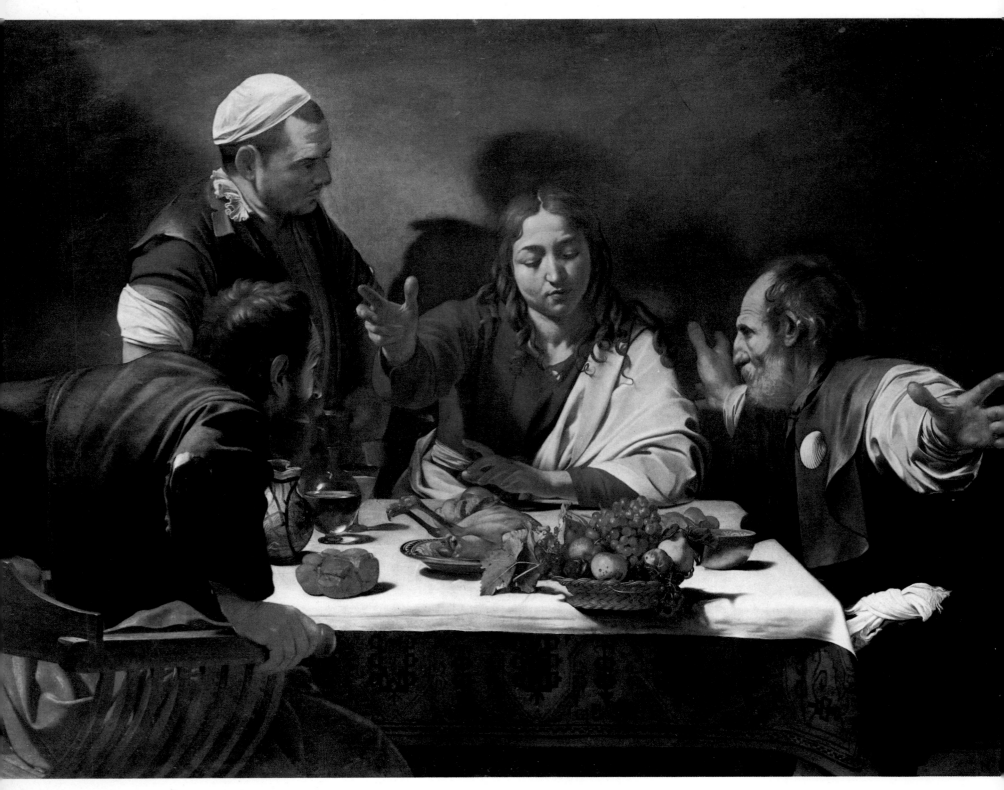

144 Caravaggio. *The Supper at Emmaus*. London, National Gallery.

He compromised this marvellous success immediately by becoming involved in a quarrel with a knight justiciary, a nobleman whose rank was higher than his own. And there he was, an outlaw once again. We shall never know what lay at the root of his psychological disturbance, but Caravaggio was truly a victim of what the psychologist Jules Laforgue has called 'the failure complex'.

The development of Caravaggio's work during his turbulent life passes through several phases. He first appears as a gifted and wayward artist, painting pleasing studies of equivocal young men, such as the *Bacchus* (Uffizi), the *Concert* (Metropolitan Museum) and the *Lute player* (Hermitage), or scenes of low life, such as the *Fortune teller* (Louvre) and the *Card players* (formerly Sciarra collection). Then, suddenly, a commission from San Luigi de' Francesi to decorate a chapel with a series of pictures of the life of St Matthew changed his whole life, bringing about a veritable conversion. X-ray examination has revealed two preliminary sketches under the surface of the *Martyrdom of St Matthew* which show

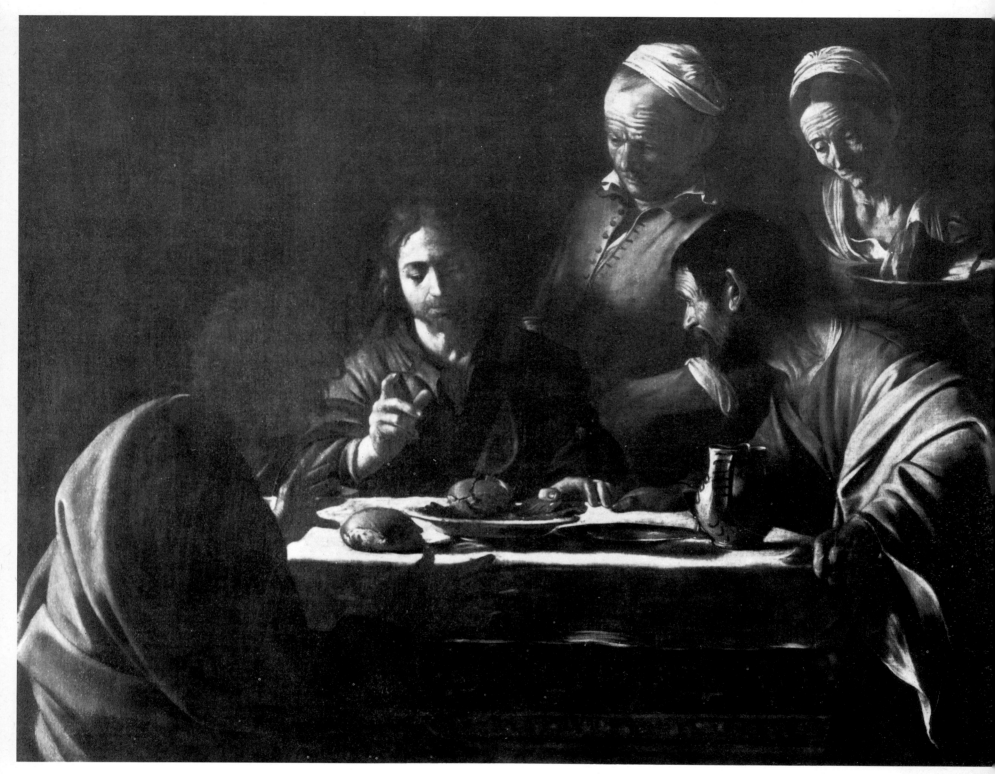

how bitterly the artist had struggled against his mannerist tendencies during the execution of the painting. He finally put youthful frivolity behind him in the *Calling of St Matthew*, where, as Giotto had done before him, he dared confront the human drama in all its naked truth.

From that moment onwards, and until the end of his life, this human resonance filled Caravaggio's paintings ever more profoundly. One subject that he treated twice at a few years' distance shows the extent of the transformation that had taken place in

him. The National Gallery's *Supper at Emmaus* (*pl. 144*), with its marvellous still-life and the exaggerated posturings of its human figures, is profane not only in the sense of being secular but even in the sense of being sacrilegious. The pilgrims' gestures would almost be appropriate to the sort of ale-house argument in which the artist so often became embroiled; indeed, these pilgrims seem about to come to blows. The Christ is a village dandy, with a sensual, vulgar face. In the later Brera version (*pl. 145*), on the other hand, the Christ is

145 Caravaggio. *The Supper at Emmaus*. Milan, Brera.

A comparison of these two pictures shows Caravaggio's progress towards a deeper understanding of the inner life; the earlier version is a somewhat blasphemous *genre* scene, whereas the later one possesses a genuine sacramental value.

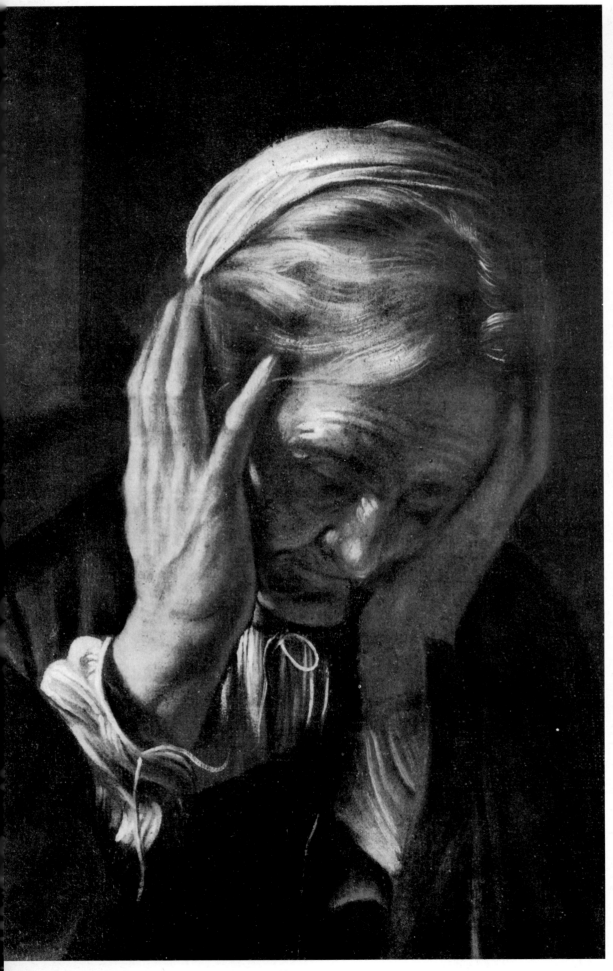

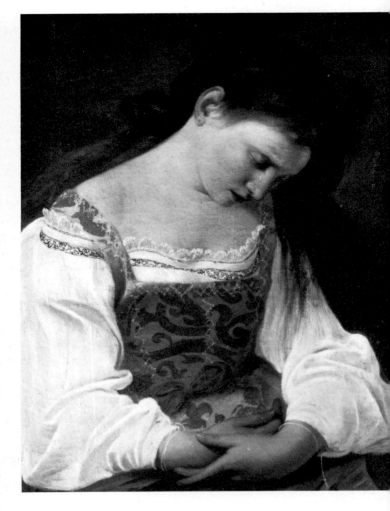

portrayed with traditional gravity of features, and the explosive violence of the London composition is replaced by an inner concentration. The actors in this drama are silent, filled with awe at the mystery they are witnessing. An old woman with a gnarled face brings the humble testimony of a being who has lived and suffered uncomplainingly. Caravaggio was fond of depicting this type of old woman; the most poignant of such representations is in the *Beheading of St John the Baptist (pl. 146)*, where the woman looking on has the same expressive power as the Virgin in the Avignon *Pietà (pl. 49)* or the old women of Le Nain.

An interesting comparison may be made, too, between the *Magdalen* of Caravaggio's worldly period *(pl. 147)*, a young maiden tearful at having to renounce her finery, and her counterpart (a picture known only by copies), painted in the Sabine hills when he had fled Rome after his homicidal duel: the later Magdalen *(pl. 148)* is bent backwards as she sends her terrible cry into the night. It is hard to imagine that the same man painted two such different works.

It is curious to note that Caravaggio's early conventional period left no breath of scandalous conduct. Only when drama entered into his art did

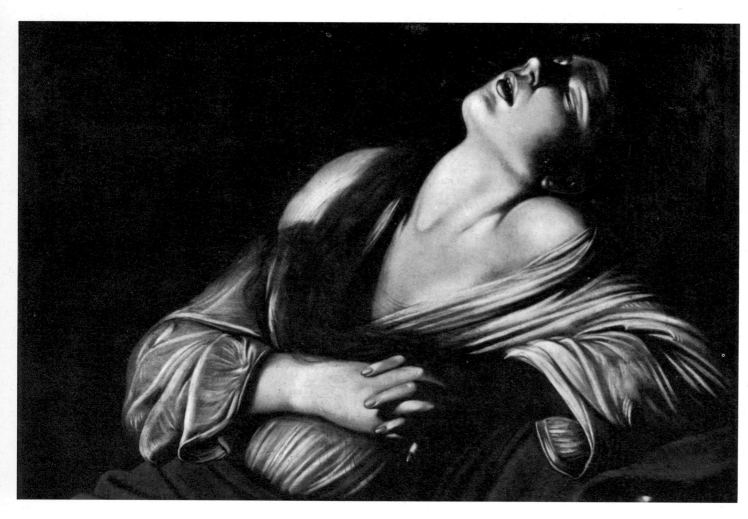

it also, apparently, irrupt into his life. The police dossier begins at the time of his first masterpiece; it is almost as though violence invaded his soul at the same time that his painting became inwardly directed and impregnated with silence.

Caravaggio was a giant among painters; and his far-reaching influence on the evolution of form was more benign than that of Michelangelo. Indeed, it may be said that whereas the latter initiated the most meretricious of the various currents of mannerism, Caravaggio blocked its way, exposed its tricks, guided painting back to its natural sources and restored the human content. He was a new Giotto, as Masaccio – to a less important extent – had been at the beginning of the fifteenth century. Italian art has shown an occasional tendency to stray into formalism, which has always needed to be corrected by the appearance of a Giotto to reaffirm that the fundamental basis for painting in that country is the human body. To rediscover the body's innate energy, Caravaggio swept away all the posturing puppets of mannerism and made his ideal the *uomo qualunque*, the man in the street, for whom he sought models in the Trastevere district of Rome. At the same time, he found human dignity in poor people, for whom the business of living and dying was a grave matter. Men, women, children, the aged, assumed the burden of fate by accepting it body and soul, having never been granted the intellectual means to discriminate, to avoid responsibilities or to indulge in self-glorification.

Bellori reproached Caravaggio for having visualized things only in their accidental, contingent aspect, but the opposite is true: it is the peripheral that he eliminates, reducing his compositions to a few essential figures who live the moment of passion with burning intensity. They communicate very little with each other; each follows his own pre-destined role. But occasionally the night is rent by the purity of a naked cry, and the harsh gesture that accompanies it is part of a vital rhetoric entirely characteristic of the Italian soul. With equal willingness, executioners and martyrs do their duty (*pl. 143*), because their destiny lies within them. Living, for them, is a religious act, and this artist, expelled by timid clerics from their churches, produced some of the most spiritually sublime paintings of the whole century.

The Madonnas of Caravaggio (*pl. 150*) are possessed of an inner strength that makes them impervious to the blows of fate, like the Virgin of

149 Caravaggio. *Entombment*. Vatican, Museum.

Anticipating the discoveries of the modern cinema, Caravaggio often places the line of the horizon (i.e. the eye level) in his pictures below the line of the earth.

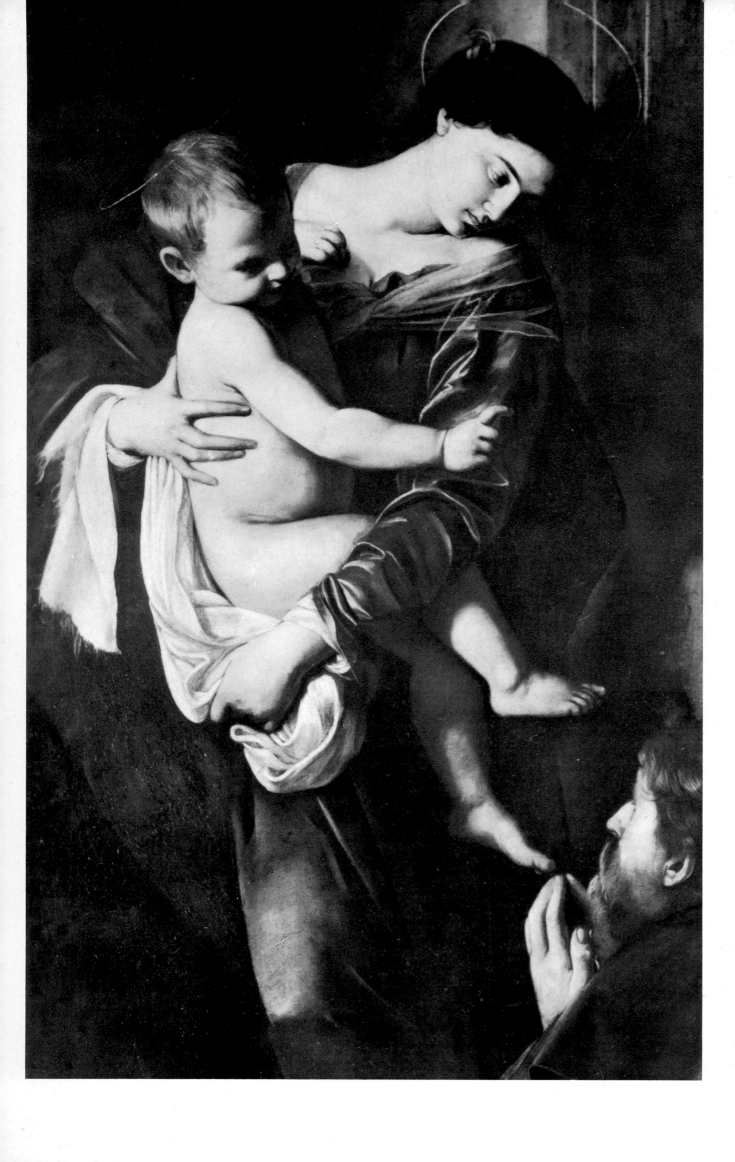

150 Caravaggio. Detail of *The Madonna of the Pilgrims*. Rome, Sant'Agostino.

This picture alone would suffice to show how wrong was the traditional opinion that Caravaggio only painted what was ugly.

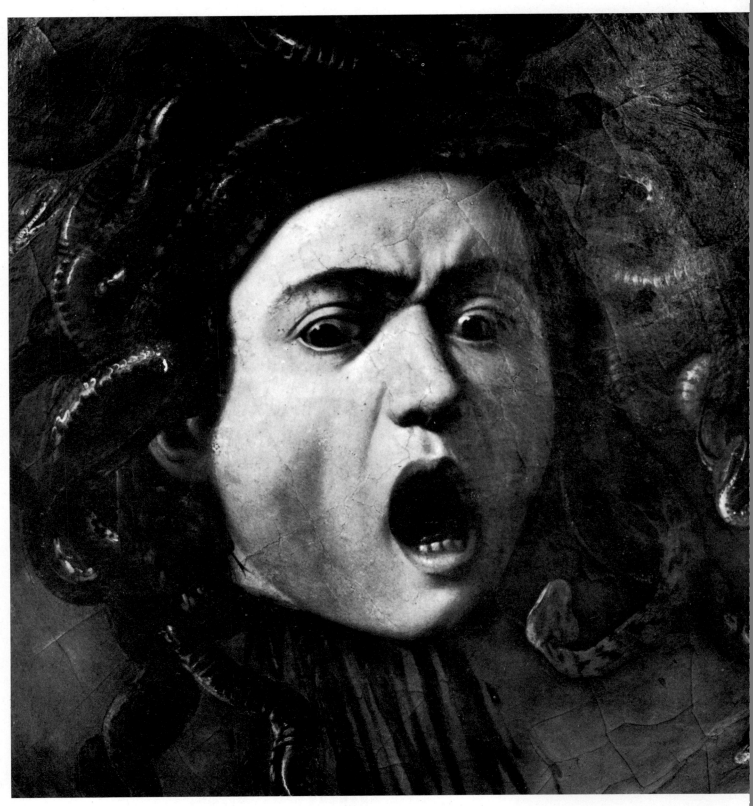

Giotto's *Annunciation* (*pl. 20*). Caravaggio borrowed the features of his Madonnas from the young peasant girls of Latium, Junos whose severe beauty and chaste gracefulness were to make them the favourite models of Roman painters of succeeding generations down to the nineteenth century. For this man with the reputation of a brute was susceptible to feminine charm. He elevated the image of woman in painting, by establishing that to be worthy of an artist's brush it was no longer necessary for her to be a goddess or a duchess; thus he fulfilled Savonarola's express wish to see painters take a woman of the people as a model for their Virgin. What attracted Caravaggio was, precisely, the pure outlines of those peasant faces which, in all their sane simplicity, seemed to have been freshly modelled by the Creator.

Having dedicated painting to man and man alone, Caravaggio suppressed the world by shroud-

ing it in night. He was not the first to appreciate the resources which darkness offered to the painter, but with him darkness was a principle, not an effect. He put an end to a century of the kind of studio lighting which, by wrapping itself round forms so as to define them more effectively, ended by stripping them of their substance. The oblique ray of light which enters his compositions penetrates the night like a scalpel and, creating great contrasts of shadow and brightness, asserts the presence of the bodies with powerful modelling of their volumes. He is careful not to attenuate this sculptural strength through the effects of brushwork; his handling is entirely traditional in its concentration on the definition of forms, and colour is for him always the servant of volume.

It was the Spaniards who understood most clearly, as early as the seventeenth century, that the very essence of Caravaggio's art was *relievo*, the sense of relief projection from a flat surface. Velázquez's father-in-law Francisco Pacheco suggested this indirectly in his book *El Arte de la Pintura*, and in the eighteenth century Palomino said so, unequivocally, in his *Museo pictórico*. In Caravaggio's last works, though, shadow takes on a more tragic hue, and in paintings such as the *Raising of Lazarus* and the *Martyrdom of St Lucy* becomes as fine as ash, turning into a shroud which veils the faces in twilight. The shadow of death stretches over everything, and in the *Beheading of St John the Baptist* (*pl. 143*) the night becomes an abyss in which the world is swallowed up.

To give the human body the greatest possible presence, Caravaggio simplified composition. By erecting statuesque groups in the foreground of the picture and propelling the gestures of these figures forward from the rear, he invited the spectator to participate in the scene (*pl. 149*). Breaking the old conventions of perspective in this way, he invented the technique of close-up which all the *tenebrosi* made use of subsequently, and which foreshadowed the innovations of the cinema. This accretion of physical presence diminishes in his last paintings, where the bodies seem to have become shadows moving in darkness.

Was Caravaggio a deliberate revolutionary who sought to draw attention to himself by adopting an eccentric attitude, and who, with this in mind, determined to make a complete break with the past? This is the traditional theory, going back to the seventeenth century; it was the view held by Poussin, who considered Caravaggio's intentions to be entirely destructive, and by Velázquez's rival Bartolommeo Carducci (Carducho), who called Caravaggio 'Antichrist'. Faithful to the classical

152 Caravaggio. Head of Goliath, detail of *David holding the head of the giant Goliath*. Rome, Galleria Borghese.

Caravaggio projected his rage into the head of Medusa; and, in an unconscious desire for self-punishment, gave his own features to the decapitated head of Goliath. These pictures thus became projections of his own inner drama.

153 Artemisia Gentileschi (1597–after 1651). *Judith and Holophernes*. Florence, Uffizi.

The appearance of sadism in art in the late sixteenth century is a manifestation of a profound spiritual malaise.

aesthetic in a century which had rejected it, Bernard Berenson refurbished this theory towards the end of his life, and so aroused the wrath of the devoted sect of Caravaggists. But this hypothesis of a desire to break away at all costs must be considered untenable in view of Hugo Wagner's demonstration (in *Caravaggio*, Berne 1958) of the extent to which Caravaggio borrowed from Michelangelo, Raphael, Correggio, Savoldo, Titian and the statuary of classical antiquity. Even the Carracci absorbed fewer influences than this. It would be nearer the mark to view Caravaggio as an heir of the Renaissance who restored its true values.

The mystery of Caravaggio has preoccupied a number of critics in the last few years. The Italian critic G. C. Argan sees him as a precursor of existentialism who possessed a tragic awareness of the total strangeness of the real, of the impossibility of a harmonious relationship between the two realities constituted by the self and the other; in Argan's view, the raw reality which Caravaggio constructs outside time and space is unreal, an attempt to discover 'the point of fracture between an equally problematical inner and outer experience, the moment at which the fury of being subsides into the absolute immobility of non-being'. In Caravaggio's poetics, death is thus the natural end of existence, a death which is not the transition from one life to another but a full-stop; the artist himself is thus, according to Argan, an unbeliever (see *Scritti di storia dell'arte in onore de Lionello Venturi*, Rome 1956). Mauro Calvesi goes even further, seeing in Caravaggio an adept of the pantheistic theories of Giordano Bruno, who was burnt as a heretic at Rome's Campo dei Fiori in 1600 (see *Trésors du Vatican*, Geneva 1962). For Walter Friedländer, on the contrary (*Caravaggio Studies*, Princeton 1955), the profound influence in Caravaggio's life was the mysticism of St Philip Neri who, in his passionate love for the poor, went to preach in the slums and was greatly beloved by humble folk.

Rather than pursue such contradictory theories, it is better to return to the evidence: the forty surviving paintings, and what we know about his life. The discrepancy between these two sets of information must surely indicate that this vigorous personality suffered from a sickness of the soul, a neurosis, which at certain moments plunged him into all the horrors of paranoia. Some of his pictures are filled with symbolic significance: he expressed his aggressiveness, for example, by painting a head of Medusa (*pl. 151*) – an unusual subject for an artist of that time – and giving it the tragic grimace of the demented youth in Raphael's *Transfiguration*. Self-punishment found an outlet in the painting in

which he has given his own face to the horrible severed head of Goliath brandished by David (*pl. 152*). He could escape this fury only when, under the spell of artistic creation, he felt himself a demiurge, soaring above his own being, his dark impulses 'sublimated'. He had the merit of being equally ignorant of the hedonist ethic which finally stifled the Renaissance, and of the kind of aristocratic disquiet cultivated by mannerism as an elegant attitude, a refinement of court life. For Caravaggio, life was a drama resting upon the essential discord between man and the world. The tragic pathos which resulted from this realization contained within it a creative, heroic principle which forced him into a perpetual confrontation with all that was, and could only be, contrary. Caravaggio, like Giotto, recaptured the grandeur of classic tragedy, but Giotto is Sophocles, while Caravaggio is Aeschylus.

Caravaggio's discoveries continued to exercise immense influence throughout the seventeenth century. Far from engendering any kind of conformism, they aroused a sense of freedom by offering artists a new means of exploring the hidden recesses of the soul. At Rome, certain painters were his disciples, if not his pupils: Baglione, for example, who later took him to court for slander, and Orazio Gentileschi, who was a witness for the defence at the trial of the action.

Gentileschi, too, was a man of contradictory temperament. His paintings tend either to add an element of poetic tenderness to Caravaggio's art or

154 Battistello (*c.* 1570–1637). Detail of *The Flight into Egypt*. Naples, Museo Nazionale de Capodimonte.

Battistello, in his few Caravaggesque paintings, maintains the profoundly human emotional content of Caravaggio's work, adding to it a particularly delicate touch of his own.

to accentuate its popular feeling to a point of triviality. The work of his daughter Artemisia was even more personal, for her pictures reveal a lascivious eroticism and an instinctual cruelty pushed to the point of sadism. These two tendencies are united in the theme of Judith and Holofernes, which formed the subject for several of her paintings (*pl. 153*). She often used the rays of light from a candle to shred the shadows, a method of cutting light and shadow into strips for dramatic effect which is contrary to the spirit of Caravaggio, whose chief aim was always to emphasize volumes. Indeed, he never made use of candlelight, with which the mannerists had already experimented and which was to become one of the trademarks of the second-generation Caravaggists, such as the Dutchman Gerrit van Honthorst who, during his stay in Italy, gained the nickname of Gherardo delle Notti.

Caravaggio's stay in Naples left a deep mark. His most faithful disciple there was Giovanni Caracciolo, called Battistello. Of all the throng who imitated Caravaggio, it was this admirable artist who assimilated most closely his art, his poignant human gravity, his pensive melancholy, and the religious solemnity which the master discovered in the life of the common people, that eternal reservoir of great primal feelings. To all these elements he added a personal accent of sentimental poetry and quickened tenderness (*pl. 154*). Trained as an academic painter, he employed chiaroscuro to obtain the solid definition of forms which was his master's great concern. Il Battistello provided the solid foundation for Caravaggism in Naples.

Giuseppe (José) de Ribera gave a new direction to Caravaggism in steering it towards a romanticism which was to become the distinguishing feature of the Neapolitan school. Although Naples became the great centre of the *tenebrosi*, the 'shadowy' followers of Caravaggio, these deviated increasingly from the spirit of the master; Caravaggio would never have recognized the sort of soupy nocturnal atmosphere in which they bathed their figures as deriving originally from his own researches.

In their enthusiasm at discovering a second Michelangelo, modern critics have made Caravaggio responsible for 'tenebrism' throughout Europe, but a more profound knowledge of seventeenth-century painting must modify this opinion. The examples furnished by Caravaggio served, rather, to reveal a tendency which was achieving more or less conscious expression in the north as well as in the south. Recent criticism has been able to enumerate the pictures by Caravaggio which had reached Spain by the beginning of the seventeenth century and which may therefore have exercised an influence on the development of the Seville school at the threshold of Spain's 'golden century'. As a result, it is no longer possible to view Zurbarán's tenebrism as derived from that of Caravaggio. Plastically, it derives from the Seville tradition of sculpture which was then at its highest point of inspiration, and psychologically the existential nothingness which envelops his human figures relates to the spiritual and monastic currents of his time. On the other hand, it is certain that the Velázquez of the first period, the so-called 'period of the *bodegones*', was directly influenced by Caravaggio. This is confirmed by Pacheco, who, after speaking of Caravaggio's naturalism, adds: 'My son-in-law follows this path.' Velázquez's painting soon took other directions, but he retained from his youthful admiration for Caravaggio the absolutely sure sense of form which never deserted him even in his most impressionist manner.

Utrecht became the furthest outpost of Caravaggism in northern Europe. Honthorst, returning from Italy in 1620, soon abandoned the spirit of the master, preferring to give a bourgeois rhetorical veneer to the popular themes he treated. The well-behaved soldiers and courtesans he included in his pictures to please his customers are very different from the male and female vagrants featured by the other Utrecht Caravaggist, Hendrik Terbrugghen. Terbrugghen genuinely deserves the appellation of pioneer, for he succeeded in producing a new Caravaggism based on clarity rather than darkness, a transformation that the admirable painter Serodine had already accomplished in Italy. Terbrugghen had trod in Caravaggio's footsteps, having arrived in Rome while the latter was still alive. In the pictures which he painted on his return to Holland in 1620, Roman Caravaggism and northern expressionism intersect, with sometimes one and sometimes the other tendency predominating. Thus, his *Crucifixion* (New York, Metropolitan Museum) has the tone of a Grünewald, whereas other works of his are linked with Roman or northern tenebrists, Elsheimer, Saraceni, Gentileschi, Pieter Lastman, and even show affinities with Serodine. The connection with Serodine poses problems, since the latter was not in Rome during Terbrugghen's stay in that city. But these analogies between artists who were sometimes working at a distance from each other can be explained by the simple phenomenon of the convergence of effects flowing from a single cause.

In 1625, Terbrugghen, who like Honthorst was a Catholic, abandoned religious themes for genre scenes, perhaps for commercial reasons, perhaps because profane subjects gave more freedom to a

painter with an experimental frame of mind. In his final years, Terbrugghen gradually abàndoned tenebrism for a 'luminism' which led him to researches which were in a sense the very opposite of Caravaggism proper, namely the study of the coloration of shadows. His last works, such as the *Jacob and Laban* (National Gallery), the same theme at Cologne, the *Lute player and female singer* (Louvre), the *Annunciation* (Diert) and the splendid *Concert* (Palazzo Barberini, Rome) painted in the last year of his life, 1629, are executed with a brush which is sensitive to delicate nuances, to the transitions of light and shadow, to the unctuous quality of thick pigment. Abandoning the strict delimitation of local tone values which had characterized his previous work painted in the Roman manner, Terbrugghen evolved a richer colour which he endowed with an atmospheric, 'impressionist' value; certain of his still-lifes make one think of Vermeer and Chardin, others evoke Monet. But, even if he went beyond Caravaggio, he never betrayed his principles. The solidity of his forms remained faithful to the spirit, if not the letter, of the master's work.

The importance of Terbrugghen in the evolution of Dutch painting was apparent in 1935 on the occasion of the Vermeer exhibition which inaugurated the Boymans Museum in Rotterdam. That same year, I showed, in my essay on the exhibition in the periodical *L'Amour de l'art*, how Vermeer's luminism may have flowed from Caravaggio's tenebrism through the agency of Terbrugghen. The school which flourished in Utrecht around 1620–30 was a great laboratory in which the blending of Roman tenebrism and northern tradition produced new directions which proved of lasting value for Dutch and European painting.

As for the 'tenebrism' of Georges de La Tour, it would now seem that its sources should be sought in Utrecht rather than in Rome. The Roman archives, and in particular the registers of Easter communion, all of which have been preserved intact, allow us to know the names of the artists who frequented the eternal city during the seventeenth century. There is no trace here of La Tour's name, although several other French artists journeyed to Rome to learn the value of darkness in painting.

During the fifteen years of his stay in Rome, Simon Vouet showed himself one of Caravaggism's most faithful adepts, and when he renounced this influence he lost his humanistic quality. His compatriot, Valentin, on the other hand, was so determined to remain faithful to the master's spirit that he spent his life in Rome and died there. When Vouet returned to the court of France he had no choice but to betray Caravaggio, confronted as he was by the French school's great tradition of bright, clear painting, a tradition which stretches without interruption from Fouquet to David.

Georges de La Tour was not really an exception to this rule. It should be remembered that he did not live in French surroundings but in the rather isolated atmosphere of Lorraine, at that time part of the Holy Roman Empire, in the provincial town of Lunéville. The drama of man's solitude in an empty, meaningless world became, for La Tour, that of the soul at grips with the terrible problem of grace. La Tour's humanism renounced the light of the sun, even those few rays which still penetrate into Caravaggio's cellars. His human beings live in catacombs by the gleam of candles and torches. Monumental figures project fantastic shadows on to the walls, while the brutal, lurid light of the candles picks out the faces and bodies in sharp relief. Acting out their whole lives in these dark, bare underground places, these cave-dwellers are born and die there, pray to God and nurse the sick there; soldiers play dice, a child helps its father who is a carpenter, a little girl learns to read among these shadows, in the flickering light of a torch, under her mother's watchful eye. And in one corner a bandy-legged, gouty, blind beggar plays a hurdy-gurdy.

All these scenes are, in fact, illustrations from the New Testament. La Tour went even further than Caravaggio in the way he costumed his characters. While Caravaggio still depicted the toga occasionally, even if it was in tatters, La Tour clothed them all in the popular dress of his time, grey, red or blue frieze; even the angels were condemned to the same drab uniform. These individuals all seem to belong to some monastic confraternity which has made a vow of penitence to lead a subterranean life, like those Egyptian hermits who chose to live among the tombs. Apparently vowed to silence, their lips are sealed. They make few gestures, and these are usually to clasp their hands together. A race of troglodytes, it consists entirely of old men ravaged by darkness (one of them is blind), sleeping children, women chastely veiling their glances behind half-closed lids (*pl. 155*). This renunciation by a whole people of the lusts of the flesh has a grandeur about it that is worthy of Pascal. Dead to the world of appearances, they are dedicated exclusively to the life of the soul. The object upon which these beings constantly meditate is revealed by one of the women: the Magdalen who gazes fixedly at her two faces reflected in a mirror, the face of today, so young and so pure, and the face of tomorrow, a skull resting on a book which she is holding in her hand.

And yet La Tour is not an avant-garde painter. His imagination is extremely limited, and he seems

to have relied entirely on a morphological repertory established in his youth. Moreover, his plastic idiom is certainly borrowed from the international language of Caravaggism, with Terbrugghen and Honthorst acting as intermediaries. No further proof is needed of the immensity of the revolution sparked by Caravaggio than the fact that it could contain within its ranks both La Tour and Vermeer!

There is nothing ascetic about the human beings depicted by La Tour. Like those of Zurbarán and Rembrandt, they are the descendants of Caravaggio's athletic plebeians. Their bodies seem to be bowed beneath the weight of their inner life. During the seventeenth century, the most profound spirituality was transmitted not through ethereal entities such as saints and angels but through the gravity of human bodies. The image of the athlete symbolized the sheer weight of the overcharged soul that the body had to carry. The life of the soul was lived as a drama of earthly life, rather than as an aspiration to the Beyond. It was only the Christians whose

minds were on this world who saw God come to life from the ceilings and altars of the churches and appear among them, surrounded by His chosen. Those Christians who rejected this life never enjoyed these dreams; bent low beneath the stern gaze of the 'God of Abraham, of Isaac and of Jacob', to whom they dared not raise their eyes, they experienced Christianity as an ethical system rather than a theology.

Speculation concerning the possibility that mere being might attain access to pure Being through the transforming power of the union with God reached its culmination with St John of the Cross and St Teresa of Jesus. Whether they were driven by charity (St Vincent de Paul, St Francis of Sales, Rembrandt) or by the egoism of an individual ascesis (Duvergier de Hauranne, La Tour), the seventeenth-century mystics lived the spiritual life in action. What tormented these men enamoured of God was less God than human destiny. There was a great deal of stoicism in Jansenism, just as there

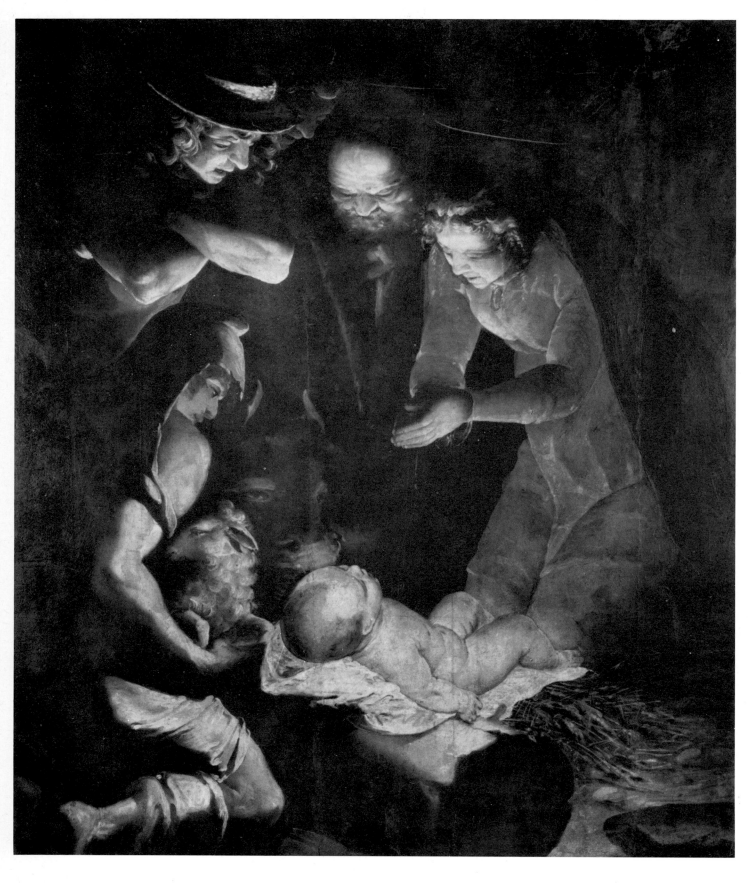

was in the art of Caravaggio. Perhaps the clerics who rejected Caravaggio's altarpieces felt dimly that this religion was humane, too humane, inspired by man's innate dignity, a pre-eminent dignity circumscribed by God alone. Between the

great eddies of the Renaissance, the Reformation and the Counter-Reformation, *virtù* had become Christianized, while sainthood had become humanized: the meeting-point was virtue. Christianity had become a humanism.

The dramatic possibilities of night effects in the *Nativity* had been explored well before Georges de La Tour, but in his case the darkness is a manifestation of the inner life.

157 Juan Carreño de Miranda
(1614–85). Detail of *The Foundation
of the Order of Trinitarians by St John
of Matha*. Paris, Louvre.

12 A new language

In 1627, Francisco Herrera the Elder, painter of Seville, received from the college of San Bonaventura a commission for a decorative scheme designed to celebrate the life of the 'seraphic doctor', St Bonaventure. He painted four of the pictures of this cycle (*pl. 158*), but for some unknown reason failed to complete it, and the task was confided to Francisco de Zurbarán. Herrera was both temperamental and hot-tempered, and it has been surmised that he abandoned the project as a result of some quarrel with the monks. It would seem, though, that aesthetic differences were more likely to have been at the root of the trouble. Herrera's romantic, passionate, allusive manner corresponded to a strain of bravura in Spanish art which must have dismayed a city in which, since the beginning of the century, the sculptor Martínez Montañés had imposed the concept of a proper classical balance in place of the exacerbated mannerism of the sculptors of the *bajo renacimiento*. Zurbarán had inherited this tradition of formal, sculptured severity, together with the lofty spirituality of Montañés. One can guess that the monks of San Bonaventura must have preferred to see their patron honoured by Zurbarán, whose solemn brush gave to the saintly figures that mystical presence which the religious mentality of the time demanded, rather than by Herrera whose caricatural figures foreshadowed those of Goya.

The altarpiece in question has long since been dispersed. Separate acquisitions, spaced over a century, have allowed the Louvre to group together four paintings, two by Zurbarán and two by Herrera, which can confidently be regarded as having originally formed part of it. Side by side, these silent witnesses of opposing aesthetic outlooks allow an immediate insight into the nature of the great debate which divided the seventeenth-century art world.

For the painters of the Renaissance, the picture was a composition of individual forms; they had inherited the aesthetic of classical antiquity, renovated by Giotto, which had based art upon the representation of the human body. Around this body, all the physical elements of the world were themselves apprehended as independent objects in their corporeity, and thus painting turned itself into

158 Francisco Herrera the Elder (1576–after 1657). Detail of *The Communion of St Bonaventure*. Paris, Louvre.

Herrera's bold treatment of his figures anticipates Goya; it is understandable that the monks of San Bonaventura in Seville should have preferred the style of Zurbarán who completed this commission.

the servant of sculpture. Raphael and Michelangelo, in the Stanze and on the Sistine ceiling, gave the sanction of classicism to this aesthetic. Mannerism itself, especially in its second phase, respected these positions; never before had pictures been 'finished' with such care, and those of Bronzino, for example, seem to be made of some hard gem-like substance.

Venetian art alone, exploiting the discoveries of Giorgione, had employed the atmosphere as a means of reuniting these separate bodies without breaking the unity of the composition. Towards the end of the sixteenth century, Venice saw a confrontation between the rival principles in the persons of Veronese, who endowed forms once again with Bellini's limpidity, and Tintoretto, who dissolved them in shadows.

Although Tintoretto pointed the way forward towards the new painting, there was no immediate response. At the beginning of the seventeenth century the centre of attention was not Venice, which had to wait for Poussin to rediscover it, but Rome. Rome, faithful to its traditions, upheld the principles of statuary form, in a conventional manner in the case of the Carracci, and by direct recourse to nature in the case of Caravaggio. The sway exercised by these artists was so great that Italy was inhibited for some time from developing the new pictorial form.

The Flemish school joined Italian tradition in one respect: it also, although adhering more closely to the real, had conceived each form as a corporeal object, all the resources of dextrous handling being applied to the definition of that object's substantial significance. So, apart from the isolated example of Tintoretto, there was nothing to suggest at the beginning of the seventeenth century that a new concept of painting as painting was taking shape. The formal Italian tradition continued throughout the century, while the Netherlands experienced a magnificent revival of objective painting. Most French painters sought inspiration from both these tendencies and remained deliberately insulated from the current of innovation: Poussin and Claude, however, were wise enough to maintain a distance between themselves and the Parisian scene, where art was becoming increasingly subordinated to the fashionable requirements of the court.

Within a few years of each other, Peter Paul Rubens in Antwerp and Frans Hals in Haarlem had turned tradition upside down and created the new language of painting.

For Rubens it was the renewed contact with his native soil, made possible by his return from Italy in 1609, that allowed him to set aside the disciplines to which he had adapted himself while in the south,

and to conquer his own individual craft. He was to become the most painterly of all painters, with the possible exception of Velázquez and van Eyck. The evolution of Venetian painting, from Giorgione to Titian, and from Titian to Bassano and Tintoretto, had been in the direction of an ever-increasing use of thickness in paint. At the outset of his career, Rubens preferred to knead the impasted paint finely, as in the *Philopoemen* sketch (*pl. 159*) and the *Adoration of the Magi* (Groningen). On his return to Antwerp, however, he revived the van Eycks' transparent technique, sketching out a grisaille which allowed the white undercoating to show through and then superimposing thin glazes or half-tints. But whereas van Eyck gave the greatest thickness to the shadowed parts and a delicate thinness to the light parts, Rubens followed the example of Bassano and reversed the process, keeping the extrusions of paint for the eye-catching bursts of light, and giving the shadows a mysterious depth by brushing them in with faint tints.

This was to be the very basis of modern painting: light expressing itself in relief. Rubens created a supple technique which held together all the assembled elements in a single fluid; it was like a generous sap circulating in the beings and things of this world, an all-embracing, eternal force manifested in short-lived individual beings, as in the *Battle of the Amazons* (*pl. 160*). His handling was amazingly rich and completely adaptable to his different needs. Rubens had no set technique; rather, he created one for each picture. Although in his sketches he allowed himself the delicious pleasure of improvisation (but only after prudent graphic meditations beforehand), he was capable in his medium-size works of giving the illusion of 'finish', of caressing forms slowly and amorously, giving them voluptuous fullness with his brush, as van Eyck would have done (the *Christ on the straw* and *Virgin with the parrot* in Antwerp, the *Self-portrait with Isabella Brandt* in Munich). For larger-scale works, he used a more summary, more opaque technique involving fewer layers of glaze (the sequence of paintings of the Medici Gallery, Louvre).

Towards the end of his life, during the period of domestic bliss resulting from his marriage to Helena Fourment, his manner became even freer and more spontaneous. Putting aside his tendency towards a somewhat overpronounced handling, he allowed himself a sort of relaxed informality which brought him close to Velázquez, abandoning compositions half-way through their execution to endow them with the charm of improvisation. Unfortunately, the balance of colour-values in these pictures is necessarily so subtle that often it has succumbed to

159 Peter Paul Rubens (1577–1640). Detail of *Philopoemen recognized by an old woman*. Paris, Louvre.

This flowing and impasted paint provides the means for the youthful Rubens to express freely his sensual temperament.

160 Peter Paul Rubens. Detail of *The Battle of the Amazons*. Munich, Alte Pinakothek.

161 Peter Paul Rubens. *Helena Fourment and her children*. Paris, Louvre.

Rubens handled transparencies, impastos and *demi-pâtes* with equal virtuosity; no subsequent painter has been able to match the genius with which he made use of all the resources of the brush.

162 Frans Hals (1585–1666).
Portrait of a man. The Hague,
Mauritshuis.

tion with other artists. His splendid handling is evident only in those paintings where, although he had assistants working for him, he remained personally in charge of the whole operation; where he allowed the entire scheme to be executed by pupils, the resulting paintings are like lifeless corpses through which the blood is no longer circulating (for example, the cartoons of the *Triumph of the Lord's Supper*, or the *Chase* of Marseilles). Only that delightful painter Jan 'Velvet' Bruegel successfully assimilated, on a smaller scale, this beautiful transparent handling, although he was considerably older than Rubens: but then Bruegel also had the example of his own father's pictures. The fact that it proved impossible to pass on the benefit of Rubens's craft of handling paint, however simple the process of transmission might seem, tends to refute Michelangelo's dictum that 'one paints with the brain, not the hand': genius does lie partly in the hand.

It is the hand, indeed, which seems to govern seventeenth-century painting, that hand which the artists took such pleasure in painting, often making it the bravura piece of the composition, the place where the message is concentrated. Its action is nowhere more evident than in the work of Frans Hals. His earliest group portrait, the *Officers of St George's Company of Archers* (Haarlem), dated 1616, shows a technique that is already mature, although it was to evolve towards the end of his life, in the expressionism of the *Governors* (*pl. 163*) and *Women Governors*. Yet expression was not Hals's aim. Probably no other painter allowed himself to be so carried away by the desire to suggest the operation of artistic creation; one has the sensation of witnessing a feverish battle in which the painter wrestles with appearance, and one feels able to measure its stages as though they were successive phases of a piece of music. Made of hatchings, slashes, spurts of colour, sometimes scarcely accentuated by a glaze, Hals's technique seems to be a transposition of drawing into painting: the brush never pauses for a moment, the frantic manipulation never stops.

Hals's pictures do not all show the same boldness, though. Working, as he did, in that most demanding of arts, portrait-painting, he was obliged to come to terms with the model's desire to be provided with a faithful likeness. He is said to have explained his manner in the following terms: 'I paint for the honour of my name. A painter must conceal the humble, arduous labour of exactitude which portrait-painting demands.' Often, having to restrain his impatience while modelling faces, he achieved compensation in his approach to the accessories, the clothing and the hands, making

the attentions of restorers (*The Little Pelisse*, Vienna). But the paintings of this period that have remained intact, such as the Louvre's *Helena Fourment and her children* (*pl. 161*), allow the spectator to participate in the miraculous creation of a work still in process of development, and indulge in the pleasure of imagining all the possible completions.

The most surprising aspect of Rubens's technique is that it remained incommunicable. Yet one cannot speak of a jealously guarded secret, since Rubens had several disciples, and often worked in collabora-

them the outlets for the joy he took in painting. In his final period he swept away all barriers and even gave faces (*pl. 162*) the same perfunctory treatment that he had previously reserved for hands.

To 'paint for the honour of one's name' was a sin in bourgeois Holland, where the artist was an artisan, neither more nor less so than a cabinet-maker from whom one ordered a piece of furniture. Hals was made to pay dearly for his pride: burdened with a large family, he spent his whole life plunged in endless law-suits with the baker, the shoemaker,

the milkman, even the canvas supplier. Fate decreed, too, that his large family should include an idiot son and a daughter who became a prostitute. However, at least part of the hardship and disorder of his domestic existence must have been due to his own flawed character. It is true that painters were badly paid in Holland, and Hals is recorded as having refused to complete a group portrait in Amsterdam because the stay there would have cost him more than the fee he would have got for the work. But he received many commissions, especially from the

163 Frans Hals. A hand, detail of *The Governors*. Haarlem, Frans Halsmuseum.

Frans Hals attacks his picture with furious energy, wielding his brush as though it were a sword.

corporations, and succeeded in transforming these wooden *doelenstukken* into jolly banquets in which the collective soul of the participants shines through. It is the impassioned movement of his brush that allows such a suffusion of warmth to pass through these figures. These commissions would have allowed a more economically minded person to live comfortably; but Hals was by nature a Bohemian, living for the moment and improvising his life as he improvised his art. No other painter produced work that was more subjective and yet less expressive. There were, for Hals, no depths to plumb; except in his last paintings, where poverty awakes a sympathetic echo in him, his work is soulless. He painted. He painted for pure pleasure, never tiring of seeing his inspired hands generate the miracle of the image suddenly taking shape on the canvas. He left behind him not so much a body of work as a splendid series of fragments.

When, in 1627, Francisco Herrera received the ill-fated commission in Seville for the San Bonaventura cycle, Diego Velázquez had been gone for more than five years, leaving behind him in that city of monasteries the sculptured style of his first manner, which Zurbarán was to take over and develop as the fashionable kind of painting there. At the beginning of his career, Murillo himself adopted this style in the cycle he began in 1646, when he was twenty-six, for the Franciscan monastery in Seville. Here, his *Miracle of St James* (the *Cuisine des anges*) and *Charity of Brother Juniper* (both now in the Louvre) represent this first manner, while the *Death of St Clare* (now in Dresden) from the same series is a harbinger of his mature style, compounded of suavity and unctuousness. Soon the sculptural style, even in Seville, became so out of fashion that Zurbarán abandoned it and made a desperate and remarkably unsuccessful attempt to imitate Murillo's prettiness and fluidity.

Velázquez's first master was Herrera, but it is doubtful whether this brief apprenticeship at a tender age left any lasting impression, since by the time he was eleven, in 1610, he had become a pupil of Francisco Pacheco who was to become his father-in-law. Pacheco, the chief representative in Seville of the academic conception of a belated variety of mannerism, had no influence whatsoever on the young man's temperament. According to Pacheco himself, Velázquez imitated Caravaggio, whose work was known in Seville through a few paintings which had recently arrived from Italy; but the artistic influence of his native city may well have sufficed for him to follow the local manner of depicting night scenes in crisp, plastic modelling.

The example of Herrera, who was opposed to this style of painting, may have been a factor in his change of course. In any case, he found his true direction as soon as the royal court beckoned him and so released him from the stifling atmosphere of Seville. His first portraits executed at the court of Philip IV aroused great enthusiasm and ensured him the protection of a monarch who was unfortunate in politics but fortunate in his artistic taste. Velázquez now had honours showered upon him, and was even awarded a coveted knighthood which relieved him of the necessity of working for commissions. From now on he had only to satisfy a king who admired him and a chief minister who protected him against court intrigues: he became the first artist to free himself from a relationship with 'customers'. He made this independence a point of honour, and when the enquiry took place which was to determine his worthiness to be received into the Order of Santiago, he persuaded several witnesses to testify that he had never received money for a painting (a claim belied by a number of receipted bills), a condition of entry into the nobility being that one must never have drawn profit from the work of one's hands.

Velázquez must have been the least mystical painter of the seventeenth century. In Madrid he was the master of his fate; freed of the importunities of the monks, he could paint men. His work includes few religious pictures, and even these seem devoid of divine inspiration; indeed, it is permissible to detect an actual element of profanation in the *Crucifixion* he executed for the nuns of San Placidio (*pl. 164*). He half masks the Holy Face, that eternal object of the ardent meditation of Spanish sculptors seeking to penetrate the mystery of the divine in human nature, using the pretext of the flowing hair. By depriving the God-man of all expressive value, he automatically avoids the most difficult problem in the art of portraiture: a strange reticence in the most versatile of painters! No doubt this effacement of God was not a deliberate gesture, since Velázquez certainly had sufficient Christian faith to live in the court of a Catholic king and is known to have possessed at least a degree of religious conviction. But *instinctively* he drew this curtain of oblivion over the divine features. One can only suppose that he felt himself to be abandoned by God, by a God whose estrangement had already begun to cast a pall of solitude and silence over the human effigies he painted.

By 1630, Velázquez's technique seems to have been fully developed. (His meeting with Rubens in 1628 must have been very useful; it certainly taught him the use of glazes.) The great problem in

attempting to describe Velázquez's technique is that it defies definition and renounces principle. Although it seems improvised, one senses that it results from a process of deep reflection; its air of spontaneous inspiration conceals a slow process of secret maturation.

His painting consists of a very diluted flowing impasto accentuated by sparse glazing, fairly dense and yet impalpable, traced by a brush which never hesitates and seems to touch the canvas as lightly as it is held in the artist's hand. This rather opaque pigment, which nevertheless has a diaphanous quality about it, tends to swirl back upon itself in an unhurried, even nonchalant, movement: a handwriting showing no sense of passion on the part of its author, but rather an attitude of complete authority over the object.

Velázquez accepted the supreme challenge in painting, that of evoking appearances so as to deny their reality and make them return to the nothingness from whence they came. Conjured up to the surface from the depths of the soul, these images retain scarcely a flicker of life: they are still-born phantoms symbolizing man's ephemeral existence. Velázquez uses his magical brush to call forth these appearances for the pleasure of showing his complete detachment from them. The Catholic Spain of Velázquez, and of Zurbarán too, seems to acknowledge the physical presence only of those things relating to God: everything emanating from man is doomed to oblivion.

Creating his apparitions only to deny them the right to exist, Velázquez dismisses the tangible world as an empty spectacle. The only trace of emotion that this misanthrope betrays is when he paints themes of childhood, that secret world in which the still innocent soul trembles at the surface of appearance, before perishing entombed in the prison inhabited by those sad individuals, wedded to the misery of their mediocre personality. Sometimes the light that gleams in these children's eyes seems all the more touching for representing the thin thread of life that preserves these graceful little bodies from the inexorable approach of death (*pl. 165*).

The Spaniards of this era were obsessed by this sense of the evanescence of things and of beings. Quevedo, the contemporary of Velázquez, celebrated the memory of the artist in a sonnet which contains the lines:

> *From the painting's frail support*
> *The colour flees like a shadow*
> *Denying the relief that the hand thinks to find.*

It is difficult to tell what kind of a man Velázquez may have been. The few references to him by his

164 Diego Velázquez (1599–1660). Detail of *The Crucifixion*. Madrid, Prado.

How is one to interpret the unparalleled audacity with which Velázquez half masks the face of Christ on the cross?

167 Rembrandt (1606–69). Detail of *Portrait of a woman*. Paris, Louvre.